THE SPIRIT OF
BEARDSLEY
A Celebration of his Art and Style

First published in 1998 by
Parkgate Books,
Kiln House, 210 New Kings Road, London SW6 4NZ

© Parkgate Books Ltd 1998

This edition is published by Gramercy Books,®
a division of Random House Value Publishing, Inc.,
201 East 50th Street, New York, New York, 10022.

Gramercy Books® and design are registered trademarks of
Random House Value Publishing, Inc.

Random House
New York • Toronto • London • Sydney • Auckland
http://www.randomhouse.com/

Printed and bound in China

A CIP catalogue record for this book is available from the Library of Congress.

ISBN 0-517-16084-6

8 7 6 5 4 3 2 1

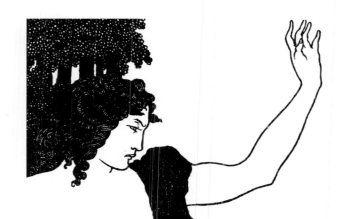

THE SPIRIT OF
BEARDSLEY

A CELEBRATION OF HIS ART AND STYLE

FOREWORD BY GEORGE MELLY
TEXT BY CLAIRE NIELSON

GRAMERCY BOOKS
NEW YORK

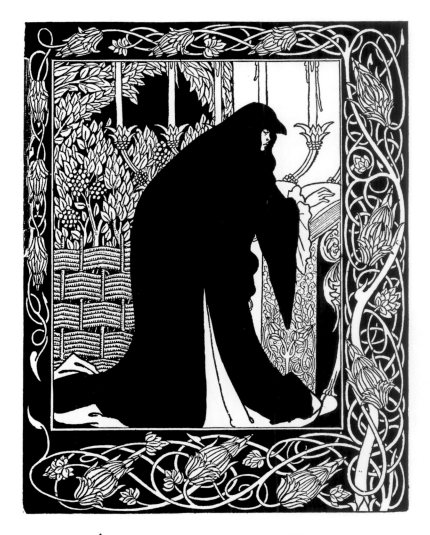

ACKNOWLEDGEMENTS

The Introduction is an abridged version of the original prefatory note by H. C. Marillier to *The Early Work of Aubrey Beardsley*, first published by John Lane in 1899.

The illustrations are reprinted from this volume and the second volume, *The Later Work of Aubrey Beardsley*, first published by John Lane in 1900, with the exception of the following:

Under the Hill by Aubrey Beardsley, London, 1904: 33 (right), 213 (bottom).

The Uncollected Work of Aubrey Beardsley by C. Lewis Hind, London, 1925: 5, 19 (top and left), 20 (top), 21 (all), 22 (middle and bottom right), 23 (bottom left), 33 (left), 137 (top and bottom), 138, 139, 213.

Bon-Mots of Sydney Smith and R. Brinsley Sheridan edited by W. Jerrold, London, 1893: 78 (bottom), 79 (bottom), 80 (bottom).

Bon-Mots of Charles Lamb and Douglas Jerrold edited by W. Jerrold, London, 1893: 79 (top).

Le Morte Darthur by Thomas Malory (Foreword by John Rhys), 2nd edition, 1909: 52 (all), 53 (all), 54 (top), 55, 56, 58 (top), 60 (all), 61 (all), 62 (centre).

An Aubrey Beardsley Lecture (with intro. and notes by R. A. Walker), London, 1924: 22 (top), 23 (right top and bottom).

Some Unknown Drawings of Aubrey Beardsley by R. A. Walker, London, 1923: 35 (left), 77, 88 (top), 94.

The illustrations from *Lysistrata*, on pages 147 to 154, are reproduced by permission of The Erotic Print Society, P O Box 10645, London SW10 9ZT.

Contents

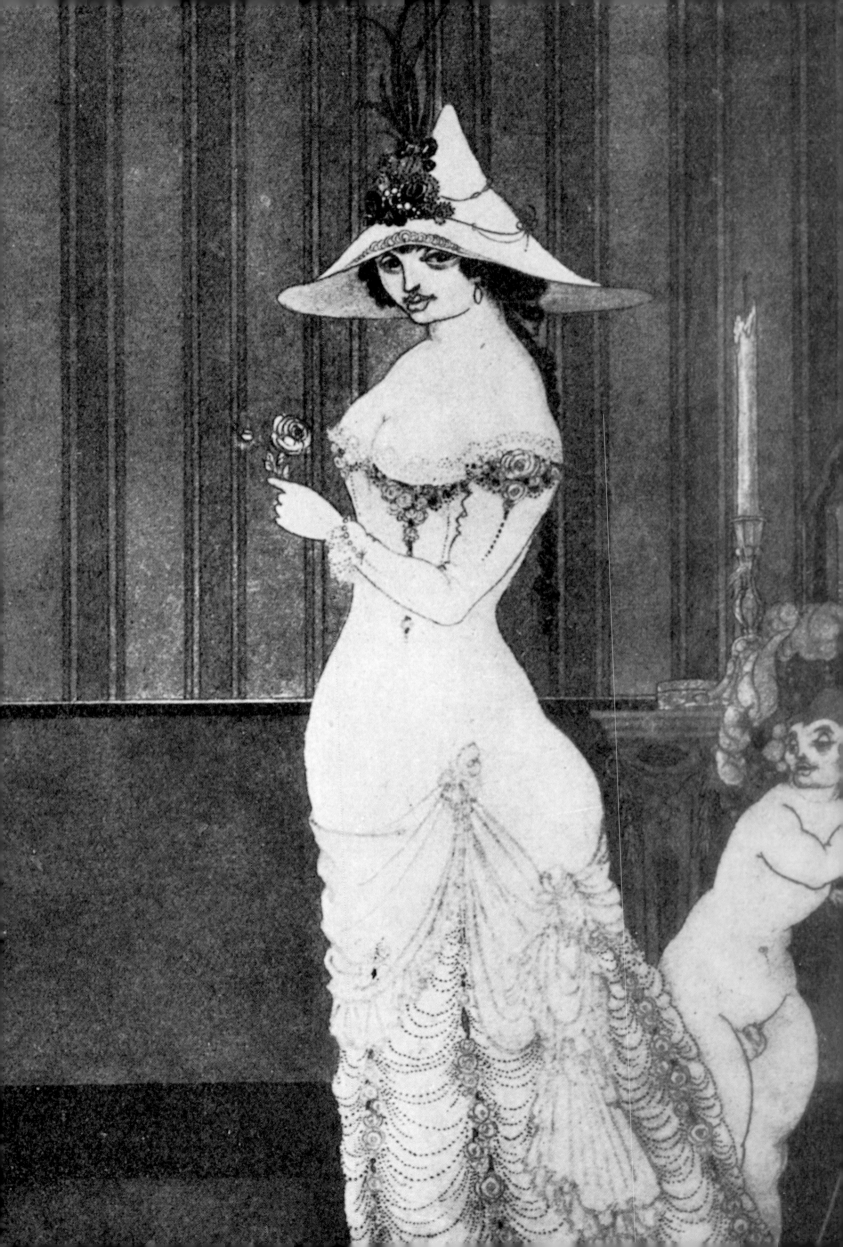

FOREWORD
BY GEORGE MELLY

A HUNDRED YEARS AFTER he coughed his last, Aubrey Beardsley seems as modern as ever. Not since the sixties, when the 'Love Generation' declared him 'trippy' and speculated endlessly as to 'what he was on', has he seemed so relevant, so great an artist. Yet this in itself is a contradiction. Most great artists transcend their period, Beardsley does not. He remains for ever trapped in the eighteen-nineties, his work, on the surface at any rate, the essence of 'decadence', of the knowing giggle, of the hothouse langour of the last *fin de siècle*, and yet he towers above the pale poetasters of his own brief time. Only Wilde remains his peer, but in Oscar's case, while he would have survived anyway, his martyrdom has made assurance doubly sure.

Beardsley too had a card up his sleeve in the form of his early death. His whole mature work, its protean invention, was completed between 1892 when he was twenty and his death only six years later. The public has always cherished an early death in artists — Keats, Chopin, Jimmi Hendrix — and can back up their prejudice by citing those who lived too long — Swinburne, for example, or Wordsworth; but in Beardsley's case they may have it back to front. He was only seven when his consumption was diagnosed and, as the disease was then incurable, he was faced by a literal deadline, which may well have forced his precocious development and fired his miraculous productivity. Like syphilis, that other butcher of the 19th century, tuberculosis was believed to stimulate the imagination.

Beardsley was born in Brighton, in 1872, into that depressing yet common condition of the Victorian age — genteel poverty. His heroic mother, alone, not only devised the stratagems to keep the family afloat but instilled in Aubrey and his older sibling Mabel a love of literature and music.

As a very young man working, when his health permitted, as an insurance clerk, Beardsley at first hoped to make

his reputation as a writer, but happily he met up with one of his heroes, the ageing Pre-Raphaelite painter Edward Burne-Jones, who, having closely scrutinized his young admirer's work, told him that, although he had seldom advised anyone to become a painter, in Beardsley's case he felt obliged to do so. It was an opinion confirmed on Aubrey's first visit to Paris by Puvis de Chavannes, the French Symbolist painter. Praised by two such *grands fromages*, Beardsley, although reluctantly, capitulated to his drawing 'faculty', and, while still at his desk by day, attended art school by night.

Within a year, casting off the exclusive influence of Burne-Jones, and taking on board the influence of Whistler and the Japanese print, he became his own inimitable (if much-imitated) self. With 'The Birthday of Madame Cigale', in which a line of grotesque figures advances to offer gifts to a bare-breasted madam, the Beardsley Age begins.

John Dent's commission to produce a vast number of large drawings, small drawings, decorated capital letters, and the covers, of a two-volume edition of *Le Morte Darthur* released Beardsley from his ledger; yet in the view of many admirers it caught him in a new trap.

The publisher's intention was to offer a much cheaper, mechanically reproduced alternative to William Morris's hand-printed Kelmscott Press edition. Although Beardsley's early work on this project was over-derivative he soon began to find his own voice, gradually transforming Morris's and Burne-Jones's innocent medieval Never Never Land into a wicked, haunted nightmare.

He also, or so it seems to me, invented or at any rate developed Art Nouveau in these tendril-lashed illustrations; but in so far as I know no-one has ever closely addressed this chicken and egg conundrum. I have observed, for instance, how Beardsley's predilection for roses is identical to that of Charles Rennie Mackintosh.

Beardsley's illustrations to Wilde's *Salome,* completed in 1893, were his first major achievement These are deliberately provocative and erotic, their blank areas of black or white broken here or there by vicious little details: a grotesque guitar-strumming dwarf, phallic flowers or candles, and that enigmatic embryo-like personage who was to become Beardsley's trademark. The drawing of Salome floating above a swamp and about to kiss the lips of the severed head of the

Baptist is certainly one of his finest drawings, and quite astonishing for a boy of twenty-one, especially as he was still entrapped in the Arthurian commission.

Soon Beardsley was scandalous flavour of the month. There were posters, book covers, *ex-libris* plates and costume designs, yet it was perhaps for books that he produced his best designs. Among them were illustrations for *The Rape of the Lock* and *Lysistrata*. Designed within a year of each other, they demonstrate how he was not, as we tend to imagine, confined to one style.

His version of Pope's *Rape*, for instance, is incredibly detailed, inspired by 18th-century Rococo. Most of the drawings are crammed with wigs, frills, costumes, fans and buckled shoes. There is cross-hatching, ornate textures, patterns and stippling, yet so certain is the composition, so crisp the draftsmanship, that there is no confusion. It is as polished and as affectionately waspish as Pope's heroic couplets.

On the other hand, his treatment of Aristophanes's play *Lysistrata* has the bawdy directness not only of the play but of an obscene Greek vase. In this jolly and moral tale the wives of Athens and Sparta, led by the eponymous heroine, refuse their husbands any

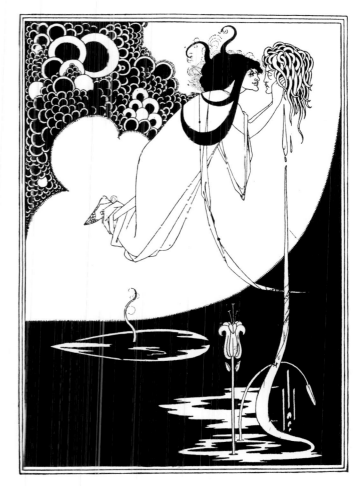

sexual congress until they end their war. Eventually they succeed, but it is both erectile and cliteral touch and go. The drawings are almost entirely linear, and with the figures posed against empty backgrounds Beardsley's magnificent draftsmanship is revealed in all its authority. An arm, a leg (or come to that a phallus), enclosed by only two penstrokes, give the illusion of convincing solidity.

Beardsley was also the art editor and a substantial contributor to *The Yellow Book*, first published in 1894 and regarded ever since as the essence of the

FOREWORD

1890s. In fact most of the contents were quite stuffy, but his contributions, and especially the bold, rather crude covers, created an instant moral furore. With the arrest and trial of Wilde this antagonism found its justification. Beardsley, having illustrated *Salome*, was tarred with the same brush. At the request of a 'respectable' contributor, he was sacked. Luckily he was taken up by Leonard Smithers, a slightly dodgy publisher and *grand luxe* pornographer, and it was he for example who commissioned and published *Lysistrata*, in a strictly limited and clandestine edition. And it was Smithers who supported the artist for the rest of his short life.

Beardsley, allegedly totally heterosexual, very much resented what he felt to be unjust victimization. Looking at his work, however, I have never been entirely convinced by this protestation. Technically heterosexual he may well have been, but in drawing after drawing are men of androgynous beauty — and indeed his whole *œuvre* is permeated with what is now called 'camp'. But then, come to that, we know remarkably little about Beardsley's proclivities. We know what he looked like: the long fingers, the prow-like nose, the sartorial dandification, but his private life, despite a dark rumour of incest with his sister Mabel, is more or less opaque. We have only the work to go on.

Legend has it that, on his Catholic deathbed, he asked for all the 'dirty' drawings to be destroyed. Luckily for us, Smithers ignored this request. I suppose by 'dirty' Beardsley meant *Lysistrata* and other erotica, but in fact almost all his work is 'dirty' — that is his point. A fatal illness often heats the sexual imagination. It is well established that sex and death, Eros and Thanatos, are intertwined. Despite his wit and elegance, it is Beardsley's obsession with this equation that gives his work its depth — its timeless meaning in a meaningless time.

George Melly

INTRODUCTION

AUBREY VINCENT BEARDSLEY

BORN AUGUST 24, 1872 — DIED MARCH 16, 1898

EXTRAVAGANTLY PRAISED AND EXTRAVAGANTLY hated, Beardsley worked in an atmosphere of exotic stimulus which was largely responsible for the eccentricities that developed themselves in his art and in his character. Pricked on upon one hand by the lavish admiration of a group which saw in him more genius than he was really conscious of himself, piqued on the other by the exclamations of a public he was delighted to offend, it is small wonder that his work presented a seesaw appearance, ranging from the nearly sublime to the more than frankly ridiculous. It is this variability, coupled with an extraordinary versatility for changing his style and adopting new ones, that makes it difficult to estimate the true position of Beardsley in the pantheon of art.

It is significant that, although Beardsley has had numerous imitators on both sides of the Atlantic, in his own particular line of work he has remained without a rival. He is not only the inventor, but *par excellence* the master, of his methods. How, except by a freak of nature, so marvellous an intuition and so perfect a mastery of style ever fell to the lot of an untrained boyish hand, we can never tell. Minerva-like, Aubrey Beardsley seems to have come into the world ready equipped with genius and the power of execution. His schoolboy drawings, of which several specimens appeared in *Past and Present*, the magazine of the Brighton Grammar School, are as healthily crude and jejune as any one could desire. It was not until he was eighteen or nineteen, an age when most artists are content to be grinding at the student mill, that Aubrey Beardsley (skipping studenthood) came forward with the drawings that at once began to make him famous.

Mr Joseph Pennell discovered Beardsley, or at least gave him his first public notice, a glowing eulogy in the opening number of *The Studio* (April 1893), which was accompanied by

reproductions of 'The Birthday of Madame Cigale,' the 'Revenants de la Musique,' 'Siegfried,' 'Salome with John the Baptist's Head,' and some drawings done for the *Morte Darthur*. Beardsley at this time, when Mr Pennell, like Cimabue, found him doing wonderful things with his hands, and exploited him, was in his twentieth year and, although not tending sheep as the parallel might suggest, was slaving at an uncongenial desk in an insurance office. Such drawings as he had were done in leisure hours for his own amusement. Of training he had had none, unless a brief experience of an architect's drawing office could count as such. But now, acting on the advice of Mr (the late Sir Edward) Burne-Jones, and of M. Puvis de Chavannes, both of whom thought they saw in his early efforts the promise of a brave recruit to the ranks of romantic illustrators, Beardsley abandoned business and took to art as a profession, putting in for a time a desultory attendance at the famous studio of Mr Fred Brown. He had little difficulty in obtaining work. Even before the appearance of Mr Pennell's article in *The Studio* he had, through the instrumentality of Mr Frederick H. Evans, always one of his warmest friends, entered into an undertaking to illustrate the two-volume edition of Malory's *Morte Darthur* for Messrs J. M. Dent and Co., a task which might well have left him reasonably satisfied and busy for some considerable time, but which, as events turned out, proved a bitter thorn in the flesh. Beardsley, as most publishers

who dealt with him knew to their cost, was a curiously nervous and fickle creature. If work pleased him, he was exultant and prompt with it; if it bored him, wild horses could scarcely get it from him.

The *Morte Darthur* illustrations are a wonderful accomplishment for a boy of twenty. The amount of invention, to say nothing of the execution, lavished upon the five hundred and forty-eight vignettes and decorative borders, is prodigious, whilst some of the full-page and double-page pictures show a power of composition and a daintiness of drawing that Beardsley himself never improved upon and that no imitator has succeeded in capturing.

The *Morte Darthur* was not the only work which Beardsley produced, or on which he was engaged, before the appearance of the first number of *The Studio*. Mr Lewis Hind employed him on several occasions in a more or less topical capacity. The results can hardly be called happy. The drawings done to illustrate Irving's *Becket* and the performance of *Orpheus* at the Lyceum, together with one or two other subjects, speak volumes for Beardsley's incapacity to adapt himself to a style of work requiring rapid execution and affording no play to the imagination. With the possible exception of the portraits of Zola, and the four humorous sketches for the new coinage, Beardsley's incursion into topical journalism was a failure, and was abandoned after a few attempts. It was otherwise with his two contributions to *The Pall Mall Magazine*,

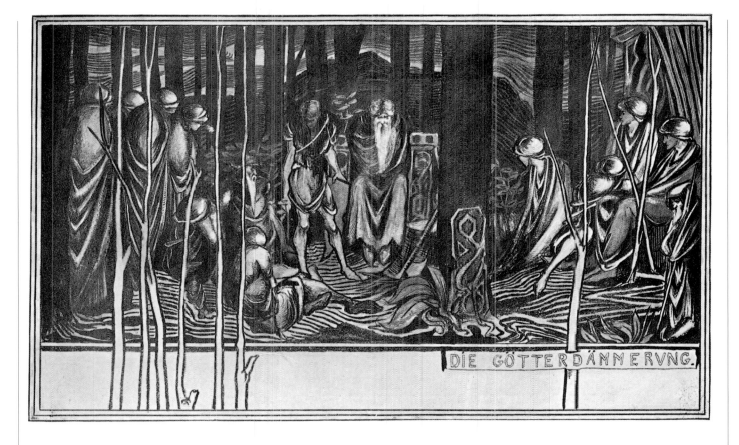

DIE GÖTTERDÄMMERVNG.

also reprinted here, one of which, the design published in the second number of the magazine (June 1893) under the fictitious title 'Of a Neophyte and how the Black Art was revealed unto him by the Fiend Asomuel', remains to this day one of his most powerful and decorative achievements.

Towards the end of 1893, or the beginning of 1894, Beardsley formed an idea of preparing what he called a Book of Masques, and he was very full of this amongst his friends. The scheme was abandoned, but revived later on, in a new shape, when it was proposed to start *The Yellow Book* as a quarterly magazine, with Beardsley as art editor. It is in *The Yellow Book*, more than anywhere else, that Beardsley first came into contact — one had written almost conflict — with the public. It is in connexion with *The Yellow Book*, probably, that he will be most widely remembered.

The method adopted by him during this period, though the outcome of previous efforts, is distinctive, and with kaleidoscope versatility he branched into an altogether different one after its close. If one may employ an illustration from the science of embryology — one not inappropriate to Beardsley's peculiar cast of thought — his art was like the growth of an unborn organism, reflecting at different stages all the traits of a distant ancestry. We see it in a crude archaic form, striving with imperfect means to express ideas which are already there. We trace its Pre-Raphaelite devotional stage; its ripe classical period; and at the last a sort of Romantic epoch, very sensitive and delicate, very decorative, and wonderfully elaborate. Taking the *Rape of the Lock* drawings as the cream of his last period, there is much to be said for the judgment of those who consider this work of Beardsley's the best that he ever did. But I doubt very much if it was the most characteristic of Beardsley. For this I believe one must go back to

the year, or year and a half, when he was startling the public in the pages of *The Yellow Book*, and frightening even his publisher with the boldness of the drawings for *Salome*.

The *Yellow Book* period of Beardsley's activity not only includes the fifteen illustrations for *Salome*, a commission obtained for him by the early drawing published in *The Studio*, but also the long series of cover designs for the Keynotes novels, with their initial keys, and a sprinkling of frontispiece drawings for different books, of which that from *Earl Lavender* is one of the most striking and important. It is pleasant to find among the archives of *The Yellow Book* several unpublished treasures, such as the frontispiece done for a projected *Venus and Tannhäuser*.

Beardsley, as I knew him, was a model of daintiness in dress, affected apparently for the purpose of concealing his artistic profession. It was part of his pose to baffle the world. He did it in his exterior manner as effectually as in his

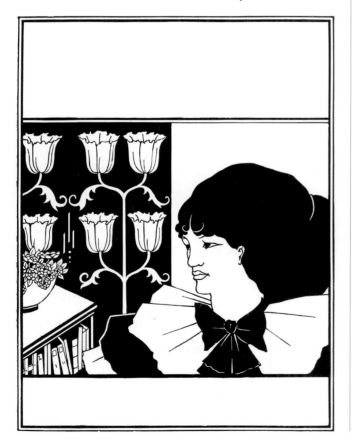

work. Those who imagine from the character of some of his subjects that Beardsley went about preaching or discussing vice are quite beyond the mark. Externally, at any rate, he was a pattern of moral decorum, warped only into such eccentricities as working by candle-light, with the shutters closed, at drawings of dubious propriety, when outside the sun was shining brightly on a healthy, virtuous world. He preferred candle-light, and he selected subjects which amused his fancy, or tickled his instinct for *gaminerie*, and that's an end on't. Max Beerbohm conceives that his mind was still that of the schoolboy playing at being vicious, and rather attracted by naughtiness. This may be so, but at the same time it must be conceded that few artists have had such an extraordinarily deep penetration into the hidden abysses of sin, and such a lurid power of suggesting them.

Beardsley could draw beautiful subjects as beautifully as any one. I know few things more flawless than his design of a 'Venus Standing between Terminal Gods,' or 'The Coiffing,' which appeared in *The Savoy*. Certainly there is no suggestion of vice in these, or in scores of his other drawings. His *Venus and Tannhäuser* was to have contained no ugly suggestions. Even when in his love of shocking the public he deliberately chooses a vicious type, his true passion for beauty expresses itself in the manner of his execution. This manner of execution it has become fashionable to refer to as 'Beardsley's line.' Beardsley had many 'lines,' all exquisite in execution, and of varying degrees of fineness, the most remarkable being somewhat akin to an angler's line, as may be seen to perfection in the drawing for *Salome*, entitled 'The Peacock Skirt.'

One thing at all events is clear, and that is, that

Beardsley was essentially a decorative artist. All his arrangement and handling of subjects, his treatment of the human figure, his use of landscape, was subordinate to the ultimate decorative effect. No trace of 'naturalism' ever creeps in to mar the set convention of his work. In his treatment of nature he is as formal as any missal scribe of the fifteenth century, as mannered as the old Egyptian or the modern Japanese. Conformably, he was quite indifferent to what may be called the dramatic or historical unities. He would cheerfully clothe Isolde in an *outré* Parisian 'confection,' or Messalina in an ostrich-feather hat — nay, has done both. The decorative effect was all he cared for, and, if the public failed to appreciate the humour of his anachronisms, so much the worse for them.

In his earliest drawings worthy of mention, the *Morte Darthur*, 'Hamlet following the Ghost,' 'Perseus and the Monstre,' and others which any one can find for himself, he was under considerable obligations to the most generous of his early patrons, Sir Edward Burne-Jones. Then the Japanese caught his wayward fancy and gave us the 'Femme Incomprise' (*To-day* and *Idler*), 'Madame Cigale,' and indirectly much of the *Yellow Book* work, in which, however, he developed a new conceit, which fully deserves to rank as original. His passion for Pierrot, the most pathetic as well as the most humorous conception that has come down to us, stands evident in his latest as well as in some of his earliest work, and it is interesting to learn, on the authority of an old school friend, that he was immensely affected when a mere boy by the influence of 'L'Enfant Prodigue.'

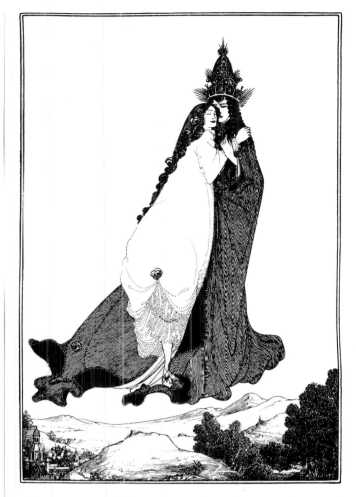

I have recently heard another theory advanced which may be worth mentioning, to account for the very persistent use of rococo ornamentation in his drawings of furniture, candelabra, wall hangings, &c. This peculiarity is so striking as really to suggest some concrete source of inspiration, and, odd as it may sound, this source of inspiration was not improbably the florid gaudiness of the interior of the Brighton Pavilion, of which, in his schooldays, Beardsley was something of an *habitué*. The Casino, at Dieppe, doubtless contributed also its quota of ideas.

One might go on indefinitely proposing models for individual pieces of work, if one cared to and if the subject were worth pursuing. But, broadly, it may be taken as a fact that Beardsley, if himself inimitable, was nevertheless highly imitative; that he could

purloin a method, and so absorb it as to render it wholly his own; that when he apparently changed his style with lightning rapidity, as in the transition from his *Yellow Book* to his *Rape of the Lock* manner, he did not really evolve some perfectly novel convention, but merely worked up a fresh 'rave'— in this particular instance the style of the eighteenth-century French engravers.

Beardsley himself signified his consciousness of the breaks in his method of working by adopting successive forms of signature. In his earliest (juvenile) drawings he is always 'A.V.B.,' or 'Aubrey V. Beardsley.' Later he dropped the 'V,' and used only the first and third initials of his name. In the illustration to *Pastor Sang* he appears to acknowledge a debt to Dürer by ranging his initials in the form of the well-known Dürer monogram. A long series of drawings,

beginning with the 'Questing Beast' plate in the *Morte Darthur*, and continuing down through *The Pall Mall Budget*, *Salome*, and what may be generically classified as the *Yellow Book* period, are signed with what has been called his Japanese mark, three strokes ranged in a particular manner, with or without dots or other ornamental accessories. In his later work Beardsley mostly wrote his two names in full, in capitals, along the bottom border line of the drawing. All sorts of variations occur at different times, which may mean something or nothing. In an ordinary person they would mean nothing, but Beardsley was not an ordinary person, and his subtleties were infinite, inviting and yet often defying analysis.

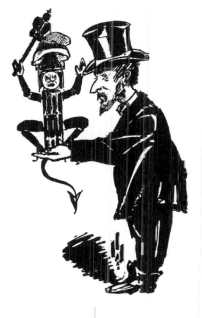

All who knew Beardsley will bear witness to many pleasant personal traits: his extraordinary love of music, his rippling wit, his wide range of reading, his capacity for hard work without even appearing to be busy. He worked mostly at night. His many sidedness has been briefly summed up in the first paragraph of Mr Symons's memoir, which I venture to quote.

'He had the fatal speed of those who are to die young; that disquieting completeness and extent of knowledge, that absorption of a lifetime in an hour, knowing we find in those who hasten to have done their work before noon, knowing that they will not see the evening. He had played the piano in drawing-rooms as an infant prodigy, before, I suppose, he had ever drawn a line. Famous at twenty as a draughtsman, he found time, in those incredibly busy years which remained to him, deliberately to train himself as a writer of prose, which was in its way as original as his draughtsmanship, and into a writer of verse which had at least ingenious and original moments. He seemed to have read everything, and had his preferences as adroitly in order, as wittily in evidence, as almost any man of letters; indeed, he seemed to know more, and was a sounder critic, of books than of pictures; with perhaps a deeper feeling for music than for either. His conversation had a peculiar kind of brilliance, different in order, but scarce inferior in quality to that of any other contemporary master of that art; a salt, a whimsical dogmatism, equally full of convinced egoism and of imperturbable keen-sightedness. Generally choosing to be paradoxical, and vehement on behalf of any enthusiasm of the mind, he was the dupe of none of his own statements, or indeed of his own enthusiasms, and, really, very coldly impartial. He thought, and was right in thinking, very highly of himself; he admired himself enormously; but his intellect would never allow itself to be deceived even about his own accomplishments.'

What drove him out of his many different accomplishments to seek art as his chief field is not quite clear. It may have been the advice of Burne-Jones and of Puvis de Chavannes; it may have been the scent of an immediate and satisfying *réclame*; it may have been the necessity for making money. Probably all these causes conspired. Why, turned artist, he should have developed such a grim satirical humour, is equally uncertain, unless it were his affection for Juvenal grafted on the bitterness of one who

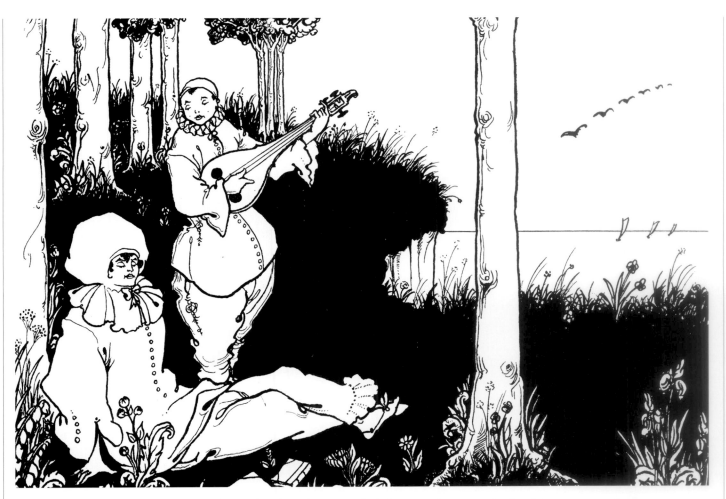

knows that he is in the grip of death, that few and evil must be the days of his life. Over all this, like Pierrot, he wore a brave mask, and faced his tragedy with a show of laughter. How he suffered, how he worked, he never permitted to be seen. If the irony took a grim form sometimes in the jests that he flung to the public, in the scorn he allowed himself to feel for a world that had not got to die, can we wonder? Pierrot's humour has mostly a subacidity, or we should fail to relish it.

Those who live healthy normal lives, unracked by hæmorrhage, untroubled by genius, may try and find some spark of sympathy and admiration for the man. One can scarcely realize what it means to have only six real years of life, and to feel that they are precarious. To have done as much in them as Beardsley did, of actual solid work, is no mean achievement, apart from the fact that so much is work of almost microscopic delicacy. A great deal of it too, one is apt to forget, is work of unsullied beauty — free from the questionable traits which have hurt his reputation with the public. Finally it must not be lost sight of that the *rôle* he played was that of a satirist; that in depicting vice he held it up for scourging; that in exaggerating its fanciful side he but accentuated its squalid and horrible reality.

Poor Beardsley! His death has removed a quaint and amiable personality from amongst us; a butterfly who played at being serious, and yet a busy worker who played at being a butterfly. Outwardly he lived in the sunshine, airing bright wings. Inwardly no one can tell how he suffered or strove.

H. C. MARILLIER
KELMSCOTT HOUSE
HAMMERSMITH
January 1899

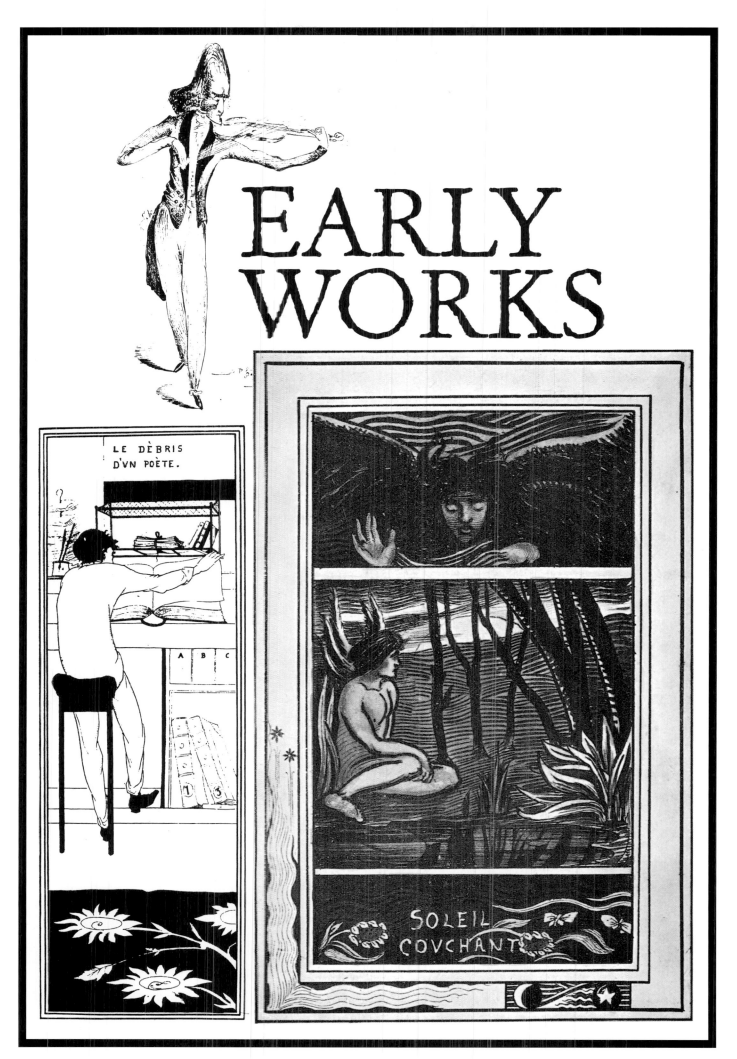

EARLY WORKS

LE DÈBRIS
D'VN POÈTE.

SOLEIL
COVCHANT

Right: KING JOHN SIGNING THE MAGNA CARTA, c. 1886. This humorous sketch, drawn to enliven a dull school history book, is typical of Beardsley's caricatures of the period. The production of comic drawings possibly served to deflect any possible teasing about his appearance. His bony face, general frailness and curiously cut red hair had led the other to boys to call him 'Weasel'. While a pupil at Brighton Grammar School, he was encouraged greatly in all matters artistic by his housemaster, Arthur King.

Below and below right: MANON LESCAUT and MADAME BOVARY, c. 1890. The two sketches are from a scrap book into which Beardsley mounted his drawings. When Robert Ross, later a biographer of Beardsley, met the young man at a party in 1892, he reported him to be 'full of enthusiasm for French literature, especially *Manon Lescaut*'. Beardsley's early ill-health encouraged his eclectic reading-habits, and he developed a love of French literature that was to have a continuing influence upon his work.

THE SPIRIT OF BEARDSLEY

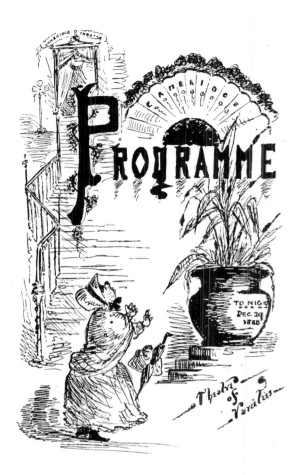

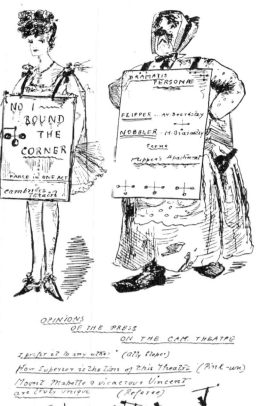

Above: TWO PROGRAMMES FOR HOME ENTERTAINMENTS, c. 1885-8. These sketches demonstrate Beardsley's theatricality and impish sense of humour. His passion for the theatre began at an early age, and was shared by his sister Mabel, who became a professional actress. Beardsley wrote, acted in and designed the programmes for a large number of humorous skits and sketches performed in 'The Cambridge Theatre of Varieties', in reality the front parlour of his home in Cambridge Street, Pimlico.

Below: THE PAY OF THE PIED PIPER, A LEGEND OF HAMELIN TOWN, 1888. The illustration was one of eleven drawn for a comic operetta that was given by pupils of Brighton Grammar School as a Christmas entertainment. Beardsley had in fact left school the term before, forced, for financial reasons, to work as a surveyor's clerk in London. These works, described as 'Original etchings by A. V. Beardsley, A Present Boy', were actually pen drawings, and Beardsley a former pupil

Below: PAGANINI, 1888. The sketch appeared posthumously in The Uncollected Works of Aubrey Beardsley, edited by C. Lewis Hind, who was a great admirer of Beardsley's work and the editor who helped to launch his professional career. Here the famous Italian violin virtuoso, Niccolò Paganini, is depicted in a strange, grotesque style quite unlike that of Beardsley's humorous sketches. Stories that Paganini was in league with the devil may have inspired this darker manner.

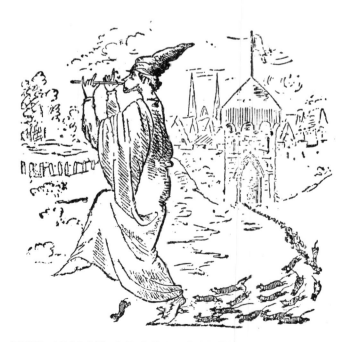

THE SPIRIT OF BEARDSLEY

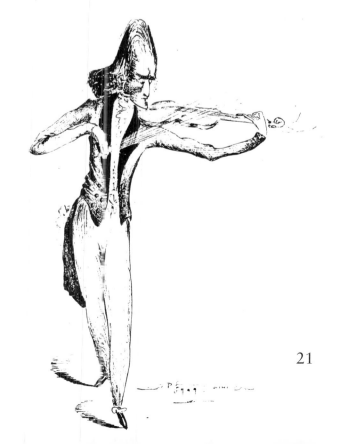

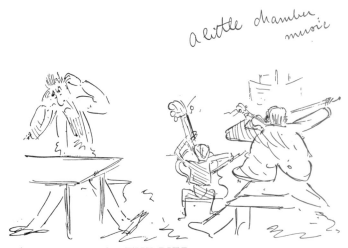

Right: A LITTLE CHAMBER MUSIC, *c.* 1885-8. One of a series of comical sketches featuring E. J. Marshall, the headmaster, drawn while Beardsley was still a pupil at Brighton Grammar School. Although the man was feared by many pupils, Beardsley was apparently unintimidated and indeed quite fond of him, lending credence to the belief that he did not necessarily dislike those whom he caricatured. Although this work is naive, it displays a wild energy of line that clearly expresses the players' fervour.

Below: MANON LESCAUT, *c.* 1890. A three-quarter length study of Manon carrying a fan, painted in watercolour on grey paper. The artist was always fascinated by *femme fatale* figures, who make many appearances in his work. Here Manon is a conventionally drawn heroine, although aspects of the depiction anticipate Beardsley's mature style, particularly the pointed eighteenth-century coiffure and the tiny waist.

Right: *THE PAY OF THE PIED PIPER*, 1888. Depicting the rats of Hamelin Town eating, as Robert Browning put it, 'the cheeses out of the vats', the sketch was printed in the programme of the Brighton Grammar School Annual Entertainment at the Dome. Robert Ross described Beardsley's series of illustrations for *The Pied Piper* as 'delightful, racy little sketches, the first of his drawings, I believe, that were ever reproduced.' Beardsley also designed the costumes, acted in the operetta, and appeared as 'Mercury' in The Prologue.

Below right: PROGRAMME FOR A HOME ENTERTAINMENT, *c.* 1888. An unmistakable self-portrait of the artist/actor saying 'Adieu' to his audience at the end of another theatrical evening. Beardsley adopted his distinctive hairstyle at a young age and kept it throughout his short life. The peculiar colour of his hair, variously described as 'tortoiseshell', 'reddish-brown', or even 'orange', and its unusual fringe parted in the middle (a style clearly seen in this sketch), together with his dapper clothes, were always alluded to in descriptions of the artist.

THE SPIRIT OF BEARDSLEY

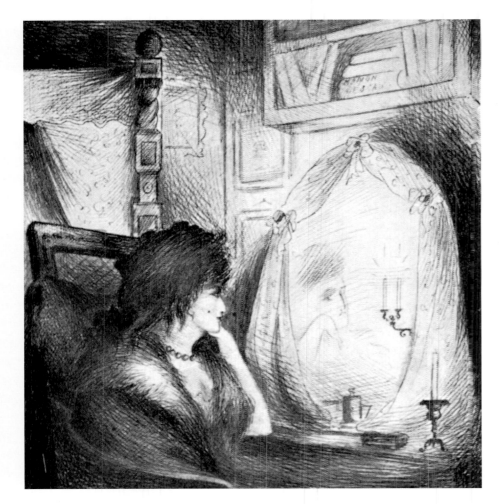

Left: LA DAME AUX CAMÉLIAS, *c.* 1890. Drawn in pen, brown ink and wash, this is a depiction of the eponymous heroine of the novel by Alexandre Dumas *fils*, one of Beardsley's favourite books. Undoubtedly, the artist identified with a character who knew her life would be cut short by fatal lung disease. Here his subject stares moodily into a mirror, resting her chin on an emaciated arm. It is interesting that the candle, dressing-table and books — objects that were to appear so often in Beardsley's work — are already present in this rather rudimentary early sketch.

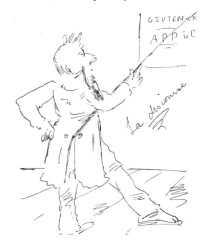

Above and below: A LECTURE ON AN APPLE, *c.* 1885-88. These two sketches are from a series featuring Beardsley's headmaster. Marshall is here seen pontificating on an apple. With typical wit, the young artist has fashioned the master's chaotic hairstyle into devil's horns and exaggerated the droop of his carbuncled nose. The series is concluded by a sketch captioned 'Flavouring the apple tart', in which Marshall has fallen bottom-first into the latter confection.

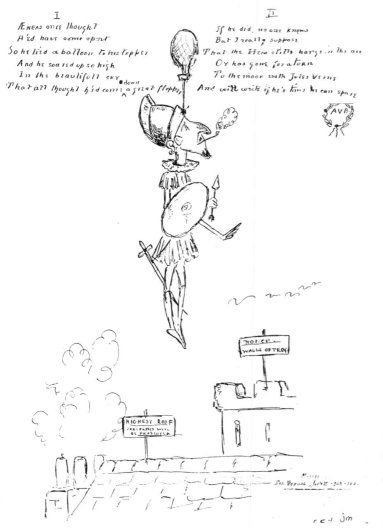

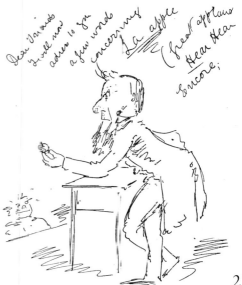

Previous page. Below left:
ILLUSTRATION FOR VIRGIL'S
ÆNEID, *c.* 1885-8. One of nine
comic illustrations, this sketch, set
between two humorous verses, shows
Aeneas being lifted into the air by a
balloon attached to his helmet. It is not
coincidental that Æneas has the same
bulbous, crusty nose as Mr Marshall,
Beardsley's headmaster and favourite
subject of caricature at that time, a
further indication of his early
irreverence towards figures in
authority.

Right: TWO FIGURES IN A
GARRET, *c.* 1889-90. The ink-and-
wash sketch of a woman haranguing a
young man was owned by Frederick
H. Evans, proprietor of the bookshop
in Queen Street that Beardsley
frequented almost daily.

Below right: MOLIÈRE, *c.* 1889. A
work in blue watercolour wash
reminiscent of the work of James
McNeill Whistler, with whom
Beardsley was to develop a love-hate
relationship.

Far right; HEAD OF AN ANGEL,
c. 1892. A pencil sketch on grey paper
that demonstrates the influence of
William Blake. The angel holds a
flaming heart, and has a sort of halo in
the shape of an embryo, an image with
which Beardsley was later to become
obsessed. The work is signed with
Beardsley's early monogram — 'AVB'
for Aubrey Vincent Beardsley. In 1905
the drawing was reproduced as a
Christmas card for private distribution.

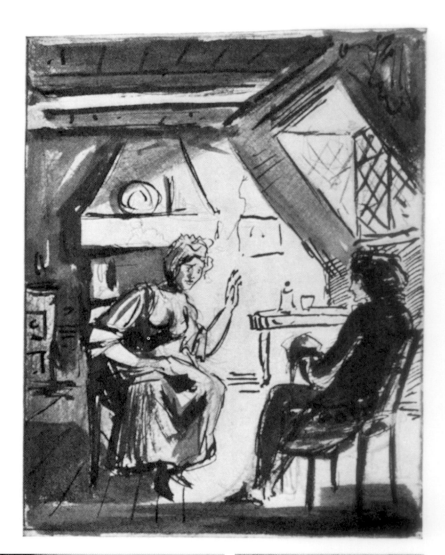

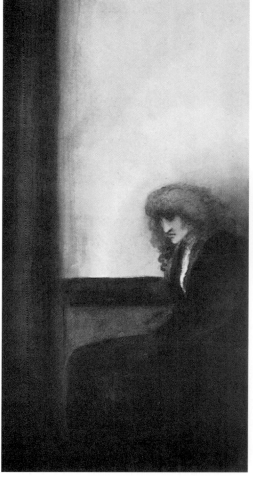

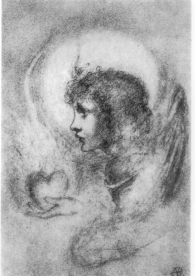

THE SPIRIT OF BEARDSLEY

Right: THE WITCH OF ATLAS, *c.* 1889. In pen-and-ink and watercolour wash, the witch sits hand on chin, deep in thought. This is a Blake-inspired drawing that also displays a strong Burne-Jones influence. Edward Burne-Jones, the Pre-Raphaelite painter, was the first artist to give Beardsley any real encouragement, telling him, 'I seldom or never advise anyone to take up art as a profession, but in your case I can do nothing else.' He also advised Beardsley to begin a formal art training, advice that the young man heeded.

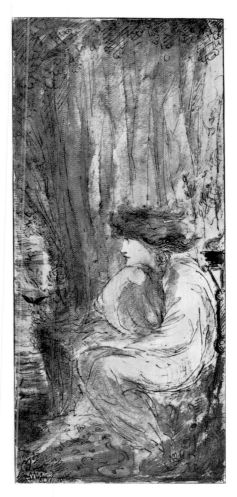

Below: LA LEÇON, *c.* 1890. This drawing, executed in Chinese white and dark sepia wash, was pasted by the artist into his scrap book. Here dramatic use is made of shadow effects to recreate the atmosphere of Gustave Flaubert's great novel, *Madame Bovary*, for which this is an illustration. One of the most distinctive features of Beardsley's later work was his almost complete abandonment of shading and reliance upon line. Only occasionally was he to use wash again, most notably in the illustrations for another work of French literature, Théophile Gautier's *Mademoiselle de Maupin*.

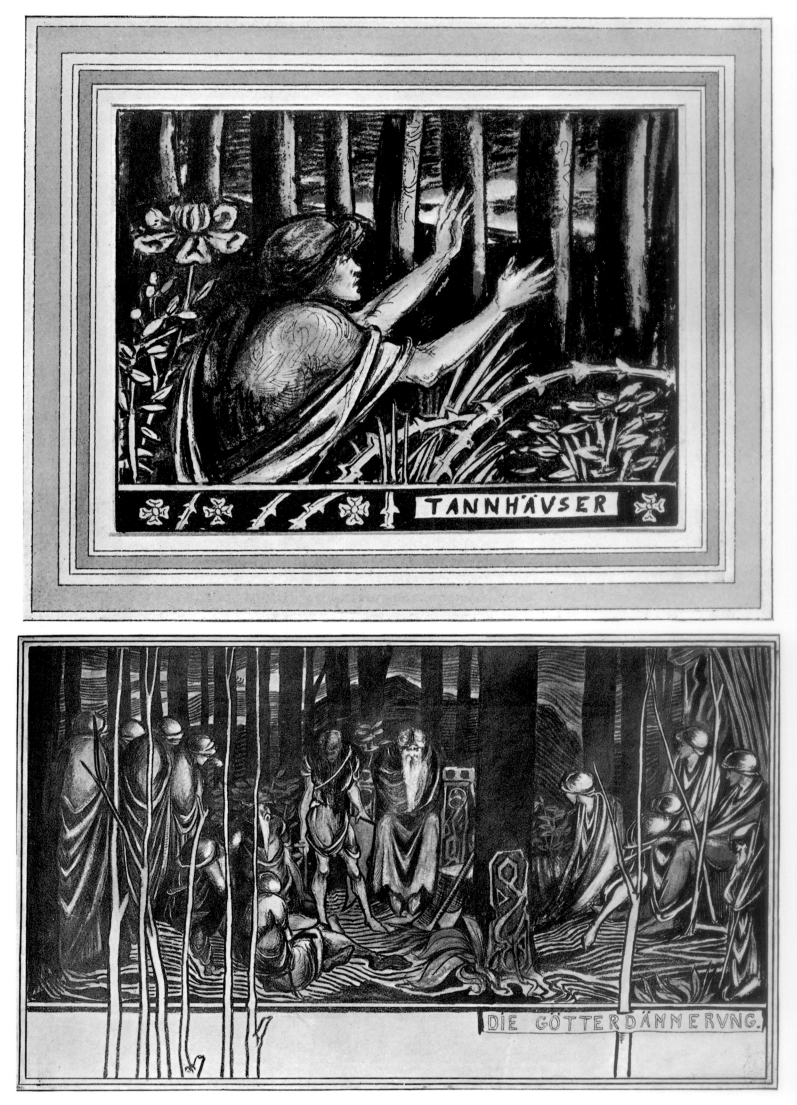

THE SPIRIT OF BEARDSLEY

Left: TANNHÄUSER, *c.* 189?. A decorative study in Indian ink, this drawing is much influenced by Burne Jones's *Briar-Rose* series of the 1870s. It is also among the first of many works by Beardsley to feature outstretched hands against a contrasting background. The character of Tannhäuser fascinated Beardsley, probably because of the former's preoccupation with the conflict between fleshly and spiritual love, a theme central to Beardsley's work.

Below left: DIE GÖTTERDAMMERUNG, *c.* 1890. This drawing resembles in style some of Burne-Jones's sketches for metalwork. It appears to be an illustration of the moment when the Rhine maidens try to persuade Siegfried to return the ring. From the first Beardsley was passionate about music, especially that of Wagner, who inspired many *fin-de-siècle* artists, musicians, writers and poets, among whom there was great enthusiasm for the Wagnerite *Gesamtkunstwerk* — the 'total work of art' which should be a synthesis of all.

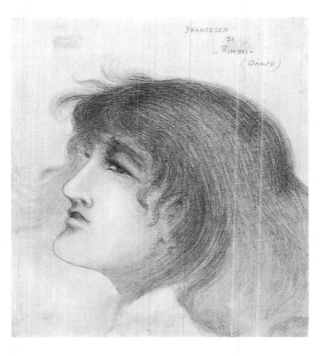

Above: FRANCESCA DA RIMINI, *c.* 1888-90. In this pencil sketch, which is very reminiscent of the style of Dante Gabriel Rossetti. Dante Alighieri's heroine is seen in profile. At this stage Beardsley was still very much under the spell of the Pre-Raphaelite artists, of whom Dante Gabriel Rossetti was a leading light. In June 1888 Beardsley started work as a surveyor's clerk, a job he hated. He spent any free time browsing in bookshops, and visiting the British Museum and the National Gallery. The fruitful results of these browsings were beginning to manifest themselves.

Below. DANTE IN EXILE *c.* 1889-90. The poet Dante is here depicted at the foot of a tree, wearing his laurel crown. The words of a sonnet are inscribed and embellished within the composition, making the whole resemble a page from one of William Blake's notebooks. A great admirer of Blake, Beardsley at a later date admitted that the *Morte Darthur* drawings had been influenced by him. He was delighted when the resemblance was pointed out since he felt kinship with a man for whom word and vision were almost indivisible.

Right: SOLEIL COUCHANT, *c.* 1890.
This tri-partite study depicts two angels,
one flying towards the viewer and
another sitting by a still pool reflecting
trees, an image that was later used for a
vignette in *Le Morte Darthur*. In the
lower panel the title 'Soleil Couchant'
(Setting Sun) is couched among flowers,
leaves and butterflies. All three parts of
the composition are contained within a
decorative border featuring the sun in
semi-eclipse, with a star connected to it,
as if to suggest day turning into night.

Below: PORTRAIT OF THE ARTIST,
c. 1892. This pen-and-ink drawing is
much more recognizably
'Beardsleyesque'. A self-portrait, the
artist was unafraid to depict his floppy,
fringed hair, over-large ears and the
cadaverous cheeks caused by his
tubercular condition. Inherited from his
father and grandfather, the disease
began to plague him when he was only
seven years old, causing his education to
be interrupted and irregular. .

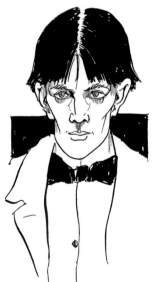

Right: PERSEUS AND THE
MONSTRE, *c.* 1891. The Perseus and
Medusa legend fascinated Beardsley.
This sketch depicts the moment just
after the hero has severed the Gorgon's
head, and has a violence of action that
is particularly dramatic and arresting.
The work was not known until 1898,
when it appeared accompanying an
article by Aymer Vallance.

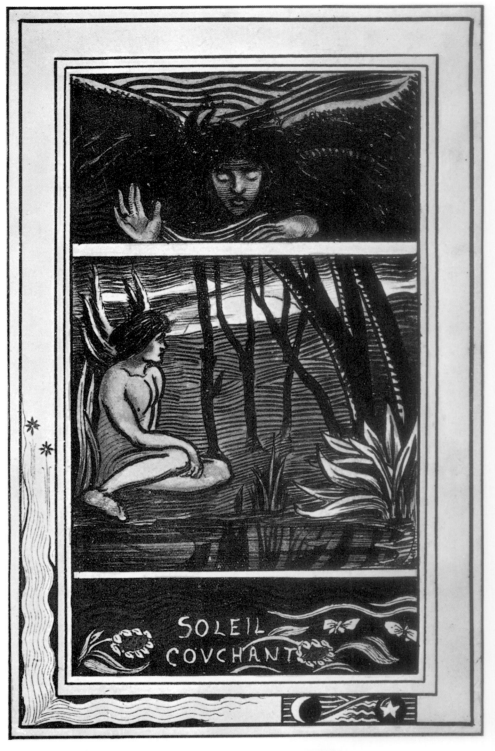

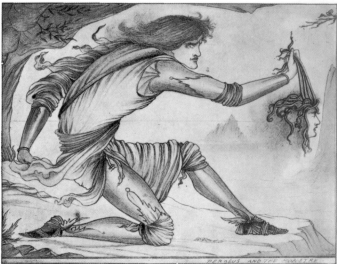

THE SPIRIT OF BEARDSLEY

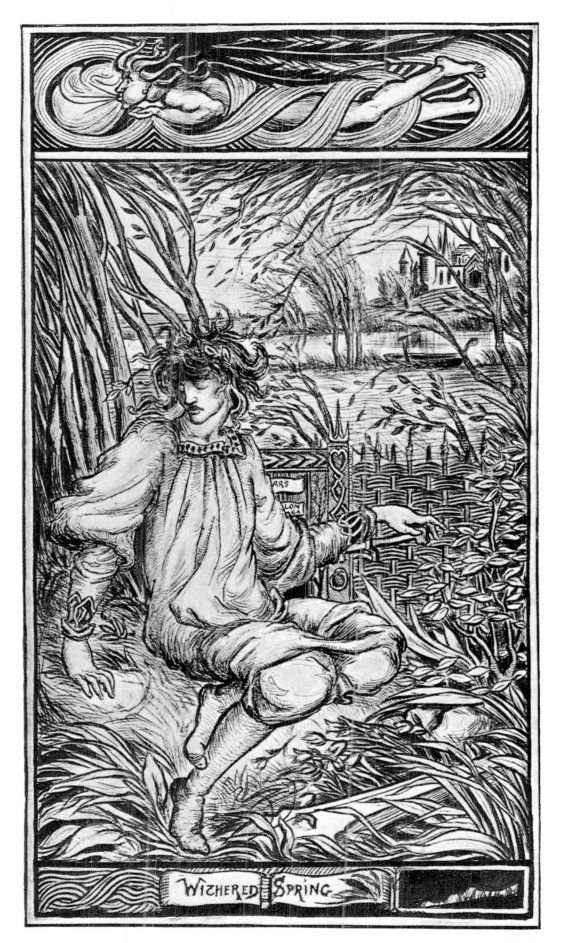

Above: WITHERED SPRING, c. 1891. A composition in Indian ink, this work was catalogued in Beardsley's own publication, *A Book of Fifty Drawings*, as 'Lament of the Dying Year'. A sad, unhealthy looking young man reaches out a languid hand towards a closed wicket gate on which is written '*Ars longa*,' a Latin phrase that continues '*et vita brevis*', meaning that to succeed in art takes a long time and life is short. The quotation must have had a particular poignancy for Beardsley, aware that his own life would necessarily be shortened by his illness.

THE SPIRIT OF BEARDSLEY

Right: PERSEUS, *c.* 1891. In pen
and ink and light wash, this drawing
is entirely Burne-Jonesian in design,
the older artist having produced a
whole series of paintings on the
subject. The standing nude figure of
Perseus holds the head of the
Gorgon Medusa in his left hand, a
strangely twisted sword in his right,
while above him in the top section
sits a naked Andromeda, whom he
rescued from the sea-monster. She is
flanked by two mysteriously draped
and hooded figures.

Far right above: INCIPIT VITA
NOVA, 1892. Executed in Chinese
white and Indian ink on brown
paper, this mysterious picture has
been variously interpreted. Beardsley
was fascinated by illustrated medical
textbooks, and especially by pictures
of embryos, which appear frequently
throughout his work. The text to
which this embryo points, *Incipit
Vita Nova* (Here Begins the New
Life), is perhaps addressed to the
sensuous-looking woman, so that
the whole may be read as a cynical
and secular Annunciation.

Far right below: SCENE FROM
MANON LESCAUT,
c. 1889-90. Another illustration to
one of Beardsley's favourite novels,
drawn with an extremely fine pen
and brown ink. The artist's love for
the theatre is palpable in this work
with its proscenium-like framing and
the dramatic postures of the three
actors. Manon is depicted with her
lover, the young Chevalier Des
Grieux, on her right.

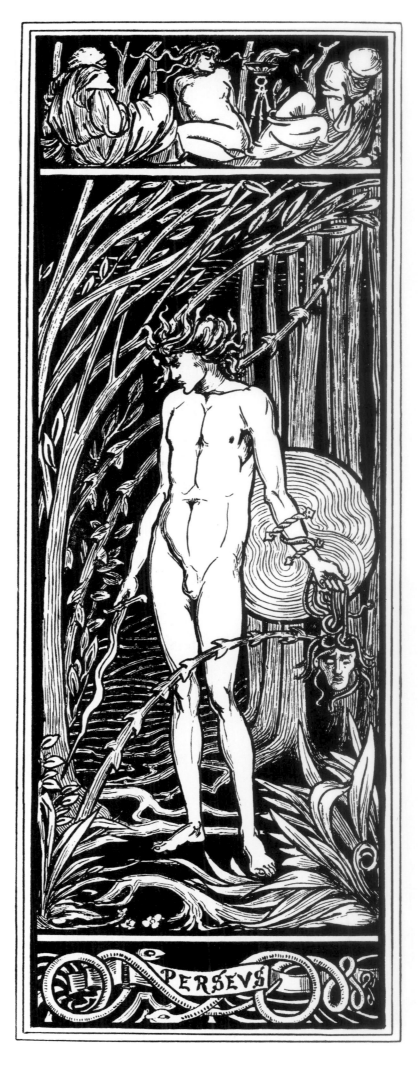

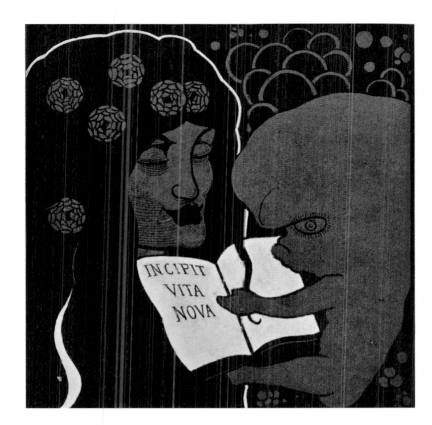

Right: HAMLET, 1891. The pencil
drawing was printed in red as the
frontispiece to *The Bee*, the
magazine of the Blackburn Technical
School of which Beardsley's old
housemaster, Arthur King, had
become secretary. Beside the
drawing King wrote a text
prophesying Beardsley's importance
to twentieth-century art. The artist
described this drawing to his friend,
G. F. Scotson-Clark, as 'my last
chef-d'œuvre . . . "Hamlet
following the ghost of his father".
- a stunning design, I can tell you.'

Below: THE LITANY OF MARY
MAGDALEN, 1891. A pencil
drawing for which the kneeling
Mary was inspired by the figure of
St John in a Mantegna engraving of
the Entombment. Beardsley's
approach in this sketch may be
compared with the ironical
treatment of a similar subject in
'The Repentance of Mrs . . . '
(p. 128). The Mantegna-inspired
pose of Mary is almost identical in
both works, but the figures grouped
around her could not be more
outrageously different in the latter.

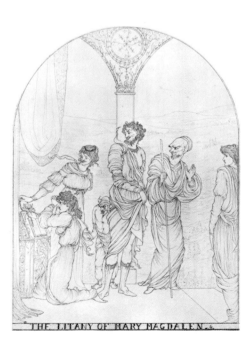

THE LITANY OF MARY MAGDALEN.

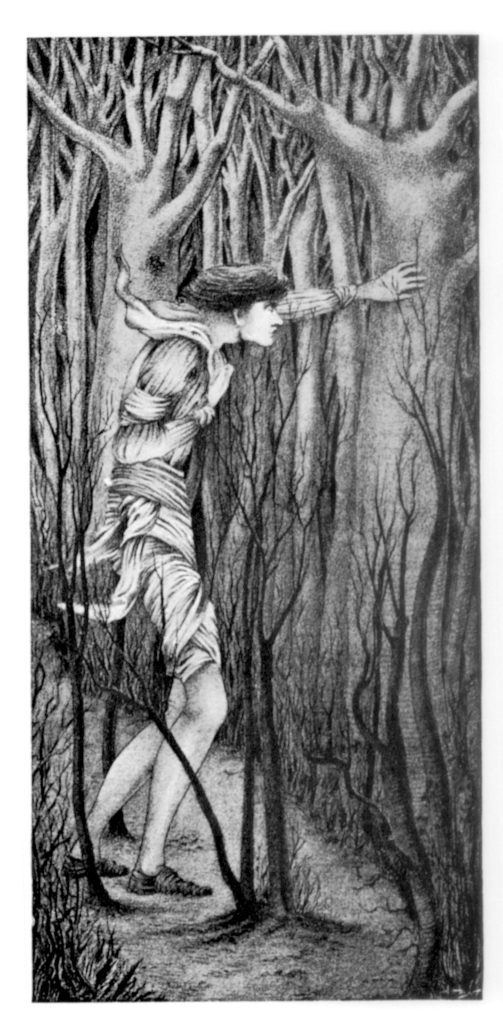

THE SPIRIT OF BEARDSLEY

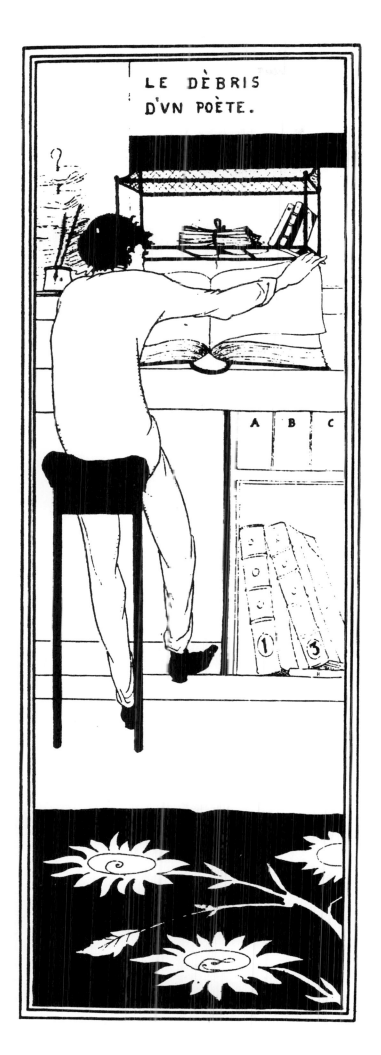

LE DÈBRIS
D'VN POÈTE.

Left: LE DÈBRIS D'UN POÈTE, 1891.
This important drawing shows clearly
the early influence upon Beardsley of
Japanese prints. The flatness of
perspective and the solid black areas
reveal both this debt and the strongly
graphic approach that was increasingly
to become a feature of the artist's
work. At this time Beardsley had just
changed jobs to become an insurance
clerk and here he depicts himself —
ironically — as the '*poète*', perched on
a clerk's high stool, surrounded by the
'*dèbris*' (misspelt) of his daily,
uncongenial employment. Beardsley
loathed the insurance job, and was no
sooner there than he suffered violent
lung haemorrhages.

Above: FREDERICK BROWN,
c. 1891. This sympathetic sketch,
intentionally in the manner of a
Whistler engraving, depicts Frederick
Brown, Beardsley's professor at the
Westminster School of Art. He studied
there for a year on the advice of
Burne-Jones. In the top left-hand
corner, above a Whistlerian peacock
feather, Beardsley has written 'Fred
Brown, N.E.A.C.', the initials of The
New English Art Club of which Brown
was a founder member. Beardsley
described his teacher as 'tremendously
clever with the brush'.

Right: A CHRISTMAS CAROL,
1892. A drawing in pencil and
coloured chalks — still very much in
Pre-Raphaelite manner — depicting
two angels, one playing pipes, the
other with hands clasped as if in
prayer. Their wings rise up like
flames, but lilies, signifying peace,
bloom softly in the foreground.
Designed as a Christmas card for the
Reverend Alfred Gurney, the vicar at
Beardsley's local church in Pimlico,
reproductions of this work also
circulated privately among Beardsley
family friends.

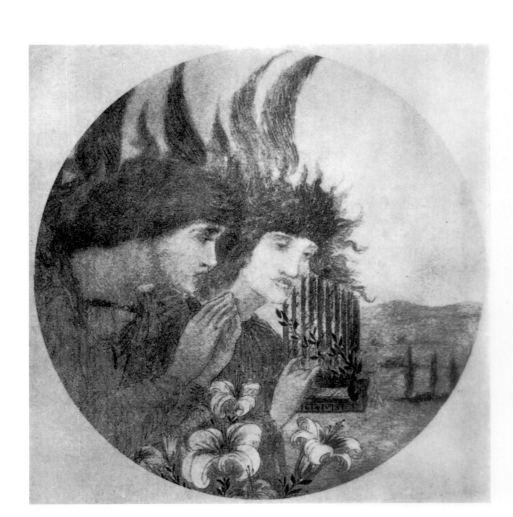

Right: SANDRO BOTTICELLI,
c. 1892. This is a pencil portrait of
one of the Renaissance painters most
admired by Beardsley, and whose
work he studied at the National
Gallery. A composite of Botticelli
portraits, it was drawn to illustrate
Beardsley's theory that artists tend to
reproduce their own physical type
(hence Botticelli drawn from
Botticellis). This was certainly true of
Beardsley, so many of the young men
in his work being represented as thin,
androgynous and rather unhealthy
looking, as in 'Hamlet' (p. 32) and
'Le Dèbris d'un Poète' (p. 33).

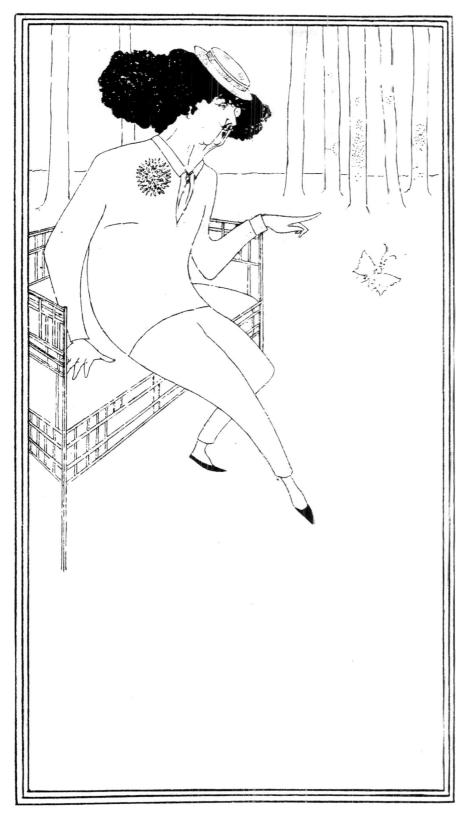

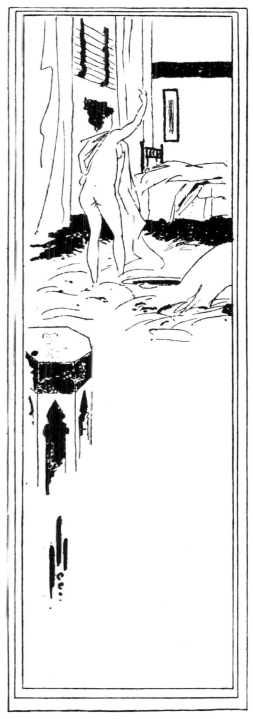

Above: CARICATURE OF WHISTLER, 1893. Although a great admirer of, and strongly influenced by, Whistler, Beardsley took offence over a failed dinner engagement in Paris and began a feud that lasted several years. In this caricature Whistler sits, tiny-footed, pointing effetely at his butterfly signature. Hostilities continued until Whistler saw Beardsley's designs for *The Rape of the Lock* and was so impressed that he conceded that Beardsley was a very great artist. Beardsley burst into tears and Whistler could only repeat, 'I mean it, I mean it'.

Above: BOOKMARK, 1893. A small drawing in Japanese style, the atmosphere of which is intimate and slightly titillating, but very charming. Beardsley must have liked the drawing himself since he gave it to Robert Ross, his friend and patron. Ross, a close friend of Oscar Wilde, introduced the two men, a meeting that was to have mixed consequences for Beardsley.

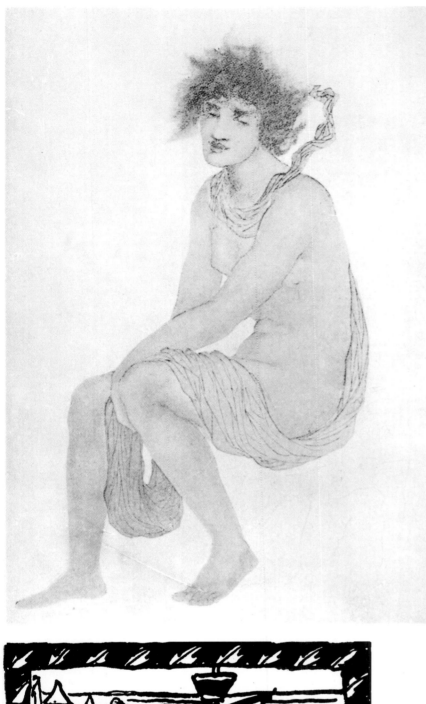

Left: HERMAPHRODITUS, *c.* 1893. Executed in pencil and pale colour tints, this drawing represents the half-male, half-female seated figure of Hermaphroditus, the softness of whose body is subtly and effectively rendered by sensitive shading. According to legend, Hermaphroditus, the son of Hermes and Aphrodite, refused to seduce the nymph Salmacis. Subsequently Salmacis prayed to the Gods to combine their bodies, and her prayer was answered. Given Beardsley's intense interest in sexual ambiguities, the legend must instantly have appealed to his imagination.

Above: VIGNETTE FROM MALLARMÉ'S, '*L'APRÈS MIDI D'UN FAUNE*', 1893. One of four designs in pen and ink illustrating Mallarmé's poem, this work uses the stippled style that Beardsley still employed despite also producing sharper line drawings during the same period. The chest hair is cleverly extended into Beardsley's 'ABV' signature, and the faun's face is not unlike his own. Mallarmé's belief that poetry should be evocative and suggestive was shared by Beardsley, who, his friend and biographer Arthur Symons said, would rather have been a poet than an artist.

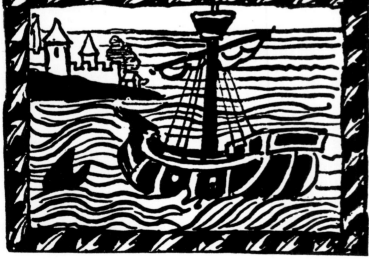

Above: DECORATIVE SKETCH DESIGN OF A SAILING SHIP, *c.* 1893. This decorative sketch, drawn in pen and ink on the back of a letter, reproduces the effect of a woodcut. William Morris was incensed by the ease with which Beardsley, not yet twenty-one, achieved with pen and ink the style his own Kelmscott Press had created and popularized. When shown Beardsley's medieval-looking designs for *Le Morte Darthur*, Morris growled, 'A fellow should do his own work.'

THE SPIRIT OF BEARDSLEY

THE PALL MALL BUDGET

Right: MR PENNELL AS 'THE DEVIL OF NOTRE DAME', 1893. Beardsley visited Paris with Joseph Pennell in May 1893, there enjoying success that was due mainly to Pennell's article about him accompanying his drawings in *The Studio* magazine. This sketch was published in *The Pall Mall Budget*, a periodical remembered only because Beardsley drew for it. Pennell had been clambering about the towers of Notre Dame, and Beardsley, amused, drew him as a gargoyle, peering over Paris towards the recently completed Eiffel Tower.

Far right: FOUR DESIGNS FOR THE NEW COINAGE, 1893. *The Pall Mall Budget* magazine published designs by Beardsley that were spoofs in the style of several well-known artists of the day. From top to bottom: a girl in the manner of the painter Sir John Everett Millais is depicted as Britannia ruling the waves — sitting on a sandcastle with a bucket and spade; the illustrator Walter Crane as a cross angel, holding a dripping pen and brandishing a smoking torch (*Demos Rex* refers to Crane's socialist beliefs); in medieval headdress, Edward Burne-Jones as Britannia, holding a shield and arrow; and a design that may be read as the face, moustache and streaked quiff of hair of James McNeill Whistler.

Right: MR ARTHUR JONES AND HIS BAUBLE, 1893. Henry Arthur Jones was at this time an extremely successful playwright, who wrote mostly comedies, hence Beardsley's depiction of his 'bauble', meaning the baton of the court fool or jester. This caricature may allude to a political comedy as the playwright holds an angry Big Ben, symbol of Parliament, with the cloth hat of the proletariat perched on its roof, brandishing its own 'bauble', which resembles a royal sceptre.

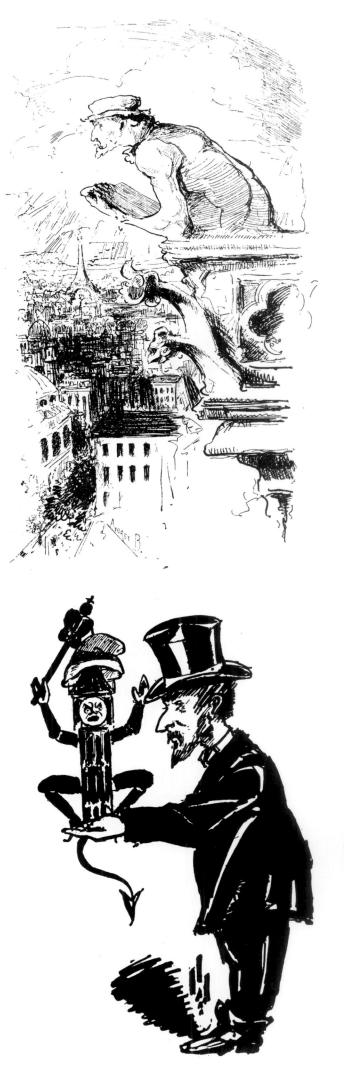

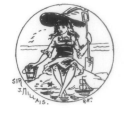

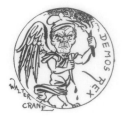

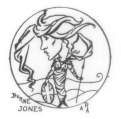

THE SPIRIT OF BEARDSLEY

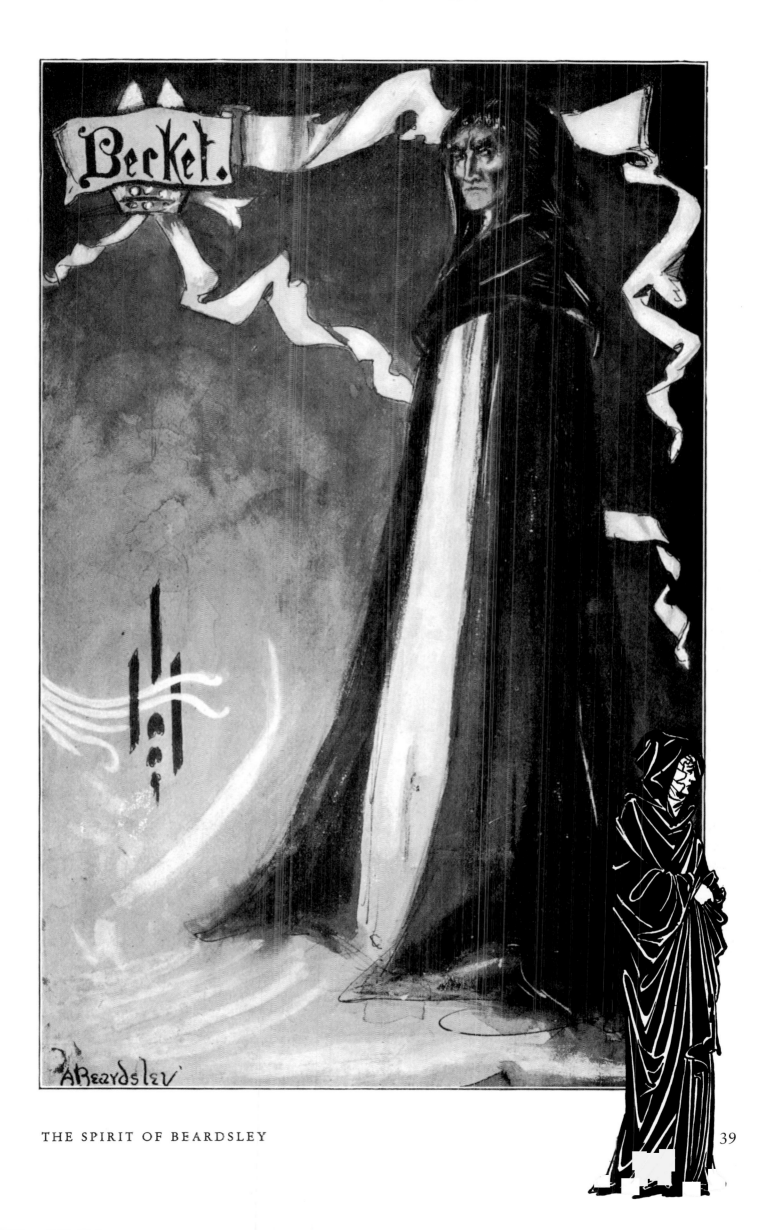

THE SPIRIT OF BEARDSLEY

Previous page: MR HENRY IRVING AS 'BECKET', 1893. Although Beardsley took etching lessons from Pennell, this is his only known etching, and that it appeared on the front page of *The Pall Mall Budget* was a measure of the actor's rather than the artist's fame. The drawing is shaded in such a way as to suggest theatrical lighting. Unusually, the artist not only signed it 'A. Beardsley', but also added his Japonesque signature.

Previous page. Below: MISS ELLEN TERRY IN *BECKET*, 1893. The most famous actress of her day, Ellen Terry is here depicted for the *Pall Mall Budget* as 'Rosamund' in *Becket*, a verse play by Tennyson staged at The Lyceum Theatre, where Henry Irving was actor-manager. In this drawing the full draperies of her costume are represented in the medieval style, giving the figure the look of a brass-rubbing.

Right: SIX SKETCHES FROM *BECKET* AT THE LYCEUM, 1893. Each of these sketches is in pen and ink over pencil and all are signed A.B. Top left: Master Leo Byrne as 'Godfrey'. Top right: Kate Phillips as 'Margery', a sketch reminiscent of the juvenile style of Beardsley's programmes for home entertainments. Middle left: Sir Charles Villiers Stanford, the composer of the music for *Becket*. Middle right: William Terriss of the famous theatrical Terriss dynasty as 'King' on the chess board. Bottom left: An unidentified actress playing 'Queen Eleanor', swathed in black robes and holding a dagger. Bottom right: Mr Gordon Craig as a scaly-armoured crusader. Craig was the son of Ellen Terry, who played 'Rosamund' in the same production of *Becket*. He was to become extremely influential as a director and designer, and to have a profound effect on modern theatre.

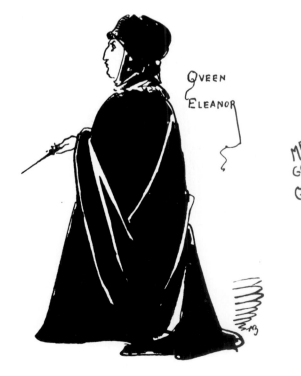

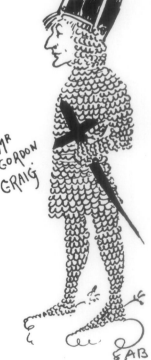

THE SPIRIT OF BEARDSLEY

Below: THE DISAPPOINTMENT
OF ÉMILE ZOLA, 1893. Yet again
the Académie Française had refused
the famous novelist entry to its
ranks. Zola had presumed that he
stood a good chance in 1893 as
there were two vacated seats and he
had just been appointed to the
Legion of Honour. Not only was he
turned down then, but he was
rebuffed nineteen times in all.
Beardsley, who admired Zola
greatly, has here pictured him
dishevelled, hands in pockets,
looking very disgruntled outside the
firmly closed door of that
institution.

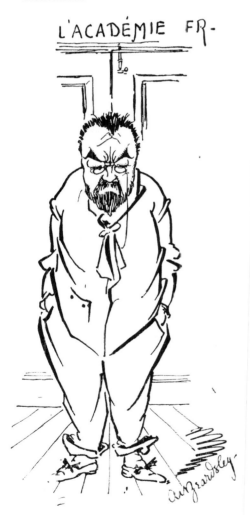

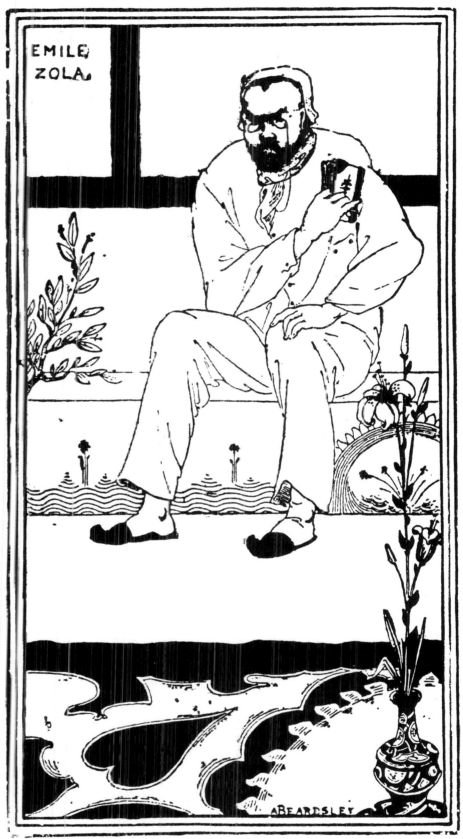

Above: PORTRAIT OF ÉMILE
ZOLA, 1893. The portrait of Zola,
drawn in the Japonesque manner,
proved so popular that it was reprinted
twice in the same year. The black-and-
white pattern of the carpet and the
foreground plant serve as decorative
borders. Beardsley drew the body in
pale stippled line, a device that draws
the viewer's eye upwards to Zola's
head, with its characteristically
determined expression.

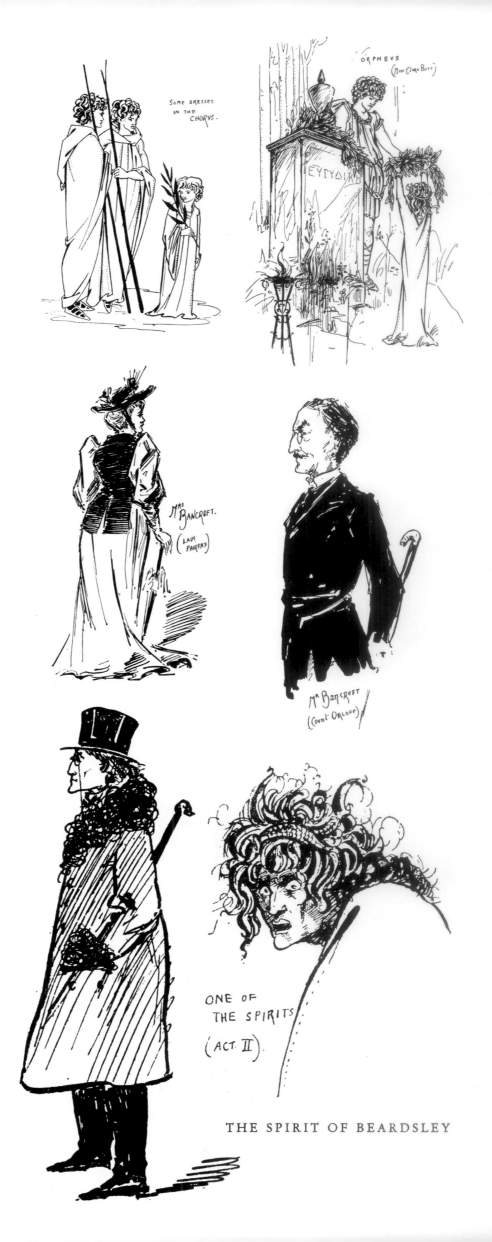

Top right: SKETCHES FROM
ORPHEUS, 1893. Two delicate little
sketches of the production of
Orpheus at The Lyceum, which
starred Clara Butt, the young English
contralto. The drawing on the left is
entitled 'Some dresses in the chorus',
and the one on the right is of Clara
Butt in the leading role of 'Orpheus'.

Middle right: SKETCHES FOR *THE
PALL MALL BUDGET*, 1893-4. Mr
and Mrs Bancroft were a theatrical
couple who had enjoyed great success
in a run of light comedies between
1865 and 1885. Their appearance in
Diplomacy, she as 'Lady Fairfax' and
he as 'Count Orloff' (in which
characters they are here sketched by
Beardsley) was something of a
London comeback for them.

Bottom right: SKETCHES FROM
ORPHEUS, 1893. On the left is 'A
Visitor at Rehearsal', who appears to
be rather grand, complete with shiny
topper, eyeglass, astrakhan collar and
pocket, and with his cane stuck under
his arm. On the right is 'One of the
Spirits in Act II', glaring frighteningly
at the viewer.

THE SPIRIT OF BEARDSLEY

THE STUDIO AND THE PALL MALL MAGAZINE

Right: LES REVENANTS DE MUSIQUE, 1892. This work in line and wash so impressed Lewis Hind (art editor of *The Studio*) that he included it in the first issue of the magazine. A sad young man sits slumped in a chair, his relaxed hand but intensely concentrated expression suggesting a trance- or dream-like state. The diminutive size of the spirits of music in relation to the central figure suggest that they are creations of the mind — possibly characters from dreams.

Far right: J'AI BAISÉ TA BOUCHE, IOKANAAN, 1893. Inspired by Oscar Wilde's French version of *Salome*, and published in the first issue of *The Studio* magazine, this is a powerful and complex work. It represents the moment when Salome kisses the dead lips of John the Baptist, and is imbued with an appropriate atmosphere of depraved sensuality. Blood drips from the severed head to feed or poison the flowers in the black lake beneath. In this work Beardsley fuses a number of influences — Japanese, Pre-Raphaelite and French Symbolist — into the distinctive style that led to his being commissioned to illustrate the whole of *Salome*.

Overpage: SIEGFRIED, 1893. Illustrating Act II of Wagner's opera, this particularly intricate work invites detailed examination. In the black lake plants are reflected from nowhere; flowers and tree branches are as sinuous as the defeated dragon, whose left wing leads the eye to a bizarre, fantastical landscape. Beardsley gave this drawing to Burne-Jones, who hung it in 'a place of honour' in his drawing room. The technical difficulties associated with its reproduction in *The Studio* magazine led Beardsley to ensure that all his works could be easily reproduced.

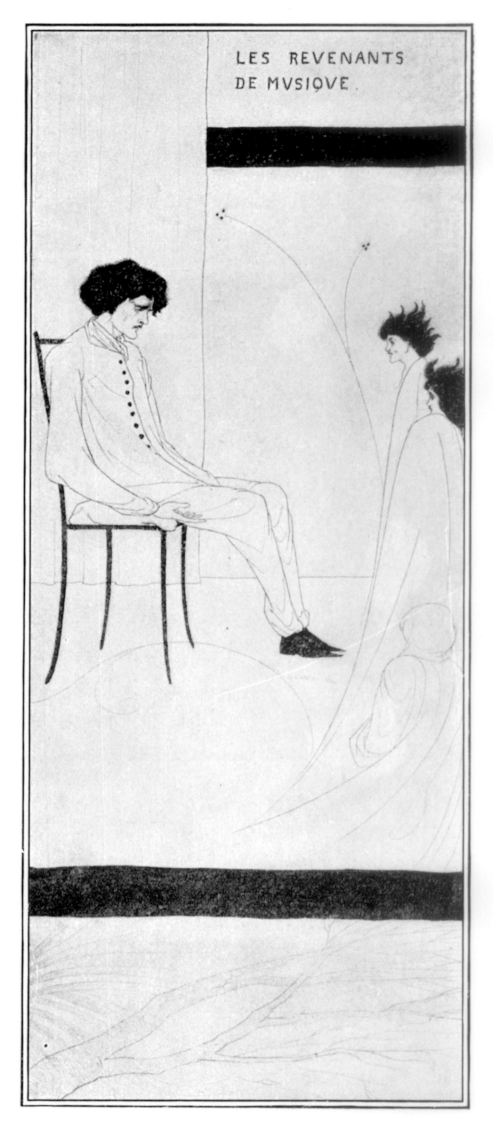

LES REVENANTS
DE MVSIQVE.

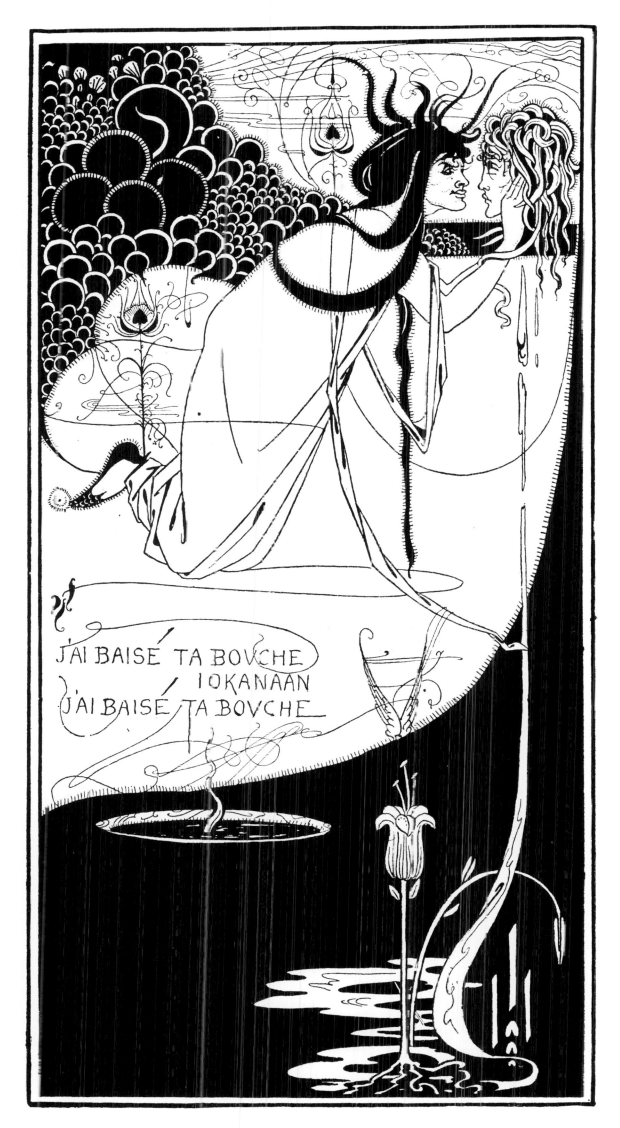

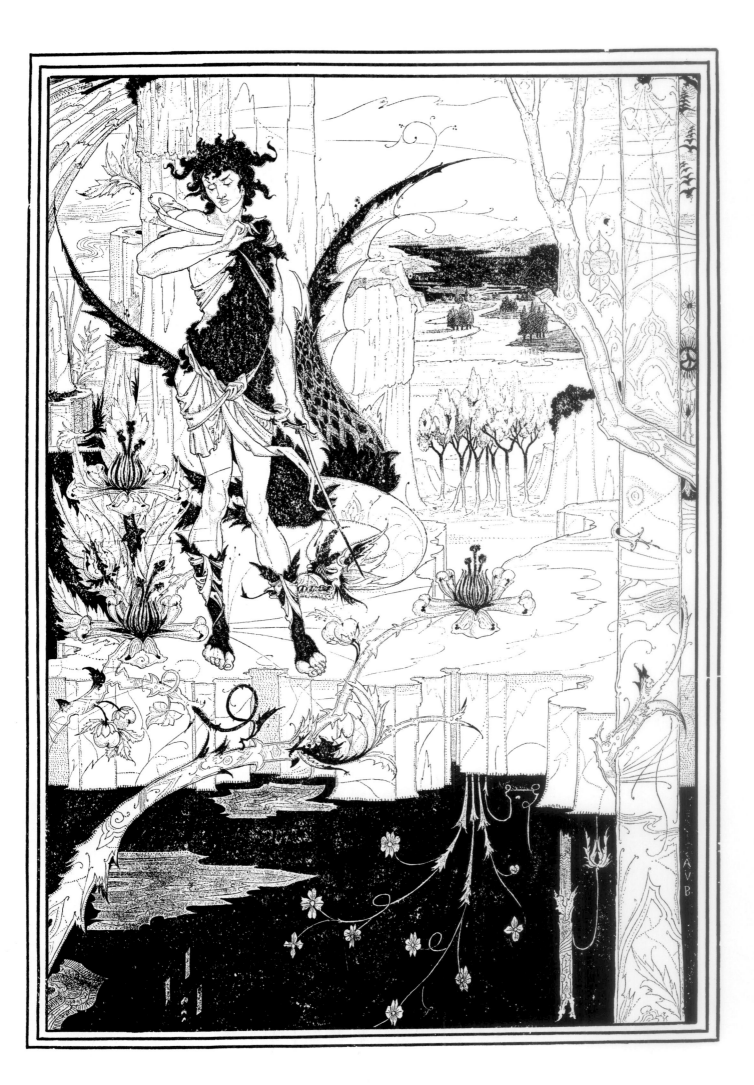

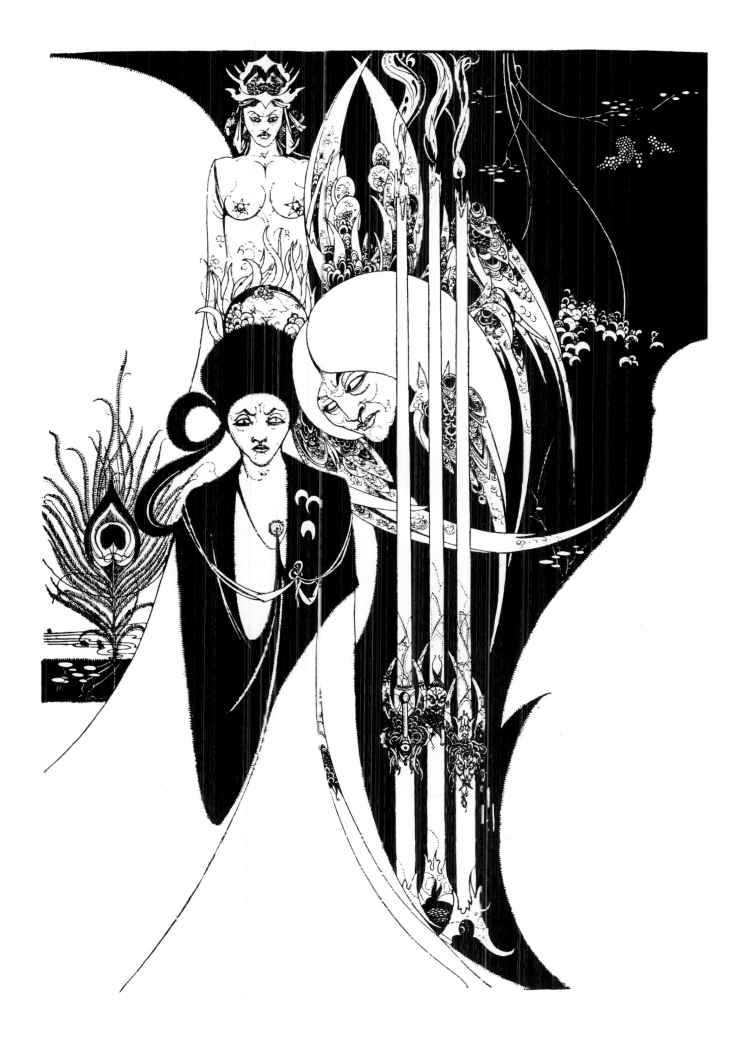

Previous page: OF A NEOPHYTE AND HOW THE BLACK ART WAS REVEALED UNTO HIM BY THE FIEND ASOMUEL, 1893. Published in the June issue of *The Pall Mall Magazine*, this pen-and-ink drawing exudes a nightmarish atmosphere. Behind lance-like candlesticks disembodied figures menacingly loom. Read by many to represent an initiation into satanic perversities, the artist explained that 'the fiend, Asomuel' stood for insomnia, the name invented by him from the Greek *alpha* (privative), the Latin *somnus* (sleep), and the Hebrew *el* (as at the end of other names, such as Gabriel, Raphael, etc.).

Right: THE KISS OF JUDAS, 1893. In this pen-and-ink drawing, published in *The Pall Mall Magazine*, Beardsley began to achieve the quality of line and elegant balance of composition that distinguishes his work. This picture has been said to illustrate the legend that the children of Judas prowl about the world intent on evil, and killing with a kiss. Many have read Beardsley himself into the little grotesque lifting the limp hand of a woman whose heavy head harks back to the 'beauties' painted by Dante Gabriel Rossetti.

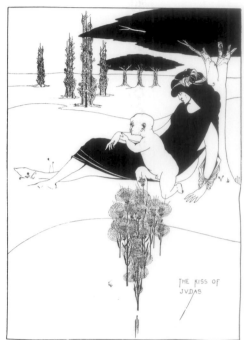

Below: THE BIRTHDAY OF MADAME CIGALE, 1893. In line and wash, and much influenced by Japanese prints, this was one of several drawings published in *The Studio* magazine to illustrate the article by Joseph Pennell, 'A New Illustrator: Aubrey Beardsley', which launched the young man, not yet twenty-one, onto the art world. Frieze-like figures bearing gifts progress towards Madame Cigale, and feet invade a decorative border of birds and plants, the whole giving the effect of decoration on Oriental lacquered furniture.

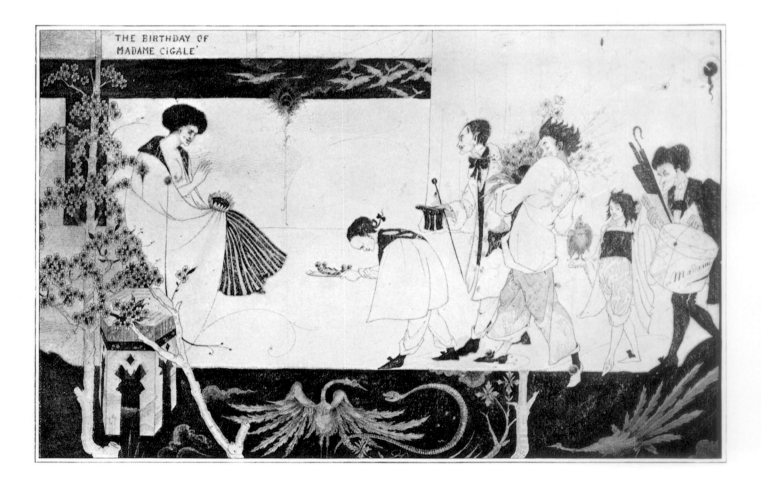

THE SPIRIT OF BEARDSLEY

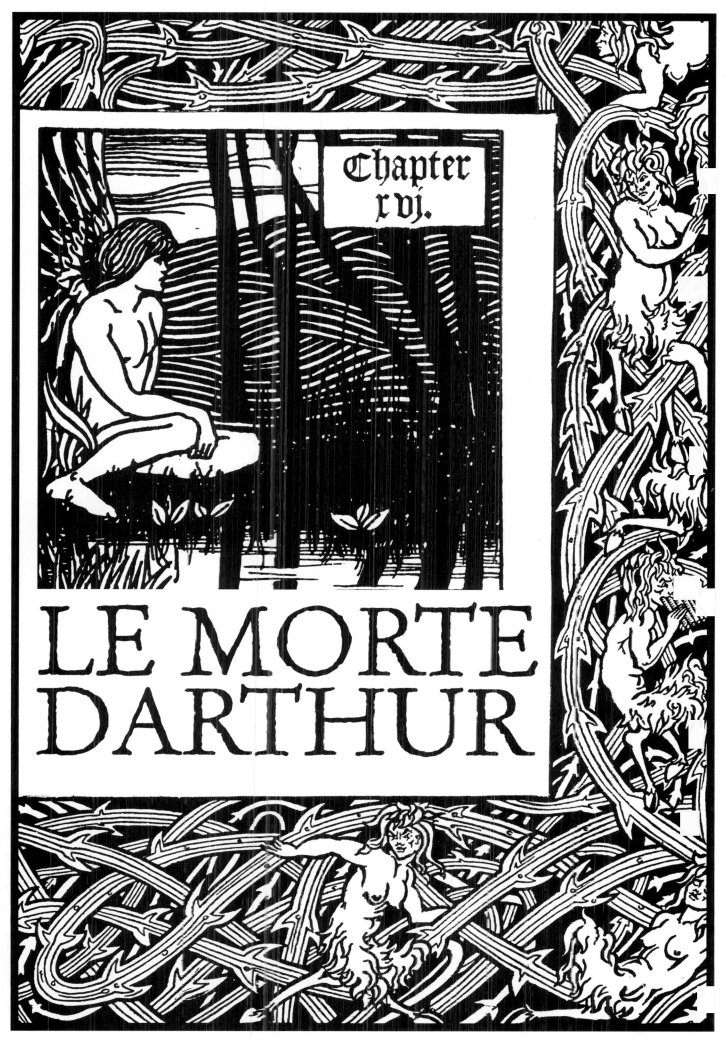

Chapter r vj.

LE MORTE
DARTHUR

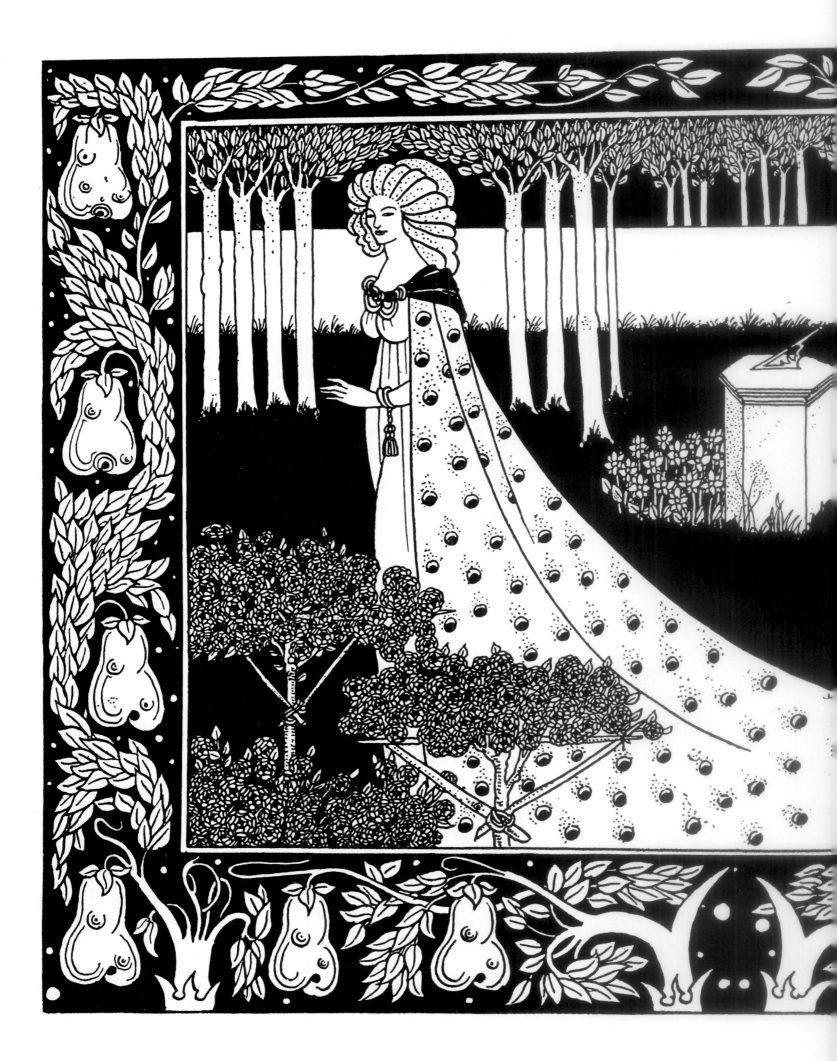

THE SPIRIT OF BEARDSLEY

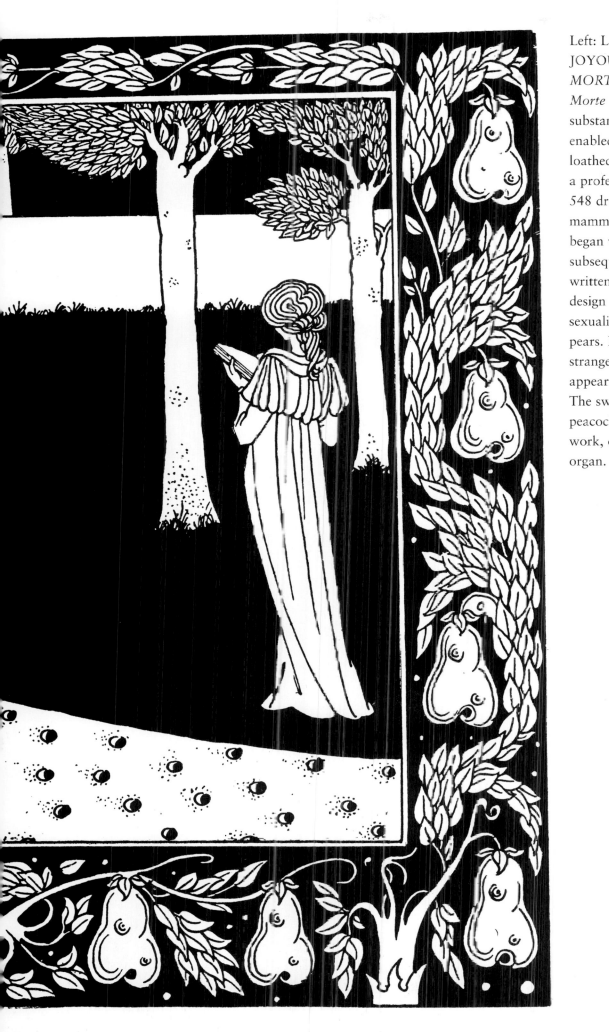

Left: LA BEALE ISOUD AT
JOYOUS GARD, FROM *LE
MORTE DARTHUR*, 1892-4. *Le
Morte Darthur* was Beardsley's first
substantial commission, and it
enabled him finally to leave his
loathed office routine for a career as
a professional artist. To produce over
548 drawings in two years was a
mammoth task, one that Beardsley
began with wild enthusiasm, but
subsequently tired of. Much has been
written about the border of this
design because of the overtly
sexualized representation of the
pears. Beardsley has given them
strangely placed breasts, and the
appearance of having pubic regions.
The sweeping cloak is patterned with
peacock eyes, which, in Beardsley's
work, often signify the female sex
organ.

CHAPTER-HEADINGS FROM *LE MORTE DARTHUR*, 1892-4. Right: An angel plays the lute beside trees that appear to bend towards the sound of the music. Their trunks and the curve of the wings create opposing arcs that are balanced and connected by fluttering drapery. Beardsley considered music and visual art to be intimately connected, Weber's piano pieces reminding him, in his words, 'of the beautiful glass chandeliers at the Brighton Pavilion', and a work by Rossini of 'the bloom upon wax fruit'.

Below far right: An androgynous youth holds bunches of grapes on a pole as if carrying an offering for a Bacchic rite. Behind him rises a Herm, originally a phallic image. Beardsley loved to shock with the ambiguous sexual content of his designs. Beyond the darkness of the wood with its formalized trees a bright seascape may be glimpsed, and above the cliffs fly a column of birds, a motif Beardsley was to use many times.

Right: In this vignette the nude figure drawing water, the standing woman, the well itself, and the trees, make for a strongly vertical composition, in the context of which the arm movements of the youth and the woman appear to have a peculiar vigour and purpose.

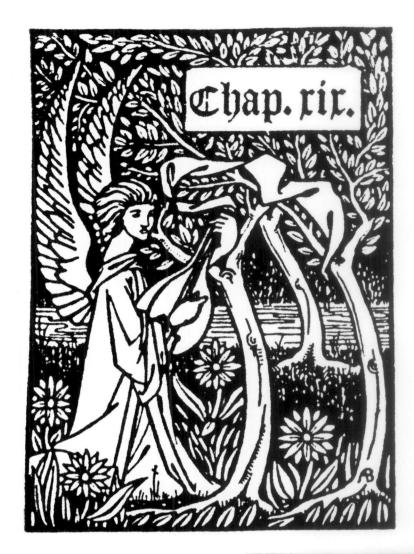

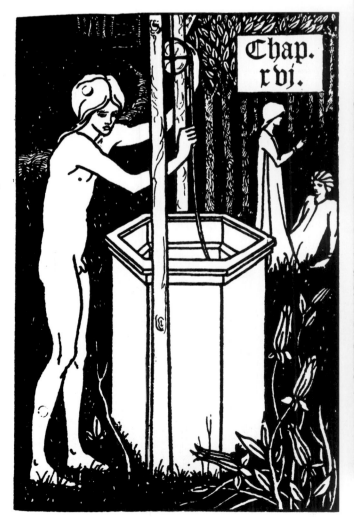

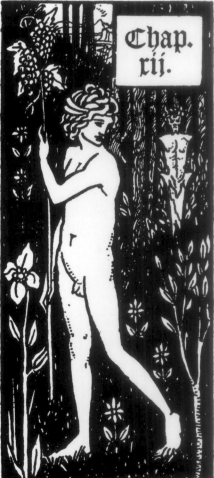

52

CHAPTER-HEADINGS FROM *LE MORTE DARTHUR*, 1892-4.
Right: Beardsley adapted this woodcut-like drawing from the central section of 'Soleil Couchant' (p. 28). As he became bored by the constant demand for *Morte Darthur* illustrations and decorations in the medieval Kelmscott style, the ironic, impish side of his nature began to assert itself. The illustrations became increasingly irrelevant to the text, which he once admitted he found tedious, and his taste for the grotesque asserted itself.

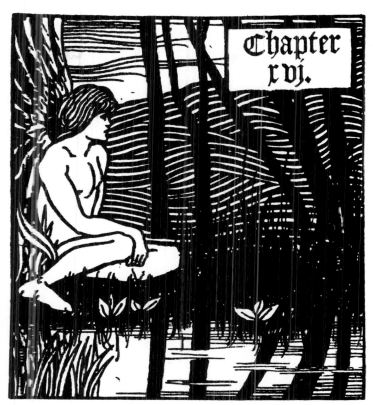

Below left: One beneficial result of the *Morte Darthur* commission was that the sheer amount of work involved forced Beardsley to simplify a tendency to over-decorate. This chapter headpiece is a good illustration of this bolder, more graphic approach. The tail of the stylized peacock flows sinuously towards the viewer, echoing the fluidity of the fountain which, like the vigorous tree, is a symbol of life. Within the trunk of the tree is the suggestion of a nude human figure.

Below: In this work Beardsley is at his cryptic best. The girl in foreground glares directly into the viewer's eye and holds up her hand in a gesture that resembles a Christian blessing, although there is nothing benevolent in her expression. Her cruel-looking little face is dwarfed by masses of stylized hair extending over her body, and what might be a tiny horn pokes through her parting. The contour lines of the hair create a strobing effect that is both startling and disturbing.

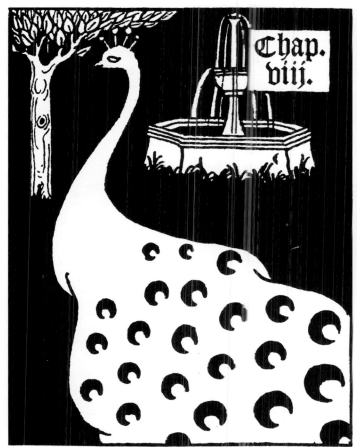

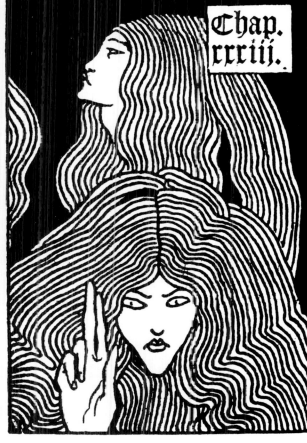

Right: HOW FOUR QUEENS
FOUND LAUNCELOT
SLEEPING, FROM *LE
MORTE DARTHUR*,
1892-4. Framed within an
elaborate, asymmetrical
border of tangled roses, four
flat-chested queens look to
where Launcelot, propped up
on one elbow, seems as if day-
dreaming, rather than
sleeping. Except for his
armour, there
is nothing to differentiate
him from the women. Strong
perspectival curves and
symmetrically placed trees
draw the eye from the figural
grouping into the deserted
amphitheatre beyond.

Below: CHAPTER-HEADING
FROM *LE MORTE
DARTHUR*, 1892-4. In
this work six warriors
struggle through a labyrinth
of scrolling foliage. These are
fighting men, muscled, armed
and violent, with no hint of
the effete about them. The
suffocating atmosphere and
the need to fight through it,
may have been subliminally
in Beardsley's mind because
of his own difficulty in
breathing.

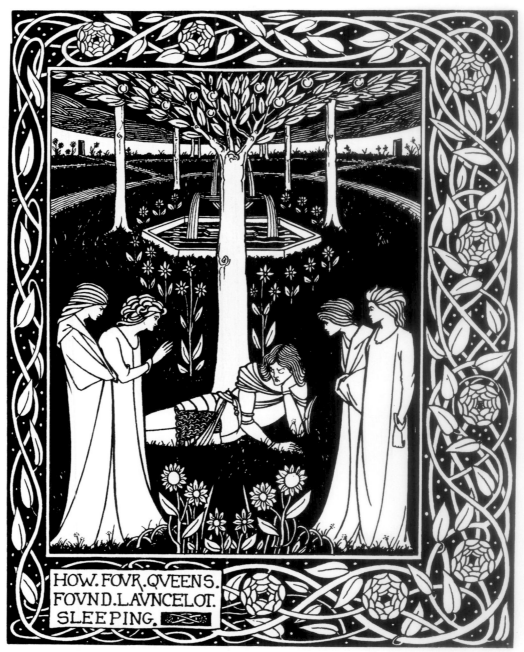

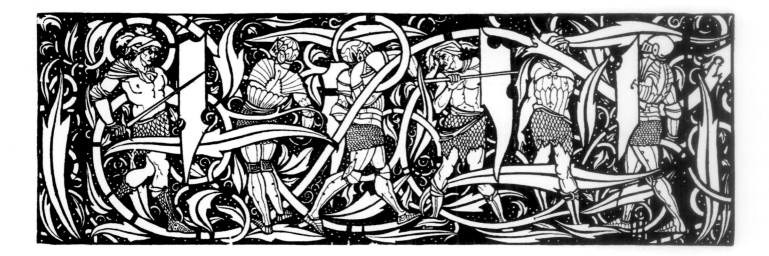

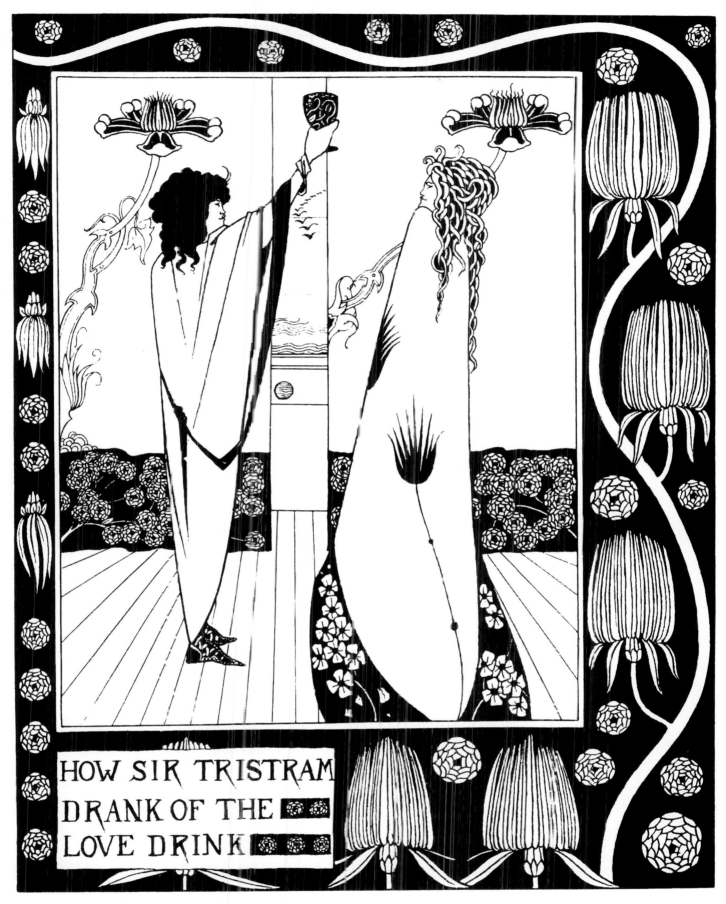

Above: HOW SIR TRISTRAM DRANK OF THE LOVE DRINK, FROM *LE MORTE DARTHUR*, 1892-4. That this Japonesque drawing can be interpreted in many way is evidence of Beardsley's poetic approach to his art. Here the mysteriousness of the image mirrors the action. Sir Tristram is willing to drink poison, and Isoud, who both loves and hates him, also believes the cup to be fatal. Neither knows that it contains a strong love-potion that will unite them until death. This connection between love and death is symbolized by the dying flowers on the left-hand border and the upright living ones on the right.

THE SPIRIT OF BEARDSLEY

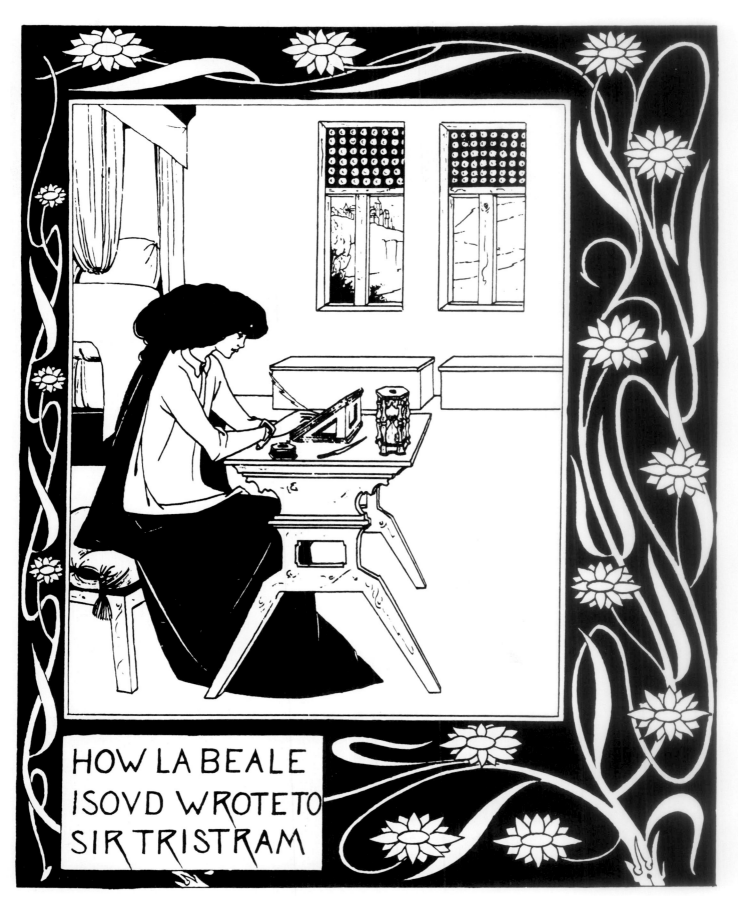

HOW LA BEALE
ISOVD WROTE TO
SIR TRISTRAM

Above: HOW LA BEALE ISOUD WROTE TO SIR TRISTRAM, FROM *LE MORTE DARTHUR*, 1892-4. Beardsley's idiosyncratic style, to which he could give free rein in other commissions of the same time, here begins to take over from the medieval manner he was meant to employ for *Le Morte Darthur*. La Beale Isoud sits in a room of Japonesque minimalism. Without the black cloak and mass of heavy hair, she could be that other writer at a desk, the '*poète*' of 'Le Dèbris d'un Poète' (p. 33).

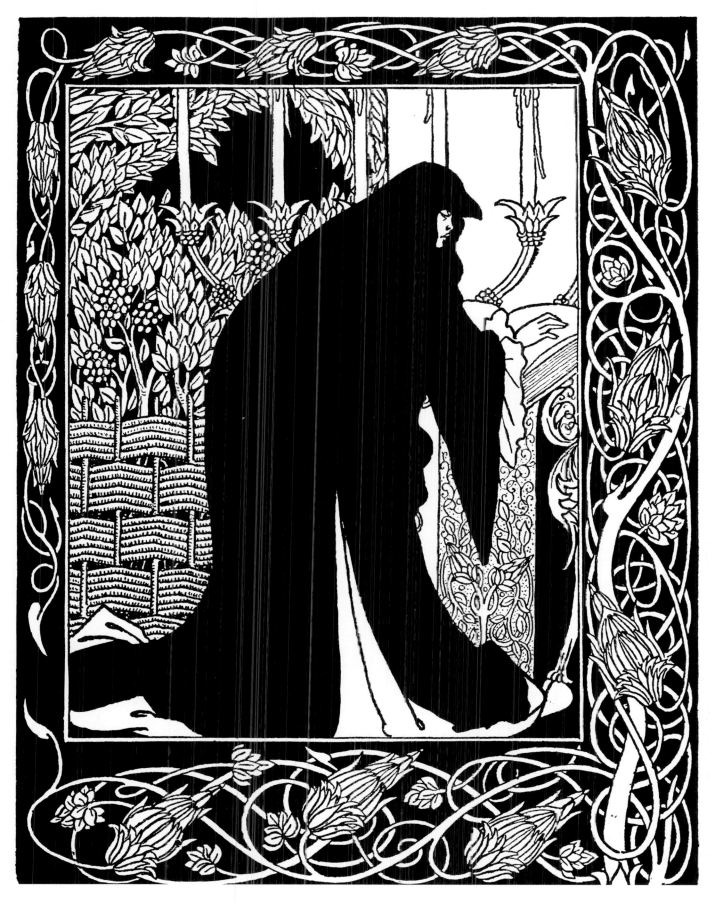

Above: HOW QUEEN GUINEVER MADE HER A NUN, FROM *LE MORTE DARTHUR*, 1892-4. Guinever appears more to be studying the black arts than becoming a nun. The hood of her cloak is fashioned into a bird's beak, her expression is menacing, and she reads, as if in a book of spells, by the light of dripping candles. If held upside-down — his publishers examined Beardsley's drawings from every angle for anything pornographic — the front panel of the cloak forms a huge phallus.

Right: HOW SIR BEDIVERE CAST THE SWORD EXCALIBUR INTO THE WATER, FROM *LE MORTE DARTHUR*, 1892-94. A full-page illustration of the second occasion in Tennyson's *Idylls of the King* when, 'an arm/ Rose up from out the bosom of the lake,/ Clothed in white samite, mystic, wonderful.' This time, however, the arm catches the sword instead of bestowing it. Unusually, Beardsley makes the lake light and its banks dark, probably so that the white vertical of the sword will show up clearly.

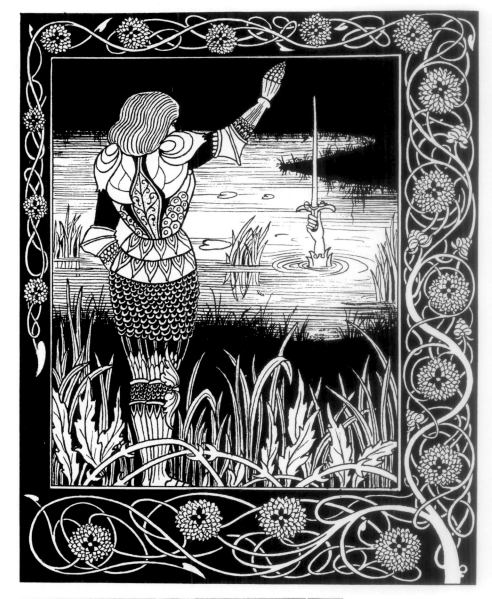

Right: THE ACHIEVING OF THE SANGREAL, FROM *LE MORTE DARTHUR*, 1892-4. Although used as the frontispiece to Volume II, this was the first drawing of the *Morte Darthur* series. It was, in fact, a test-piece drawn by Beardsley in a successful bid to win the commission to illustrate the book. The work contains fascinating hints of bizarre things to come in his *œuvre*: the black lake contains odd reflections; the knights' armour has a disturbing, scaly quality; the flowers are of an exaggerated size; the angel's robes bear a strange cabalistic design, and her wings are ragged and menacing.

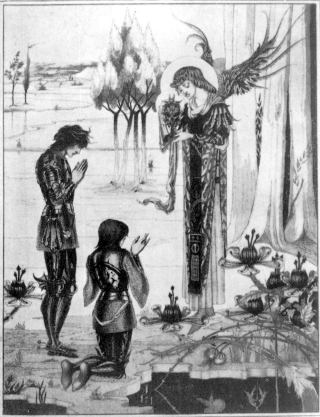

THE SPIRIT OF BEARDSLEY

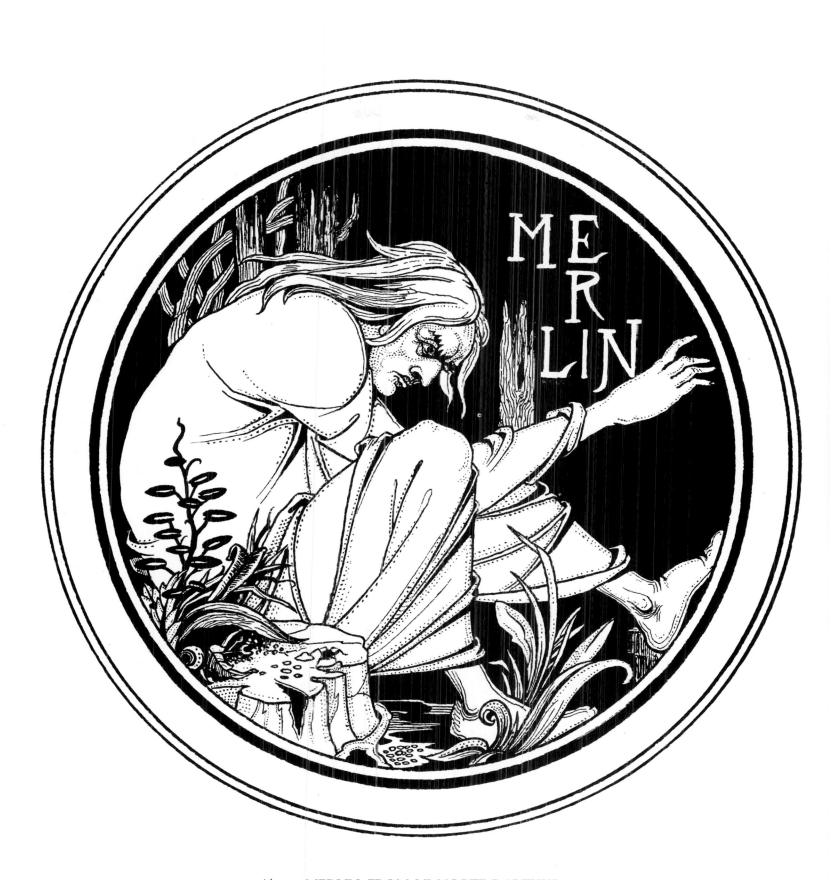

Above: MERLIN, FROM *LE MORTE DARTHUR*,
1892-4. The conflicting legends surrounding Merlin, as
bard, necromancer, and the son of a damsel seduced by a
fiend, must have fascinated Beardsley. In this design he
confines Merlin within a circle, a clever means of
symbolizing the differing accounts of his imprisonment: in
a rock; in an oak tree; entangled in a thorn bush. The
drawing may also refer to the historical Merlin, said to
have gone mad and died on the banks of a river, which
this design illustrates perfectly.

CHAPTER-HEADINGS FROM *LE MORTE DARTHUR*, 1892-4. Right: In this strongly graphic vignette Beardsley plays with the balance of vertical and horizontal, black and white. The work displays a marked interest in symmetry, with three swans, three trees and three streams — even the four flowers are matched by the segmentation of the black background into four. Naturalistic perspective is denied by the swans being of equal size, so that the effect is of a flat pattern.

Far right: In the tradition of Renaissance goddesses, a curvaceous female figure rises from the sea. She gazes at a rose held in her left hand, and rests her right on a sword that bears a heart at its hilt. The sea-nymph's hair is a finer version of the sea, and the pattern of the wave round her knees is echoed in the sweep of hair above her neck and face.

Right: Beardsley quite frequently represented young women or angels playing musical instruments surrounded by flowers. In this serene drawing the dominant vertical lines of the woman, the cello and the central flower are like a main theme in music, while the gentle inclines of the outer flowers, the diagonal of the player's left arm and the bow in her right, subtly vary that theme. The motif on the woman's upper sleeve may be read as the eye of a peacock or a lute.

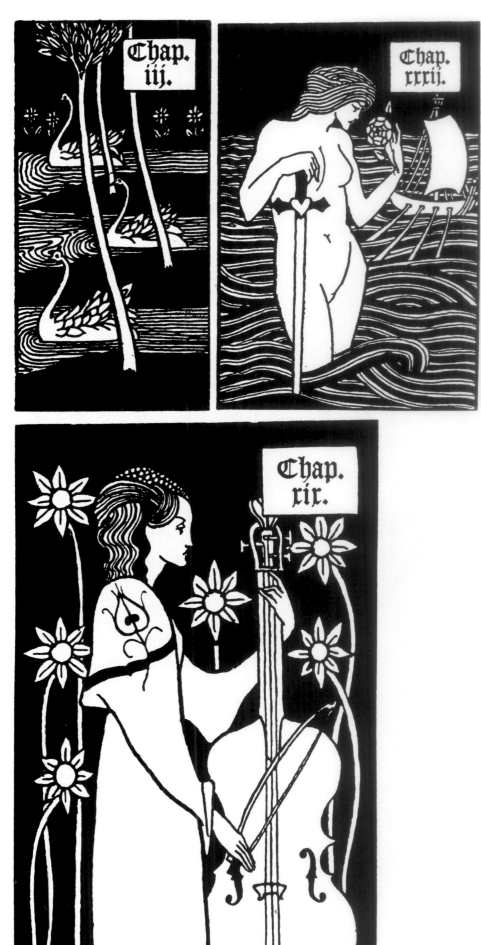

THE SPIRIT OF BEARDSLEY

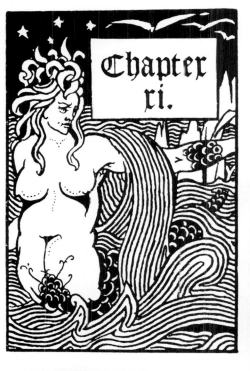

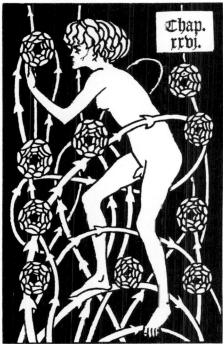

CHAPTER-HEADINGS FROM *LE MORTE DARTHUR*, 1892-4. Top: Michelangelo used male models for the depiction of female figures, superimposing breasts on to them. Similarly, this deity has a male face and body except for its full breasts, and rises from the sea, literally shouldering the waves. Beardsley has drawn an ambiguous shape, like a sea-snake, writhing through the sea and nestling its antennaed head in the pubic region of the sea-god's body.

Left: 1892-4. Hermaphrodites feature often in Beardsley's work, and are thought by many to have represented his own unfulfilled desire. Tuberculosis is known to increase physical appetite, while producing such weakness as may prevent satisfaction. In this drawing a puckish creature with breasts and penis yearns towards a rose, a symbol of physical love. Briers with sharp thorns encircle the body and arch between the legs, making the figure's nakedness seem all the more vulnerable.

Middle left: The piper in this design is reminiscent of Beardsley's schoolboy illustrations for *The Pay of the Pied Piper* programme (p. 21), which he drew in 1888 for the Brighton Grammar School Christmas entertainment. The composition contains many typically Beardsleyan motifs: the emergent Medusa-haired figure; the cliff-top and distant landscape; the column of birds; and the stylized plants in the foreground.

Overpage: BORDER DESIGN AND VIGNETTE FROM *LE MORTE DARTHUR*, 1892-4. The border design uses symmetry but also departs from it, as is particularly noticeable in the unfinished figure of eight in the bottom section. Beardsley enjoyed establishing visual rules, only to break them. At the bottom right-hand corner he has fashioned the stem into a little horned face, upside-down, that looks cheekily at a leaf. Within the border the vignette depicts an angel who appears to be remonstrating with a satyr for playing his pan-pipes. This tension between Christian and pagan values represents a central paradox in Beardsley's character and work. In the last year of his life, encouraged by his friend and patron M. André Raffalovich, he was received into the Roman Catholic faith, but at the same time he was writing to another friend, Leonard Smithers, publisher of *Lysistrata*, requesting erotic and pornographic literature.

KEYNOTES
BOOKS

Right: TITLE-PAGE DESIGN
FOR KEYNOTES, 1893-6.
Keynotes was a series of novels
and short stories dealing
principally with the subject of
women, and particularly — in
keeping with *fin-de-siècle*
preoccupations — their role and
sexuality. In this design, for the
first of the series, *Keynotes*, by
George Egerton (the pen-name of
Maria Chevelita Bright),
Beardsley suggests manipulation
of the female in an extraordinary
way: a Pierrot holds a woman on
a stick that reaches up under
her skirt.

Below right: TITLE-PAGE
DESIGN FOR *A CHILD OF
THE AGE*, 1893-6. The design is
for the bottom panel of the title-
page of the book by Francis
Adams, the fourth in the Keynotes
series. It resembles a *Morte
Darthur* chapter-heading, albeit
simplified, and is another example
of Beardsley's use of flowers as a
symbol of sexuality. Buds in his
work tend to represent
immaturity, and fully opened
blooms mature, sexual love. The
'Child' of the story, if represented
by the six main flowers, is open
to experience, unlike her more
timorous sister buds.

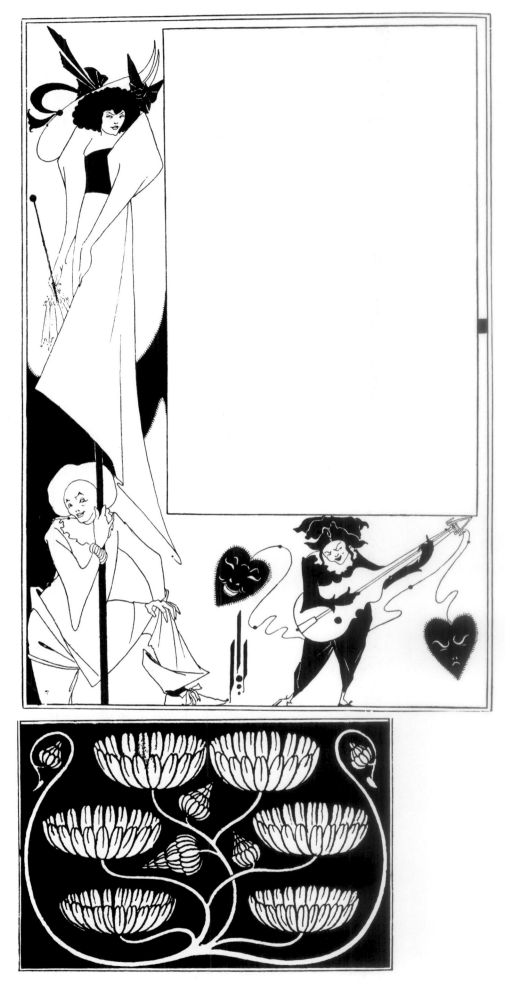

THE SPIRIT OF BEARDSLEY

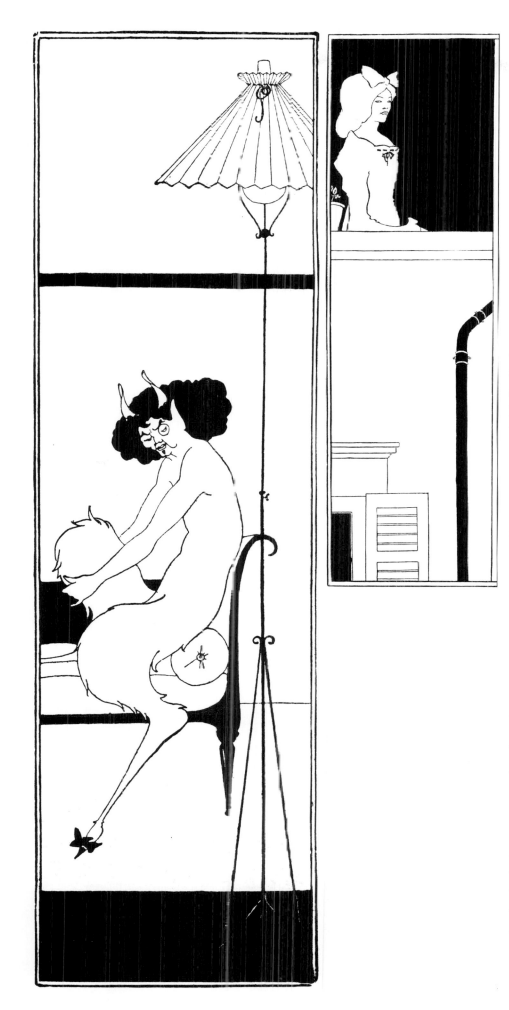

Left: TITLE-PAGE DESIGN FOR
POOR FOLK, 1893-6 Translated
by Lena Milman from the
Russian of Fyodor Dostoevsky,
the illustration for the third
Keynotes novel offers a good
example of Beardsley 'extracting
from literature whatever was
suggested as pattern' (Robert
Ross), for what could be less
Russian in atmosphere than this
little girl in the manner of Kate
Greenaway? Greenaway's
drawings had an early influence
on Beardsley, and he had earned
money as a child by imitating her
style on cards that were bought
by his mother's friends.

Far Left: TITLE-PAGE DESIGN
FOR *THE DANCING FAUN,*
1893-6. In this illustration for the
second book in the series, by
Florence Farr, a faun sports the
monocle, facial features and shoes
of the artist James McNeill
Whistler. He is an urbane creature
— no wild woods for him — and
he sits perched on an elegant
Empire sofa, hugging one shaggy
knee (which may be read as a
phallus) and eyeing the floor
enigmatically. Strong blacks
throw into relief the delicacy of
this foppish creature, who is
carefully positioned within a
border divided in the Japonesque
manner.

Above: UNFINISHED SKETCH
FOR *THE GREAT GOD PAN
AND THE INMOST LIGHT*,
1893-6. Arthur Machen was the
author of this, the fifth in the series,
and the sketch was found on the
reverse of the drawing for the
finished cover design. It indicates
Beardsley's drawing process, which
was to cover the page in faint
scribbles and shapes in pencil, and
then draw boldly in ink, rubbing out
the pencil marks. Here two cherubs,
encircled by scrolling tendrils, flank
the three-breasted, horned and long-
haired god Pan, whose skull-like
features obviously did not satisfy the
artist as they have been obliterated.

Right: COVER DESIGN FOR
PRINCE ZALESKI, 1893-6. M. P.
Shiel's book was the seventh of the
Keynotes titles. Beardsley created a
fantastical sword (the hilt appears in
the lower right corner), with the
blade softening into scrolling foliage,
from which hang stylized
pomegranates. This may symbolize
the transference of aggression into
sexual passion. A sword hilt may
also be read into the small border
design above.

Above: COVER DESIGN FOR *THE WOMAN WHO DID*, 1893-6. For the eighth in the series, by Grant Allen, Beardsley cleverly suggests the isolation that threatens a woman who flowers creatively by depicting two full-blown roses separated by, and within, encircling leaves. In this novel the heroine, Hermina Barton, suffers for fulfilling her promise at the expense of neglecting her 'womanly' duties: the tip of the leaf above the first rose points up hopefully, but above the second it droops downwards. The top border establishes a symmetry that makes this difference all the more noticeable.

Right: COVER DESIGN FOR
WOMEN'S TRAGEDIES, 1893-6.
The vinous cover of H. D. Lowry's
book, ninth of the Keynotes, suggests a
Bacchic theme. Beardsley took great
delight in establishing an apparent
symmetry that upon closer examination
reveals many subtle variations. The
Victorian eye expected symmetry in
design, a perfection that reflected and
reinforced other comfortable
certainties. Beardsley enjoyed
disappointing such bourgeois
expectations. As his friend and
biographer Arthur Symons wrote, 'He
had an immense contempt for the
public.'

Right: COVER DESIGN FOR *GREY
ROSES*, 1893-6. Tenth of the Keynotes
series, the author was Henry Harland,
a friend of Beardsley, and also a
consumptive. Harland features as one
of the characters in the frontispiece to
Plays by John Davidson (p. 93), and
Beardsley later conceived *The Yellow
Book* with him. 'Grey roses' appear in
this composition, the rose-tree tops
seeming at first to be simply a mass of
leaves until the eye picks out the many
roses nestling among them. The entire
design forms a large 'H' for Harland.

Right: TITLE-PAGE DESIGN FOR *AT
THE FIRST CORNER AND OTHER
STORIES*, 1893-6. Written by H. B.
Marriot-Watson, this was the eleventh
in the series to be published. In this
arresting composition the full-blown
poppy, fat, bursting buds and flame-like
leaves create a mood of passionate
turmoil. Such turbulent designs are
heavily influenced by the tangled briar
effects created by the artist Edward
Burne-Jones. The sheer volume of the
earlier *Morte Darthur* commission, in
which the influence of Burne-Jones is
also apparent, demanded a bolder,
more graphic approach.

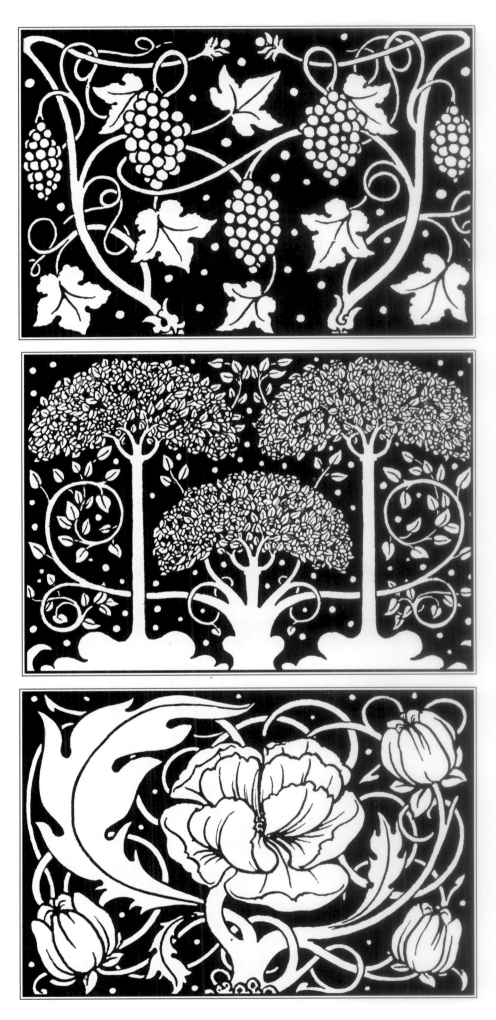

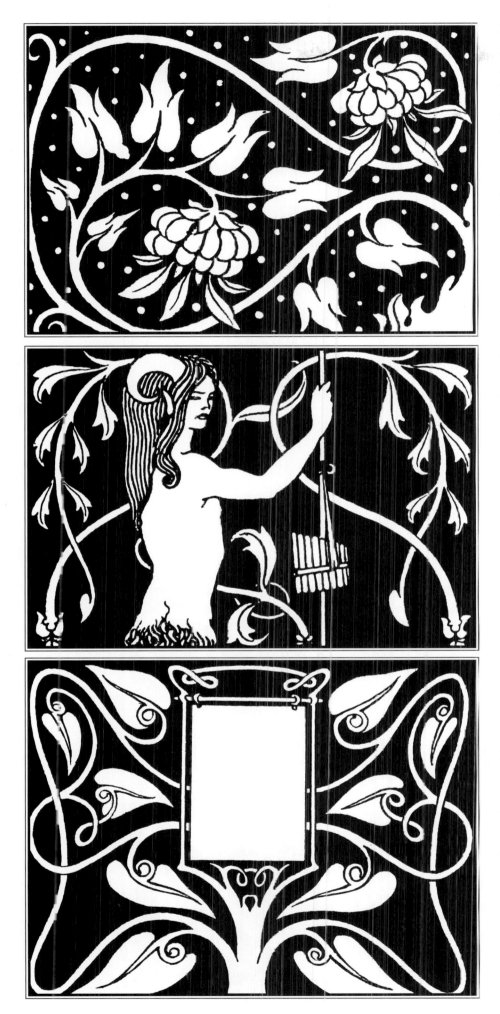

Left: TITLE-PAGE DESIGN FOR *MONOCHROMES*, 1893-6. The title of Ella Darcy's book, the twelfth in the Keynotes series, has an apt title for illustration by Beardsley. In this drawing the artist again uses one of his favourite decorative devices, a curling plant stem, here with sensuous blooms and leaves, whose tips lead the eye in many directions. These stems suggest the 'whiplash' line of the Art Nouveau style, as seen in the work of such artists as Carlos Schwabe, a book-illustrator known for his sinuous patterns of organic forms.

Left: COVER DESIGN FOR *THE GREAT GOD PAN AND THE INMOST LIGHT*, 1893-6 (see p. 66). It was also used for the title-page of Arthur Machen's book. Here Pan has a familiarly androgynous look, and aggressively curled horns that emerge from a mass of long hair. Beardsley often used the device of an extended arm against solid black or white, a gesture that reflects his love of the theatre.

Left: COVER DESIGN FOR *AT THE RELTON ARMS*, 1893-6. The inn sign, which relates to the title of Evelyn Sharp's novel, the thirteenth in the series, was ingeniously designed by Beardsley to contain the imprint of The Bodley Head, publishers of the series. This was the firm run by John Lane, who was a great friend and supporter of Beardsley at this time, but who was later forced to sack him as art editor of *The Yellow Book* because of the homophobia aroused by the Oscar Wilde scandal with which Beardsley was wrongly linked.

THE SPIRIT OF BEARDSLEY

70

Far left: COVER DESIGN FOR *THE GIRL FROM THE FARM*, 1893-6. This design for Gertrude Dix's book, the fourteenth of the Keynotes books, is reminiscent of the work of Charles Rennie Mackintosh, designer, painter and architect of the Glasgow School, which flourished in the late nineteenth and early twentieth century. *The Studio* magazine's publication of Beardsley's illustrations, particularly 'J'ai baisé ta bouche, Iokanaan', made a strong impact on the Glasgow artists, and an interplay of influences is indicated in that both *The Studio* and *The Yellow Book* were later to publish work by the Glasgow School.

Left: COVER DESIGN FOR *THE MIRROR OF MUSIC*, 1893-6. The design was also used for the title-page of the novel by Stanley Makower, the heroine of which is a woman who attempts to pursue an artistic career. It has been read into this drawing that the angel with cello represents the woman-musician, the wings an allusion to her death (which resulted from her bid for freedom) and the cello a symbol of her creativity. More pragmatically, this design may be a re-use of a vignette from *Le Morte Darthur* (p. 60), the recycling prompted by pressure of work. *The Mirror of Music* is the fifteenth book in the series.

Right: COVER DESIGN FOR
YELLOW AND WHITE, 1893-6. Used
also for the title-page of W. Carlton-
Dawe's book, the sixteenth of the
Keynotes, the stylized tree cleverly
suggests outward health but hidden
unhappiness: the canopy of the tree is a
thriving mass of leaves and blooms, but
drooping hearts lie at the tree's roots.
Apparent symmetry is subtly sabotaged
by many differences in detail and, more
overtly, by the unevenly bulbous root of
the tree-trunk. Beardsley had an
extraordinary talent for investing his
decorative plant forms with vigorous,
almost human, energy.

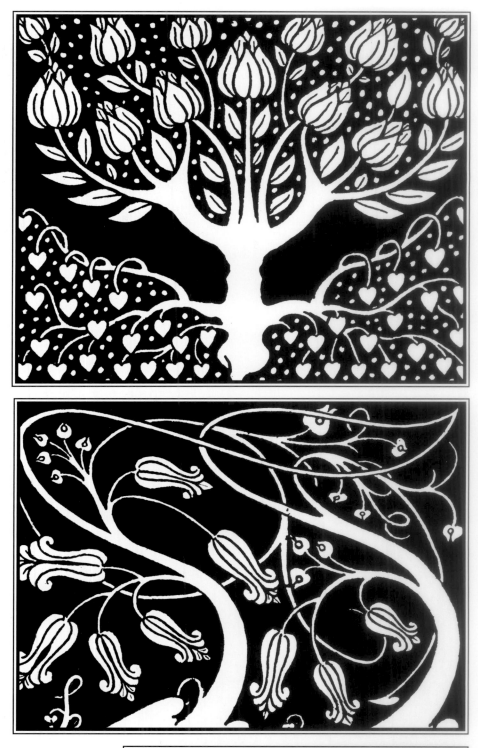

Centre right: COVER DESIGN FOR
THE MOUNTAIN LOVERS, 1893-6.
Fiona Macleod, the author, was the
pen-name of William Sharp. The shifting
sexuality of Beardsley's androgynes is
mirrored in the sex-change pseudonyms
adopted by some of the authors of the
Keynotes series. Into this design
Beardsley incorporated Celtic elements,
including mountain bluebells and the
sinuous outline of a Viking prow. It was
also used for the title-page of this, the
seventeenth title in the series.

Below right: COVER DESIGN OF *THE
BRITISH BARBARIANS*, 1893-6.
Grant Allen was the author of the
twenty-first book in the Keynotes series,
and here, for the cover and title-page,
Beardsley illustrates an apparently
unimportant part of the novel in which
the maid of the Monteiths serves tea in
the garden. The story deals with the
familiar theme of whether a woman
should deny herself personal fulfilment in
order to be a good wife. The downcast
eyes of the maid seem to bear out Grant
Allen's contention that woman is
subservient to man, although, from what
we know of Beardsley's beliefs, he was a
supporter of liberated women.

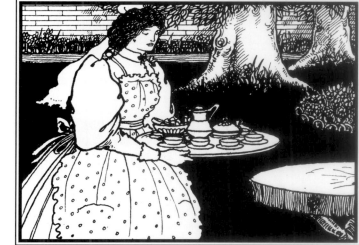

Left: COVER DESIGN FOR *THE WOMAN WHO DIDN'T*, 1893-6. The book, by Victoria Cross, is an answering title to *The Woman Who Did* (p. 67). It is the eighteenth in the Keynotes series. With its mixture of representational and abstract forms, this drawing has the look of a wallpaper design, somewhat in the manner of William Morris. It is easy to see why Morris was angered by the younger man's borrowings from the style he had developed, particularly since Beardsley's drawings often contain risqué references and imagery.

Centre left: COVER DESIGN FOR *NOBODY'S FAULT*, 1893-6. The design was used on both the cover and title-page of Netta Syrett's novel. For the Keynotes novels, which deal primarily with women's rights to sexual and other equalities, Beardsley often employed the symbolism of flowers. In this drawing the well-behaved, modest demeanour of the half-open young buds of womanhood, their heads submissively bowed, is contrasted with the shocking boldness of the upright, unashamed glory of the fully open bloom in the top-right corner. This was the nineteenth title in the series.

Below left: COVER DESIGN FOR *THE THREE IMPOSTERS*, 1893-6. The design for another novel by Arthur Machen, the twentieth in the series, appears to be entirely symmetrical, but on closer examination there are many tiny variations that test the viewer to identify where all is not as it seems (as is the situation in the novel). It is almost as if Beardsley is challenging the viewer to 'spot the difference'. There is a strong eighteenth-century feel to this design, or 'decoration', as Beardsley often called his drawings.

Right: COVER DESIGN FOR
PLATONIC AFFECTIONS, 1893-6.
The shape of the cover and title-page
design for the novel by John Smith may
have been suggested by 'the inkblot
technique'. Beardsley would make a
symmetrical inkblot by folding the
blotted paper in half and then allowing
the resulting shape to suggest images to
him. The blot-like black background of
this work does not fill the rectangle of
the border but instead stands out
against a further white background,
and, for once, the pattern formed is
almost precisely symmetrical. The main
shape of the whole may be read as two
bearded men, back to back. The novel
is the twenty-second of the Keynotes
books.

KEY DESIGNS FOR THE
KEYNOTES SERIES OF BOOK,
1893-6. Each of these ornamental keys
incorporates the initials of a writer in
the Keynotes series and was printed on
the contents page of the relevant book,
and again on its back cover. The
Keynotes novels were considered
'daring' and were extremely popular as
a result. Reading from left to right, top
to bottom, the keys represent the
following authors: Netta Syrett, Fiona
Macleod, Henry Harland, Fyodor
Dostoevsky, Evelyn Sharp, Victoria
Cross, George Egerton, Gertrude Dix,
Grant Allen, Arthur Machen, H. D.
Lowry, Ella D'Arcy, Florence Farr, W. C.
Dawe, Stanley V. Makower.

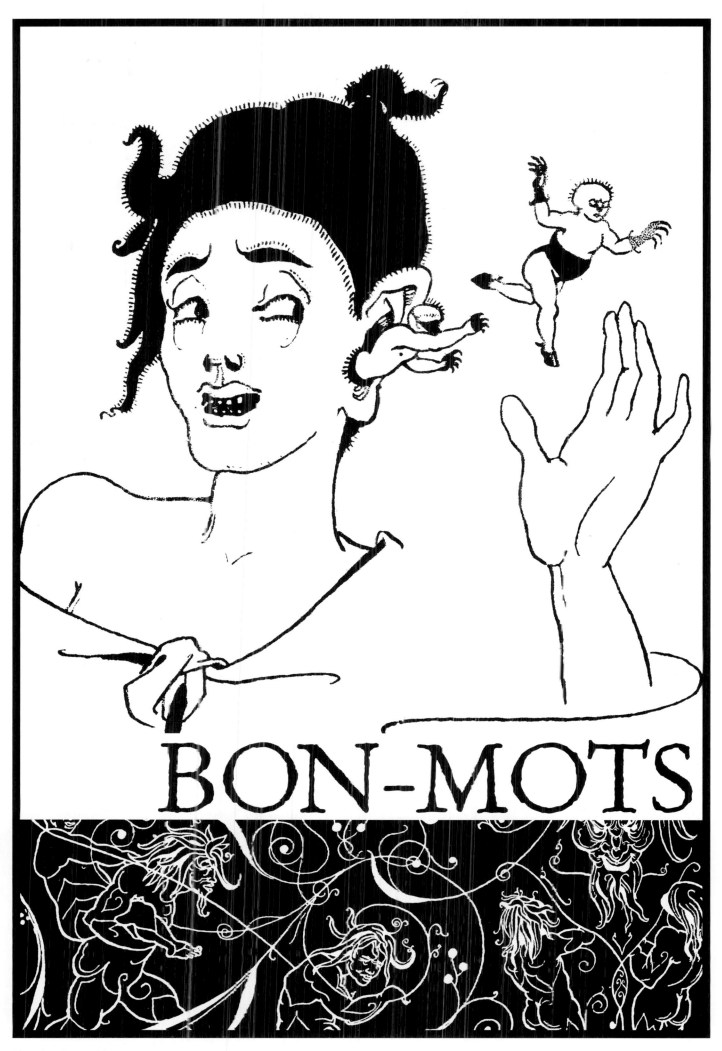

BON-MOTS

THE SPIRIT OF BEARDSLEY

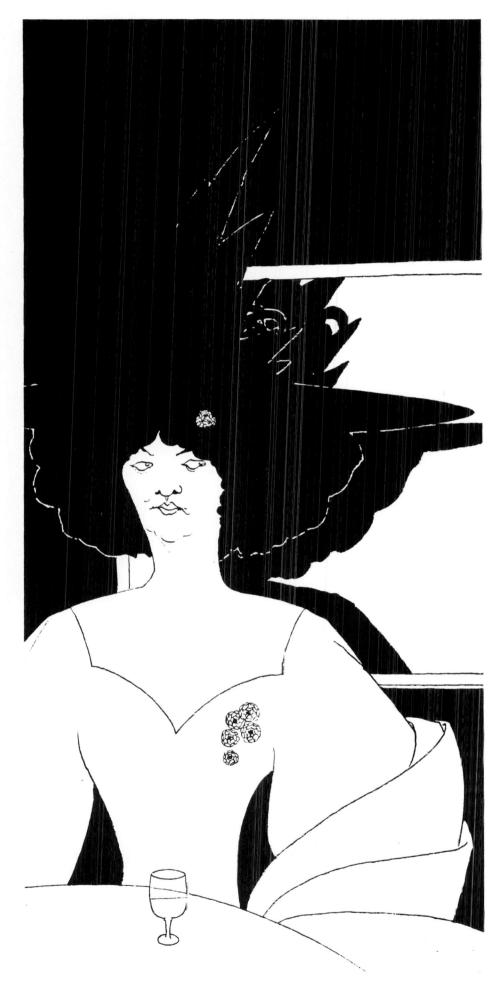

Far left: *BON-MOTS,* 1893-4. Dent and Co. published three volumes of *Bon-Mots* in which the sayings of witty writers were illustrated by the drawings of four contemporary artists. In his contributions Beardsley tended to satisfy his passion for the grotesque. In this delicate design for the title-page of the first volume, human and animal forms are interwoven with foliage to create a playful yet sinister effect. Italian Renaissance discoveries of fantastical designs on Roman ruins may have had an indirect influence upon Beardsley.

Left: *BON-MOTS,* 1893-4. This illustration, entitled 'Waiting', is from the *Bon-Mots of Samuel Foote and Theodore Hook*. There is uncertainty about its exact date, but no argument about its debt to French painters; indeed it may have been inspired by Henri de Toulouse-Lautrec's poster for Le Divan Japonais, 1892, and Henri Degas's painting *Absinthe*, which had been exhibited at the Grafton Galleries in London in February 1893, giving rise to public outrage of a degree that would have delighted Beardsley.

Right: *BON-MOTS*, 1893-4. This
extraordinary image was thought worth
using twice, in two different *Bon-Mots*
volumes: the sayings of Sidney Smith
and R. Brinsley Sheridan, and those of
Charles Lamb and Douglas Jerrold. The
sickly looking youth with the strange
hairstyle seems both unable to prevent
and anxious to catch the little grotesques
escaping from his ear. The high fevers
that accompany tuberculosis often cause
shocking hallucinations, which Beardsley
would probably have welcomed
creatively, but which the puritanical side
of his nature might have feared.

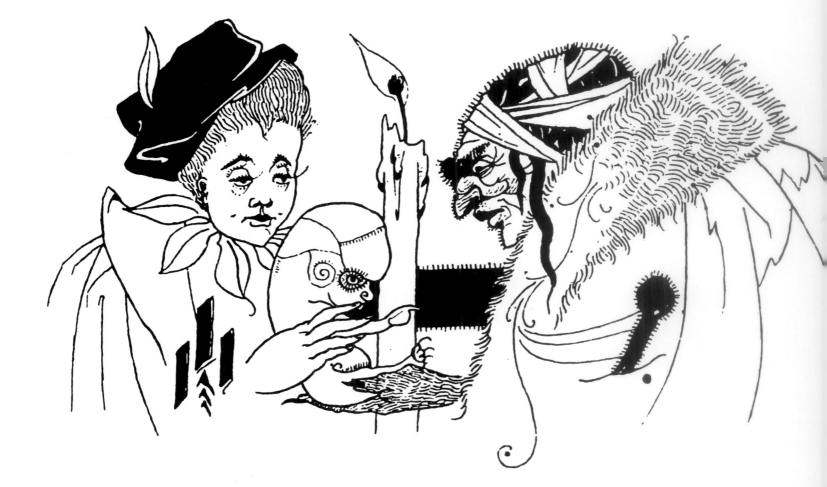

THE SPIRIT OF BEARDSLEY

Far left below: *BON-MOTS,* 1893-4.
This vignette from the *Bon-Mots* of
Smith and Sheridan has caused much
speculation about Beardsley's private life.
Around 1892 foetal images started to
appear in his work. It has been suggested
that his sister Mabel had a baby aborted
that was fathered by Beardsley himself
— although this is mere speculation.
Whatever the cause, this little drawing is
ambiguous in its moral message, because
all three characters have a horrific
aspect: the abortionist, obviously, but
also the degenerate-looking mother and
the embryo itself, with its partitioned
head, accusing finger and clawed hoof.

Above left: *BON-MOTS,* 1893-4. A
naked baby shelters beneath a large
umbrella, while trees bend in the
distance and Beardsley's familiar flight of
retreating or advancing birds fly in
formation through the sky. This vignette
from the *Bon-Mots* of Smith and
Sheridan was re-used in a smaller form
in the *Bon-Mots* of Charles Lamb and
Douglas Jerrold. The image is
ambiguous, both humorous and
menacing, as the abandoned putto is
exposed to the elements with only the
temporary shelter of an umbrella.
Possibly Beardsley was alluding to
human vulnerability under the veneer of
civilization — in contemporary French
painting umbrellas or parasols often
appear in depictions of Parisian life.

Left: *BON-MOTS,* 1893-4. Around the
time this drawing appeared in the *Bon-
Mots* of Smith and Sheridan, Beardsley
drew two very similar figures, who seem
to loom from nowhere, in 'Les
Revenants de Musique' (p. 44) for the
first issue of *The Studio* magazine. He
was also using these ghost-like forms for
many of the images in the *Salome*
commission. It is quite startling to realize
the volume of work this delicate boy
was managing to achieve, as if aware
that he would die early.

THE SPIRIT OF BEARDSLEY

Right: *BON-MOTS,* 1893-4. This autocratic-looking grotesque is from the *Bon-Mots* of Foote and Hook. It may be a particularly unflattering caricature of someone known or observed by Beardsley, but there is no record of who it was. She stands in profile, less monstrous than some other grotesques, but on close perusal several details amuse and disturb: her ear is a mere flap with no folds, three chins cascade from below her lower lip and she wears a ringless heart on her wedding finger.

Below: *BON-MOTS,* 1893-4. The execution of these two clown-like figures, from the Smith and Sheridan *Bon-Mots,* owes much to the Manga series of humorous prints by the Japanese artist Hokusai, though Beardsley, as with all influences, has used only what serves his purposes. The situation here is extremely mysterious. The left-hand figure takes pleasure in frightening his tame bird by confronting it with the stick-puppet held by the jester.

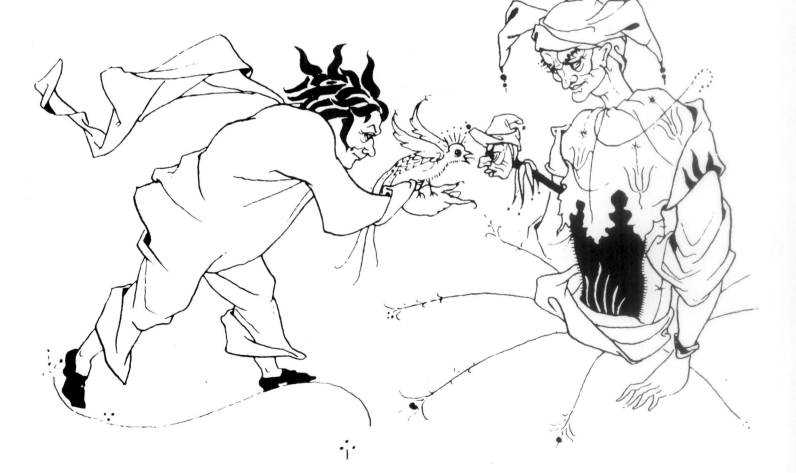

THE SPIRIT OF BEARDSLEY

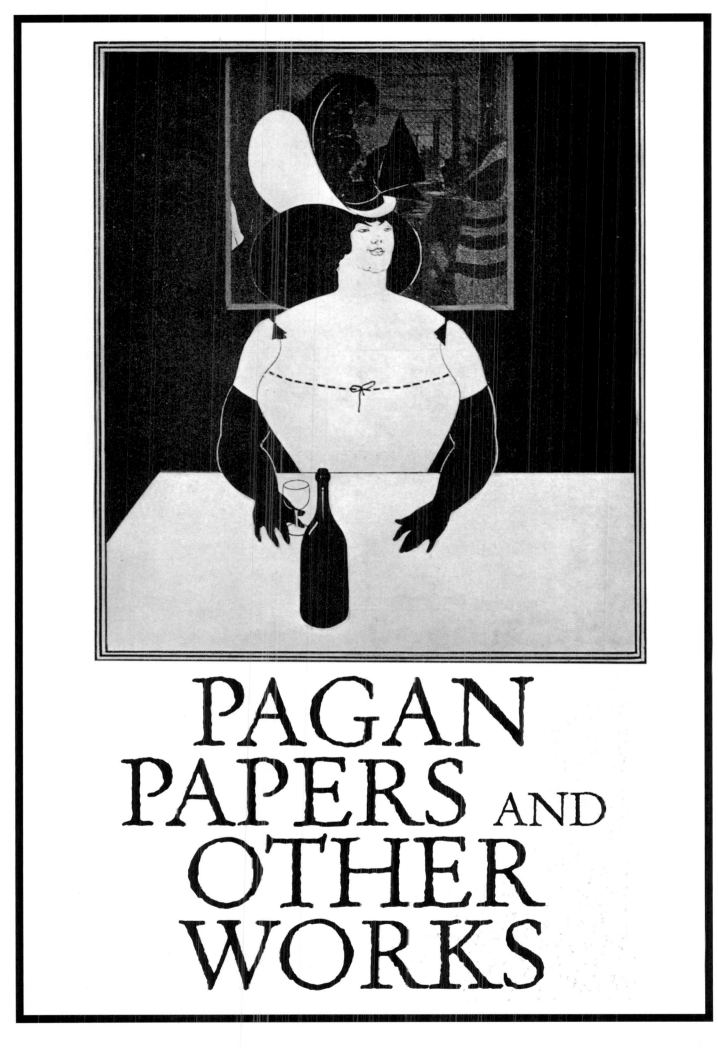

PAGAN PAPERS AND OTHER WORKS

82

Far left: *PAGAN PAPERS*, 1893. *Pagan Papers*, being a collection of essays by Kenneth Grahame (of *The Wind in the Willows* fame), Elkin Mathews and John Lane, featured a number of Beardsley's drawings. There was a *fin-de-siècle* vogue for the 'Pagan', particularly the god Pan, who seemed to represent a collective longing for childhood innocence crossed with the sexual freedom of the pagan gods. Here the creature on the left is only part human, with collar and tie but also horns that are just becoming apparent. He looks at Pan, whose hand is in a suggestive position just out of the frame.

Left: FRONTISPIECE TO *PASTOR SANG*, 1893. This illustration of Björnson's drama *Over Aevne* is a conscious homage to Dürer, as is emphasized by the monogram at the centre of the bottom of the frame. A monster with all of the typical Beardsley characteristics — 'Medusa' locks, lolling tongue, animal skin, and horned hands and feet — pushes at a rock to send it crashing on to the peaceful Norwegian village below, while baby birds shriek their alarm from the toppling nest.

Left: FRONTISPIECE TO *THE WONDERFUL HISTORY OF VIRGILIUS THE SORCERER OF ROME*, 1894. Strongly Japanese in design, the sorcerer emerges from the patterned flatness of his robes, his left arm and leg raised as if casting a spell. Using a stippled technique, the artist has drawn the crossed arcs familiar in his work, and a peacock feather in the lower and upper left of the border, developing the arcs to form a centipede-like insect marching towards the viewer to the lower right.

Right: PORTRAIT OF MADAME RÉJANE, 1893. Beardsley drew several portraits of Madame Réjane, the famous French actress. Most of them were flattering, and it is likely that he idolized her. When Réjane saw this drawing, however, she is reported to have screamed with outrage at its sneering expression. The artist has made clever use of black and white areas to suggest the actress entering from the wings on to a stage-set, the fan pointing the way. Beardsley gave this drawing to the writer Henry James.

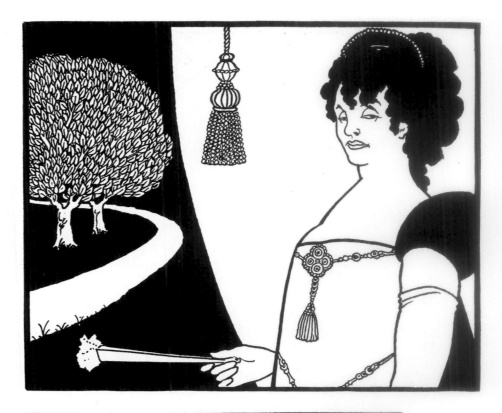

Right: FRONTISPIECE TO *BARON VERDIGRIS, A ROMANCE OF THE REVERSED DIRECTION*, 1894. The strangely titled story by Jocelyn Quilp was dedicated to 'Fin-de-Siècle-ism, the Sensational Novel, and the Conventional Drawing-Room Ballad'. To suit the mood of pseudo-medievalism, Beardsley's 'Baron' is anachronistically clothed. Against a black hill topped by a fairy-tale castle, he stands resting his sword. His coat of mail is covered by a clown suit and a feathered topper is perched on androgynous locks. Beardsley also includes a Japonesque detail — the feet extending out of the lower frame.

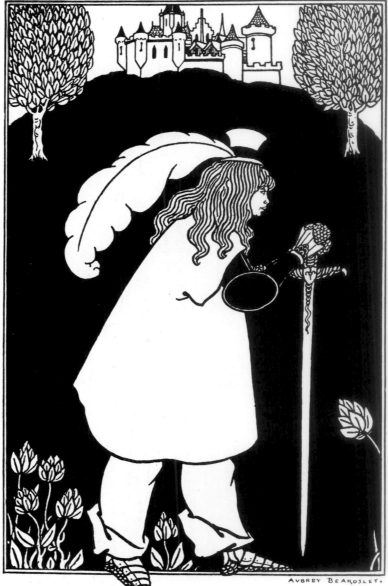

THE SPIRIT OF BEARDSLEY

POSTER FOR THE AVENUE THEATRE, 1894. Some members of the public were appalled by this lithograph, which was clearly inspired by the work of Henri de Toulouse-Lautrec. Printed in blue and green, it was produced as the poster for a production of *A Comedy of Sighs* by John Todhunter, and the one-act play that preceded it, *The Land of Heart's Desire* by W. B. Yeats. One critic broke out in doggerel, 'This sort of stuff I cannot puff./ As Boston says, it makes me "tired"/ Your Japanese-Rossetti girl/ Is not a thing to be desired.'

Below: PLAYGOERS' CLUB MENU, 1895. Designed for the tenth annual dinner of the club, these sketches are very much in the *Bon-Mots* style, and similarly influenced by Japanese art. In the little bald masked figure can be seen the grotesque who was to be attendant on so many of Beardsley's women. The design on the left decorated a list of members; that on the right featured photographs of the President, Vice-President, Treasurer and Secretary of The Playgoers' Club.

Above: DESIGN FOR A POSTER ADVERTISING *CHILDREN'S BOOKS*, 1894. Some parents found this distastefully ironic, considering the seated woman to be hardly a typical figure of maternity, with her low-cut evening gown, fulsome bust, feathered head and sensuous lips. Interestingly, Aymer Vallance's catalogue of Beardsley's work refers to the winged armchair as a 'groaning-chair', the type of chair women sat in to receive congratulations after having given birth to a child.

Above right: DESIGN FOR THE PSEUDONYM AND AUTONYM LIBRARIES POSTER 1894. Adapted from an earlier Beardsley drawing, 'Girl and a Bookshop', this poster frames its subject unusually, marginalizing the figure to the left of the space. Beardsley wrote wittily in defence of poster art, 'the public find it hard to take seriously a poor printed thing left to the mercy of sunshine, soot, and shower, like any old fresco over an Italian church door.'

Right: POSTER FOR SINGER SEWING MACHINES, *c.* 1895. This work was developed from a drawing in the first issue of *The Yellow Book*. Beardsley's pun on the word 'Singer' led the poster to be much ridiculed, as people with over-literal minds found it ludicrous that a woman should play the piano sitting on a drawing-room chair in a field. A lithograph, it lacks Beardsley's usual clarity of line, the unfamiliar technique making the work appear uncharacteristic of the artist.

Right: ILLUSTRATION FROM *TODAY*, 1894. The bald, bulbous head, black mask and clown outfit of the strange creature on the left are features that appear many times in Beardsley's work. Almost invariably such creatures make lewd gestures, as does this one. The appearance of the character he is trying to lure, and the suggestion of Venice in the background, are redolent of the Commedia dell'Arte and Carnival. This design was used by the *Today* magazine as a headpiece to an article on 'Stageland'.

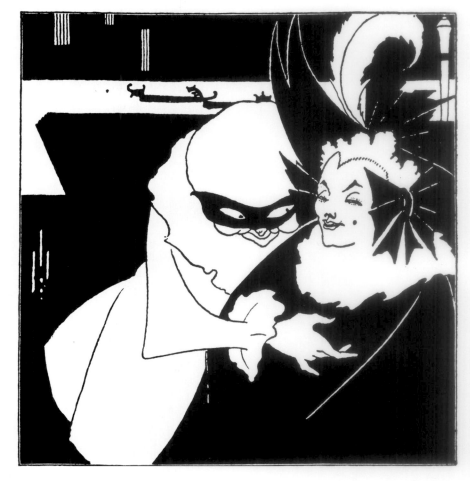

Right: LUCIAN'S STRANGE CREATURES, 1894. Intended as an illustration for a privately published book, *Lucian's True History*, translated by Francis Hickes, this drawing did not appear until 1906, when it was published by Leonard Smithers. One of the reasons for this may have been the wicked little caricature of Oscar Wilde which Beardsley placed in profile on the right. Around the central woman assorted grotesques, including the masked, bald clown of the above design, lear and fondle, and a Whistler-esque butterfly takes wing.

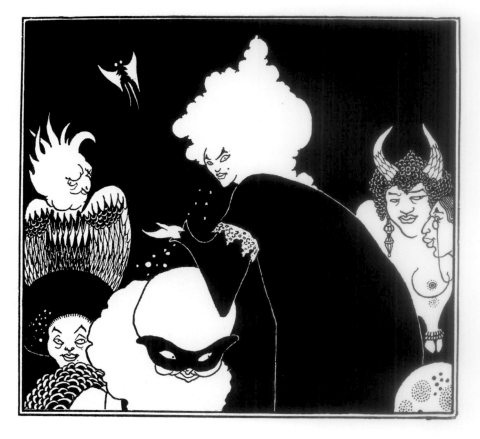

Below: DREAMS, FOR *LUCIAN'S TRUE HISTORY*, 1894. Here is Beardsley at fever pitch, in a drawing that looks confused and rather messy but may be the artist's attempt to convey the chaotic nature of dreams. A scaly-armed woman holds out a glaring, clawed embryo, while in nightmare profusion devilish grotesques, one sprouting breasts and others with gothic wings, look towards Lucian expectantly. The defeated dragon under the stunted angel's foot seems horribly ready to revive.

Below: POSTER FOR *THE SPINSTER'S SCRIP*, c. 1895. Two women, one a typical 'Beardsley' woman in exaggerated high fashion, the other hatless and with her bodice missing, exchange a knowing, complicit look, suggestive of Sapphic pleasures. There has been argument as to whether this poster for the book by Cecil Raynor was ever used. Another version of the drawing shows the dog held on a lead by the woman on the right. The eye-catching design of the figures is clearly influenced by the style of French poster art.

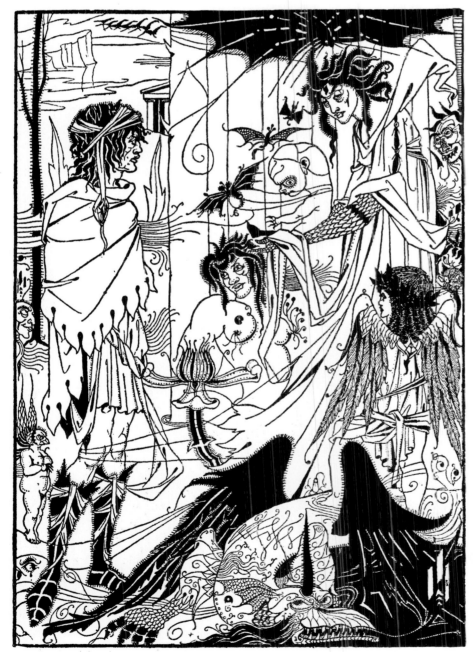

Overpage: *THE CAMBRIDGE ABC*, 1894. Three of Beardsley's Cambridge friends persuaded him to design the front wrapper of their undergraduate magazine, called *ABC* after their surnames: Austen-Leigh, Baring and Cornish. Typically enigmatic, the little masked boy seems to hush the woman who gestures towards him. The flame-like shapes on his owl mask have burst into lively flames in her dress, and the black central mass has invaded her body. The students paid ten guineas for this work, but were irritated when no-one believed it was a real Beardsley.

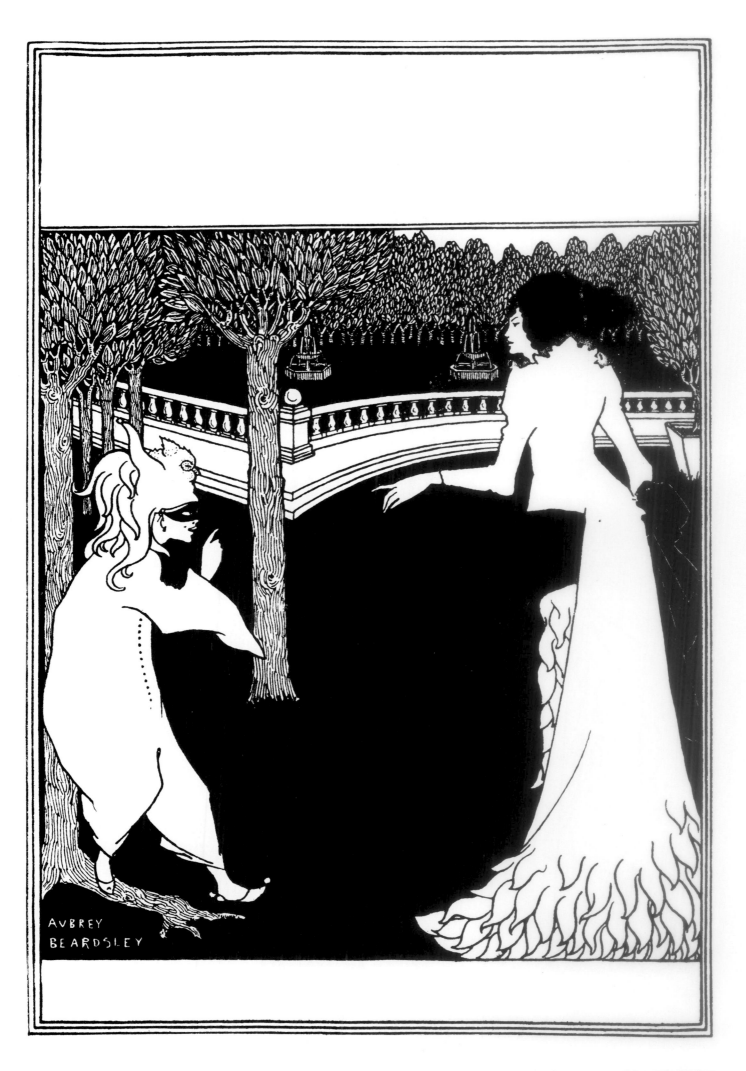

AUBREY
BEARDSLEY

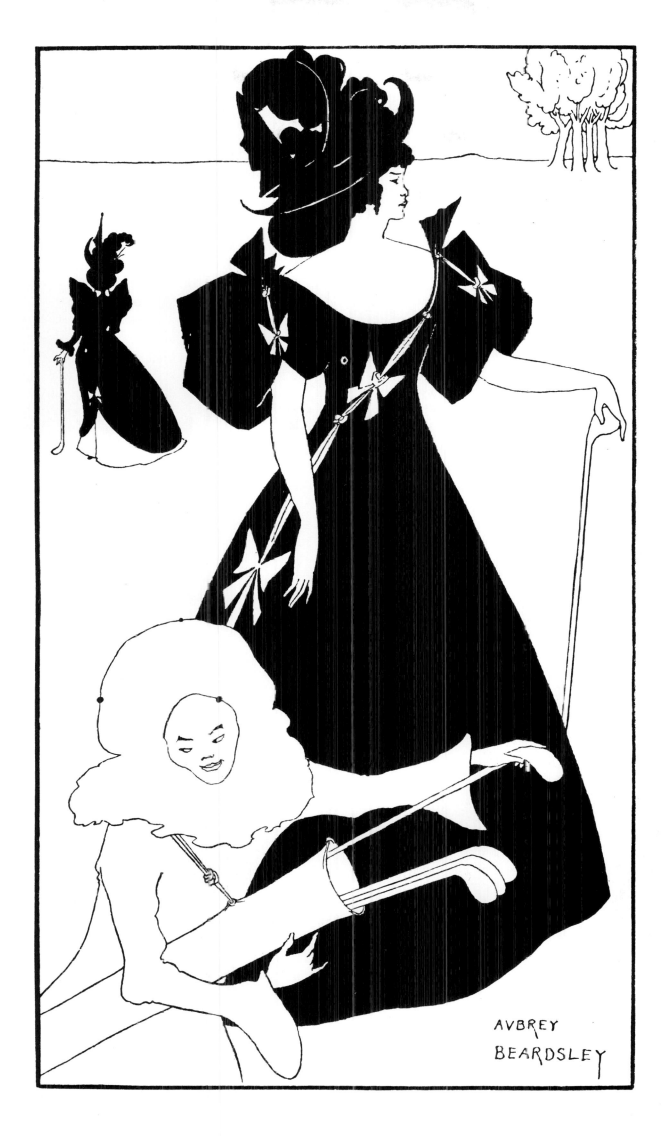

Previous page: DESIGN FOR A GOLF CARD, 1894. It is difficult to discover why Beardsley designed this card for the opening of the Prince's Ladies' Golf Club at Mitcham, Surrey. It could have been a straightforward commission from the club, but there is a possibility that Mabel, Beardsley's beloved sister, was a member and asked him to draw it for her. Contemporary photographs of her suggest that she may have been in the artist's mind for the central figure, while the little thin-faced Pierrot could be a self-portrait of Beardsley.

Right: THE FAT WOMAN, 1894. Beardsley intended this Indian ink and wash drawing to be a wicked caricature of Whistler's wife Trixie — a symptom of his continuing anger with the older artist for ignoring a dinner invitation. Beardsley first entitled the work 'A Study in Major Lines', satirizing Whistler's titles and in reference to Mrs Beardsley's size and domineering personality. Brilliantly executed, it carries with it, like 'Waiting' (p. 77), the additional malign suggestion that this fat woman is a prostitute awaiting a customer.

Right: DESIGN FOR THE TITLE-PAGE OF *PLAYS* BY JOHN DAVIDSON, 1894. The masked figure was drawn in black and white for the title-page and reproduced in gold on the cover of Davidson's plays. The character combines qualities both of Harlequin and of Pierrot from the Commedia dell'Arte, having the confidence and insouciance of the former, and the sadness of the latter (in the uncharacteristic black of the Pierrot costume). This fusion is appropriate and ingenious for a book of plays, as it suggests, like the traditional masks, both comedy and tragedy.

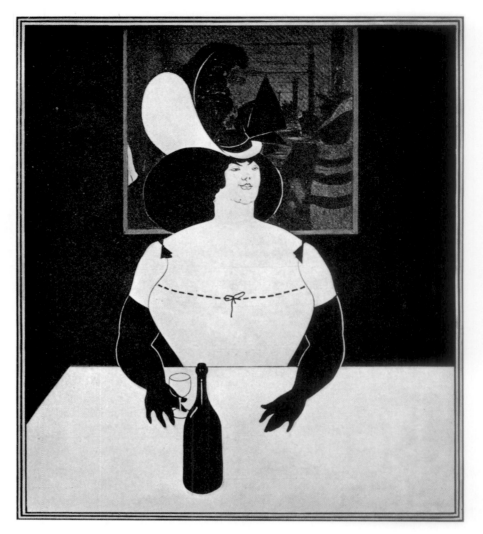

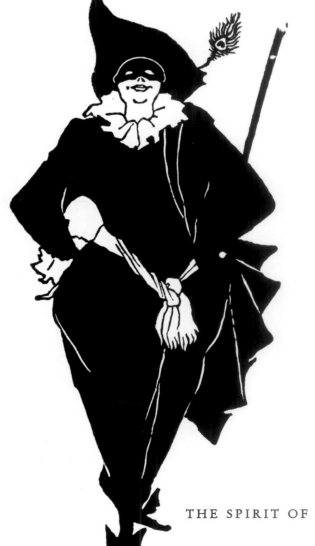

THE SPIRIT OF BEARDSLEY

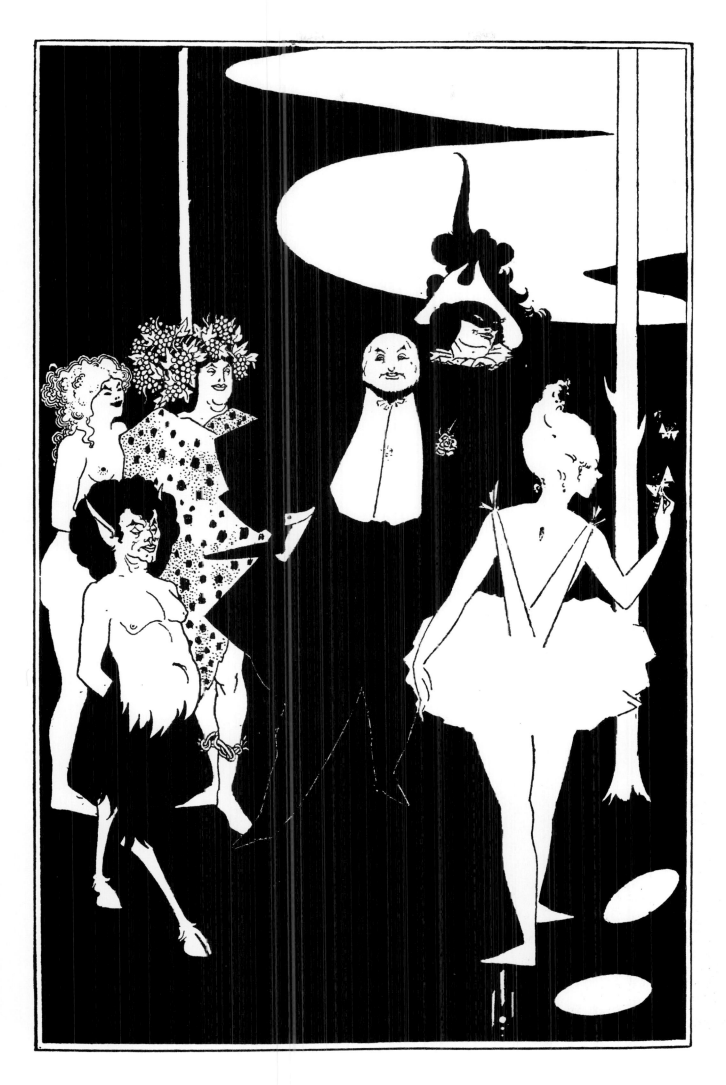

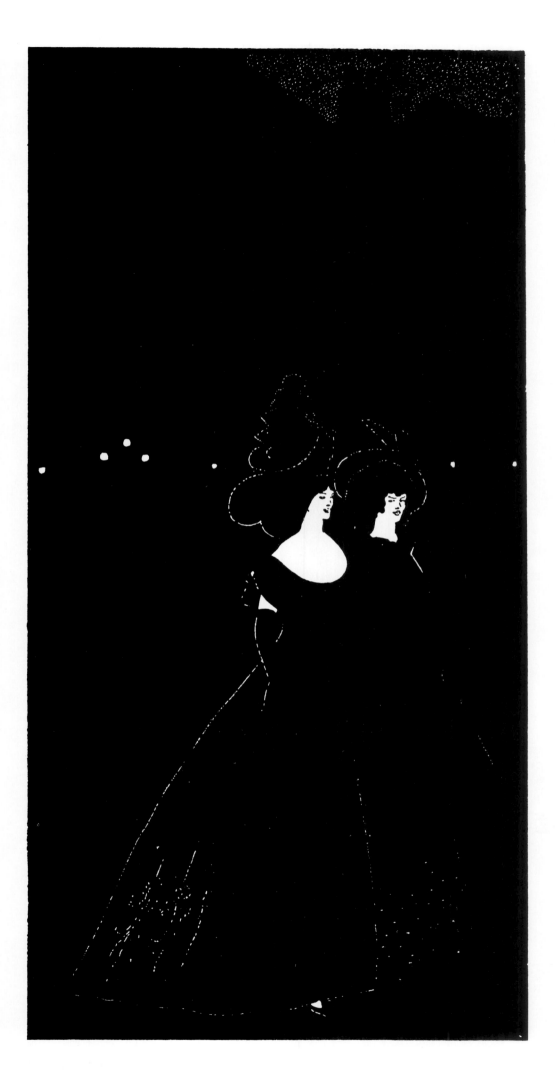

Previous page: FRONTISPIECE OF DAVIDSON'S *PLAYS*, 1894. Here Beardsley seizes the opportunity to indulge his sense of humour in wholesale caricature. From left to right appear: his sister Mabel, unambiguously female; Henry Harland and/or Whistler as faun/satyr; Oscar Wilde as Bacchus with shackled legs; Augustus Harris, theatre impresario, tailcoat flying; Richard Le Gallienne, poet and critic, as vain Scaramouch; and Adeline Genée, famous dancer, toying with a butterfly – another sly allusion to Whistler. The abstract white shapes (swirl and disks) suggest pools of stage lighting.

Left: LES PASSADES, 1894. Requiring a half-tone plate rather than a line-block because of the treatment of the sky, this masterly print was published in the magazine *Today*. The word '*passade*' means a passing fancy or an amorous whim, which Beardsley interprets punningly as fanciable girls passing — 'women of pleasure', whose tempting white flesh gleams out of the nocturnal blackness. This work has much in common, both in technique and in its punning title, with 'A Night Piece' (p. 113).

THE SPIRIT OF BEARDSLEY

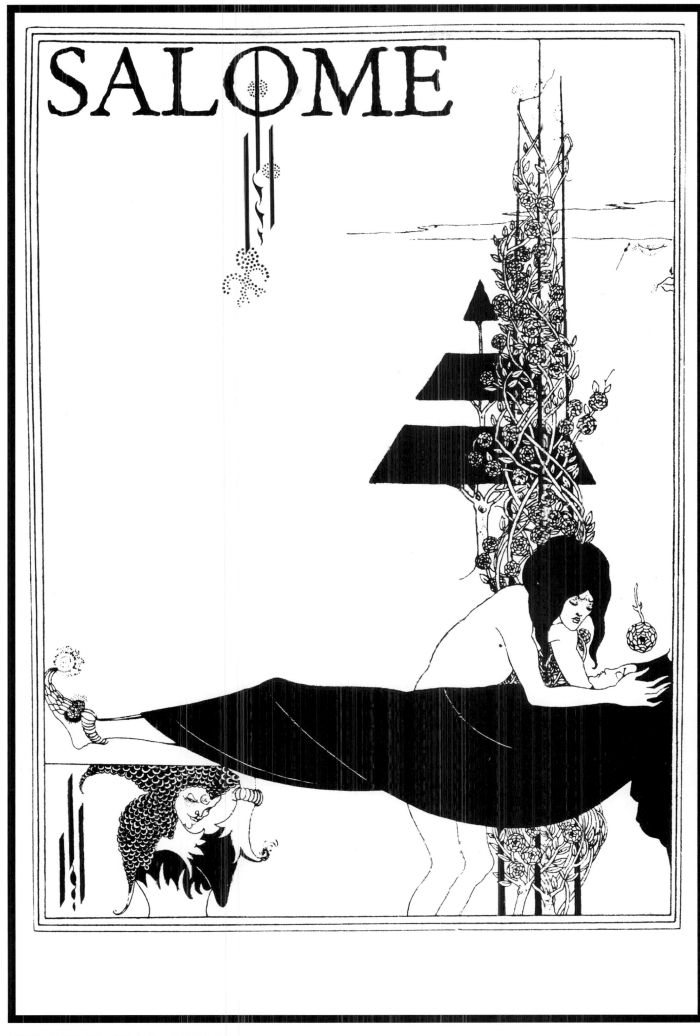

Right: TITLE-PAGE OF
SALOME, 1893-4. Beardsley's
illustrations to Wilde's play
Salome, translated from the
French by Wilde's lover Lord
Alfred Douglas, caused a
sensation and made the young
artist famous. Defying
contemporary conventions, the
bizarre eroticism of the drawings
either attracted or repelled. In the
earlier, unexpurgated version of
this drawing, the female-breasted
herm between the dripping
candles possessed male genitalia,
and the kneeling satanic angel
was in a semi-aroused condition.
The nipples and navel of the herm
in both versions are human eyes.

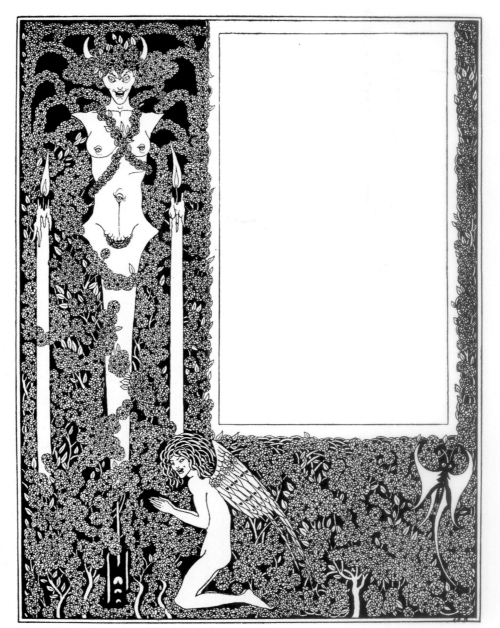

Right: FRONT COVER OF
SALOME, 1893-4. Beardsley was
very skilful at endowing abstract
decorations with emotional life,
an ability probably developed as a
result of the numerous decorative
illustrations required for *Le
Morte Darthur*. This design seems
at first totally unrelated to the
theme of *Salome*, until we become
aware that the asymmetry is
disturbing, the tangled 'roots'
make the whole design appear
unstable, and the central motif,
shaped like a Byzantine
headdress, is surrounded by petals
suggestive of the dripping blood
that is the climax of the story.

THE SPIRIT OF BEARDSLEY

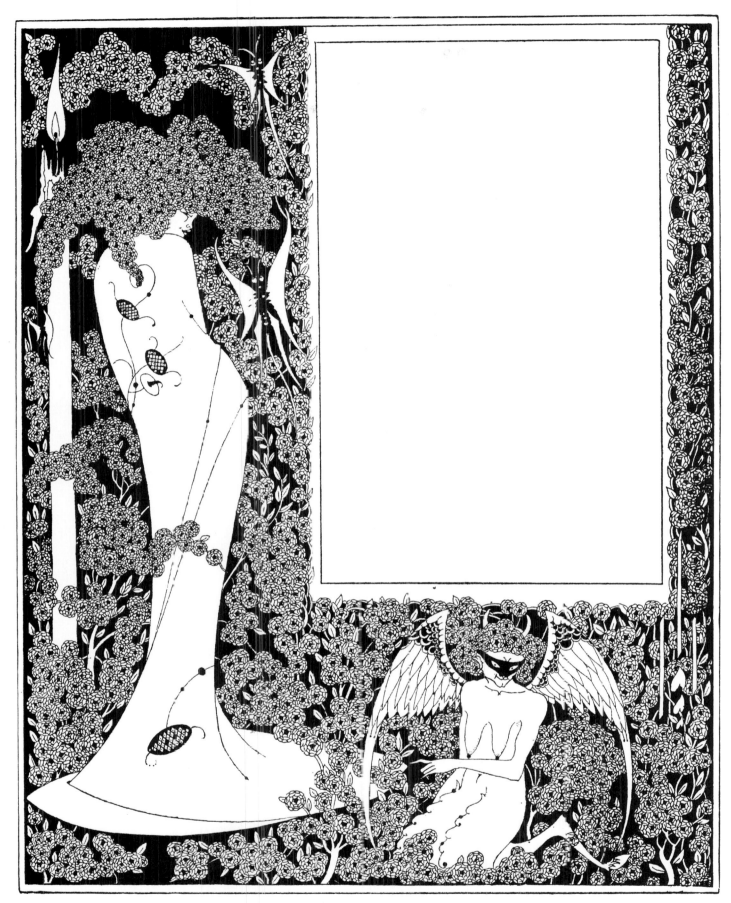

Above: BORDER FOR THE LIST OF PICTURES IN *SALOME*, 1893-4. Set amid Beardsley's version of Edward Burne-Jones's briar-rose tangle, Salome stands, viewed from the back like a Japanese print, her hair formed by the roses and her body sinuously tilted. She looks towards bizarre flying insects, a mixture of bats and Whistler butterflies, while a phallic candle flames behind her. To complete the enigma of this drawing a masked and winged hybrid of angel, devil and satyr, with hanging breasts, seems to mock both Salome and those who might be enticed by her.

THE SPIRIT OF BEARDSLEY

Right: THE WOMAN IN THE MOON, *SALOME*, 1893-4. There are innumerable conjectures, invariably sexual, surrounding this drawing, which caricatures Oscar Wilde as the moon-face looking longingly at a boy and an androgynous youth, who may or may not be Salome. The growing abstraction of Beardsley's graphic style — with elements such as the lines of the right-hand figure's robe becoming the shoulder-drapery of the nude youth — was unique and had great influence upon musicians and writers as well as artists.

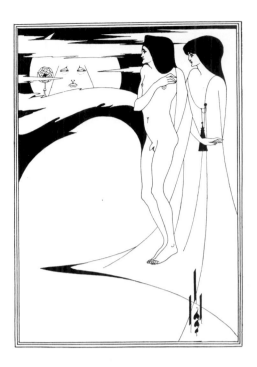

Right: THE PEACOCK SKIRT, *SALOME*, 1893-4. Although strongly influenced by the Japanese print, and by his visit to James McNeill Whistler's Peacock Room, this arresting design is quintessential Beardsley. No previous artist had worked such miracles with line and mass. The weighty black swirl of Salome's cloak, echoed in the headdress of the accompanying figure, the spider-thin arabesques of the peacock feathers and the stippled decoration at the top left, although all abstract features, combine to create a heightened sense of drama between the two protagonists.

Far right: THE PLATONIC LAMENT, *SALOME*, 1893-4. This elegant work represents Herodias's page grieving over the body of the Young Syrian Captain who has killed himself for love of Salome. The word 'platonic' in the title may be ironic as the physicality of the youth's gesture and his grief-stricken expression suggest a passionate attachment.

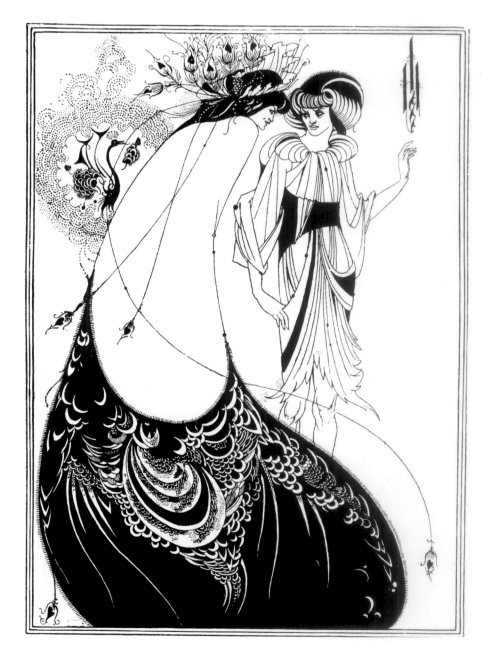

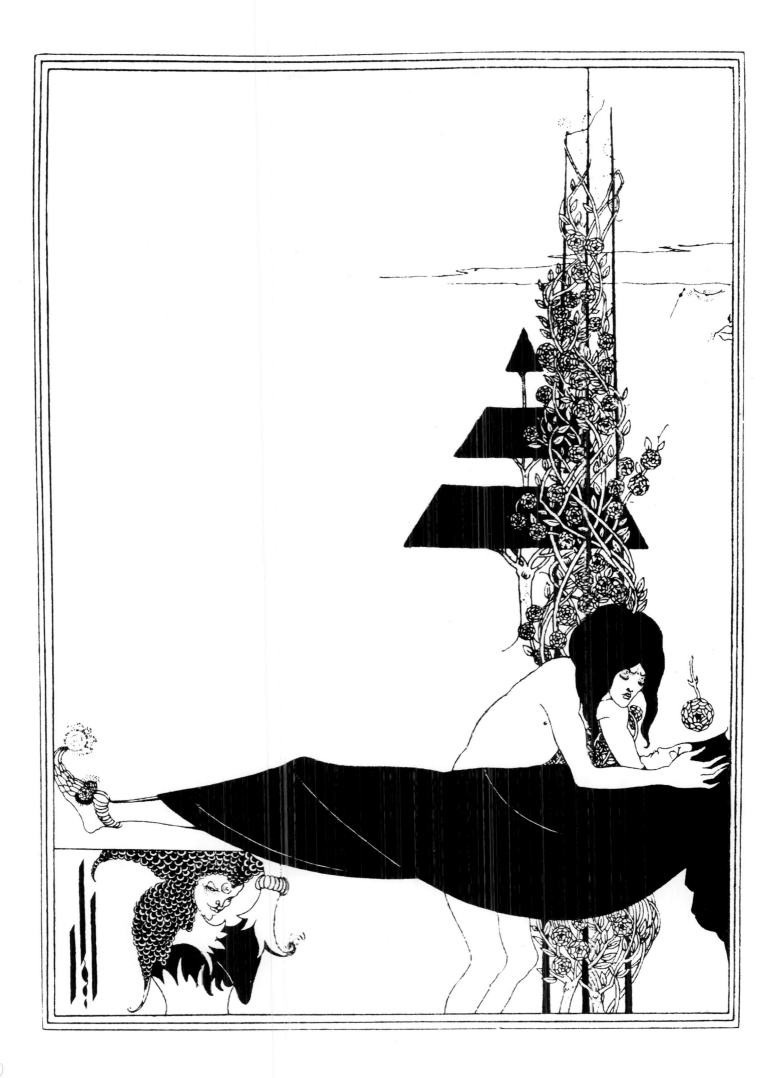

THE SPIRIT OF BEARDSLEY

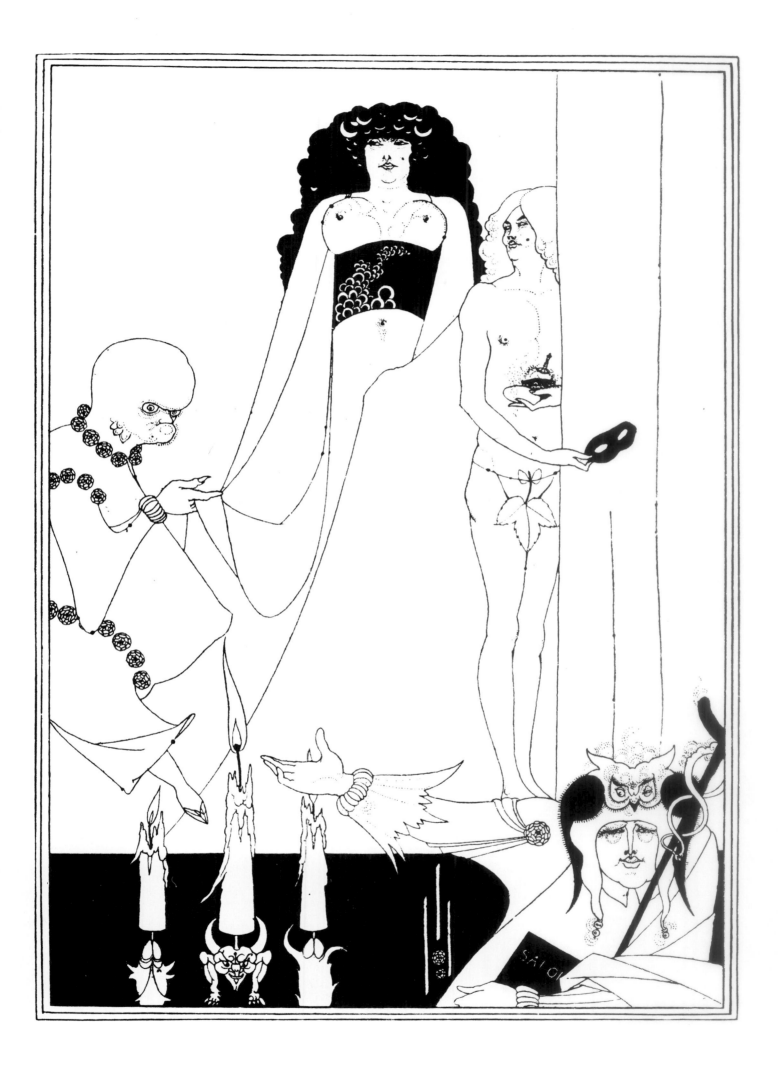

THE SPIRIT OF BEARDSLEY

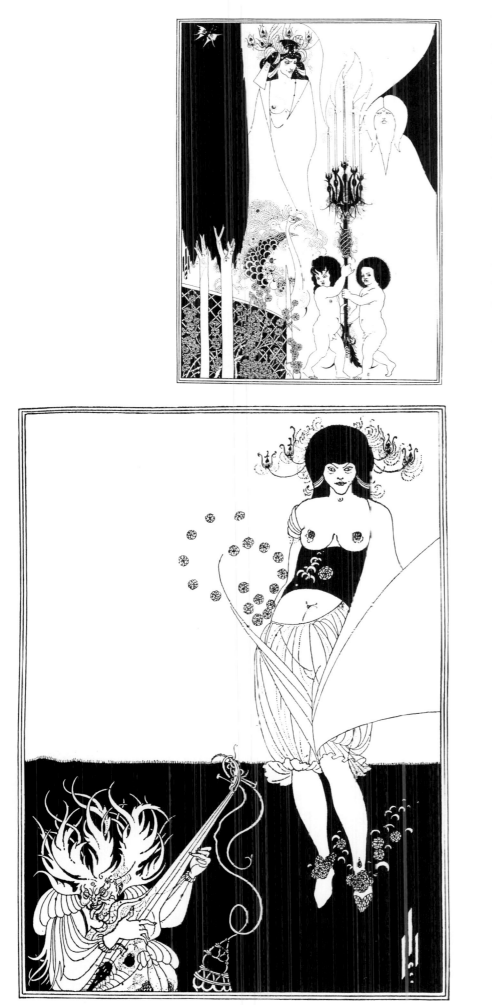

Far left: ENTER HERODIAS, *SALOME*, 1893-4. This is the expurgated version of a drawing on which Beardsley wrote: 'Because one figure was undressed/ This little drawing was suppressed/ It was unkind/ But never mind/ Perhaps it all was for the best.' When first drawn, the page's genitals had been uncovered and in a limp condition, indicating his lack of interest in women, in contrast to the hideous grotesque, whose clown costume is obscenely stretched. Beardsley reacted to censorship by ironically covering what is probably the least erotic element of this drawing with a coyly tied-on fig leaf.

Top Left: THE EYES OF HEROD, *SALOME*, 1893-4. Wilde appears again, here as Herod, looming into the white central area from a dark background. Effects created by the black masses in this picture are almost hallucinatory, the right one being balanced by a similar dark area on the left that on close inspection reveals itself to be the foliage of poplar-like trees.

Left: THE STOMACH DANCE, *SALOME*, 1893-4. Illustrative of the famous moment when Salome performs her lascivious dance, this drawing employs a whole range of erotic iconography. In the dip between the dancer's collar-bone is a small breast, the navel is a miniature mound of Venus (the transparent Turkish trousers revealing the real one), while from between Salome's legs a phallic swirl ejaculates the same roses that trail from her heels. Beardsley got away with the tumescent condition of the lolling-tongued musician-monster because it was mistaken for costume detail.

THE SPIRIT OF BEARDSLEY

Right: THE TOILETTE OF
SALOME, 1893-4. This was
Beardsley's first drawing on the
subject, and the work was banned
despite its already having been
expurgated. Although it may appear
innocuous to the modern viewer, it
was thought at the time that the
seated youth with his hands
between his legs was pleasuring
himself while looking at the genitals
of the little tray-carrying
hermaphrodite. The mummified,
pointing foetus on the dressing-
table, and what were deemed to be
the suggestive positions of the
musician's, and Salome's, hands also
caused offence.

Far right: THE DANCER'S
REWARD, *SALOME*, 1893-4.
Here Beardsley achieves sensational
effect through the interplay of
dramatic and quasi-comic elements.
What looks at first like a table-leg
is, in fact, the skinny extended arm
of the executioner, complete with
long curly hairs. Salome gloats over
the head of John the Baptist, and
the folds of her draperies almost
mimic the dripping gore.

p.104: THE CLIMAX, *SALOME*,
1893-4. A comparison of this
drawing and 'J'ai baisé ta bouche,
Iokanaan' (p. 45) reveals just how
much Beardsley's style had
developed in one year. All inessential
details have gone, and from this
point even the artist's more complex
works display an impressive
economy. Here Salome floats in the
white space, alone with the head,
the curving spike of her drapery
penetrating the column of blood like
a penis. The triumph of the living
Salome over the dead John the
Baptist is symbolized by the upright
and the drooping blooms that rise
from the lake.

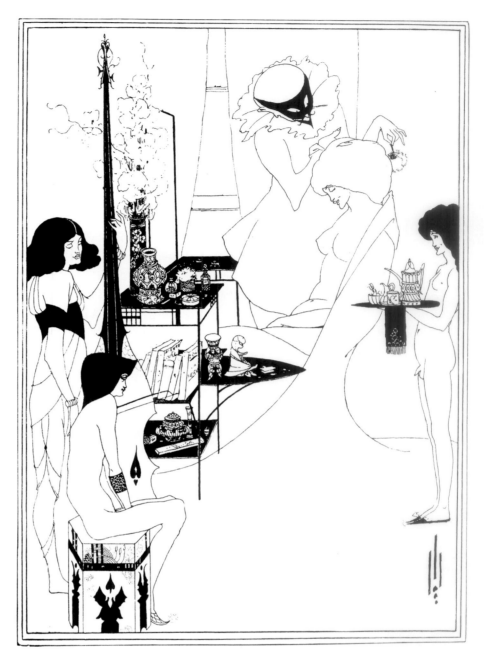

p.105: THE TOILET OF SALOME,
1893-4. This is the second version of
the subject, the first design having been
considered too obscene for publication.
Always mischievous when his drawings
were censored, Beardsley makes no
attempt to define period or location,
but instead places Salome at a modern
dressing-table on which rest
anachronistic books, his own favoured
reading-matter. Salome's body and
dress are achieved by a few masterly
lines.

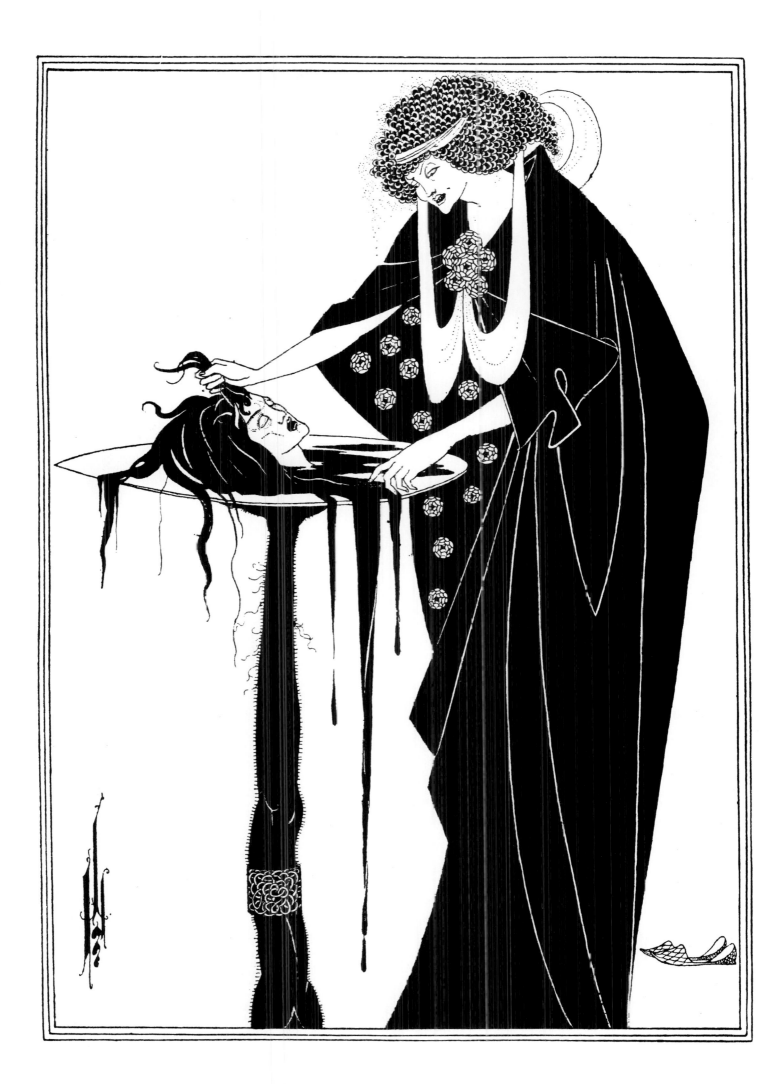

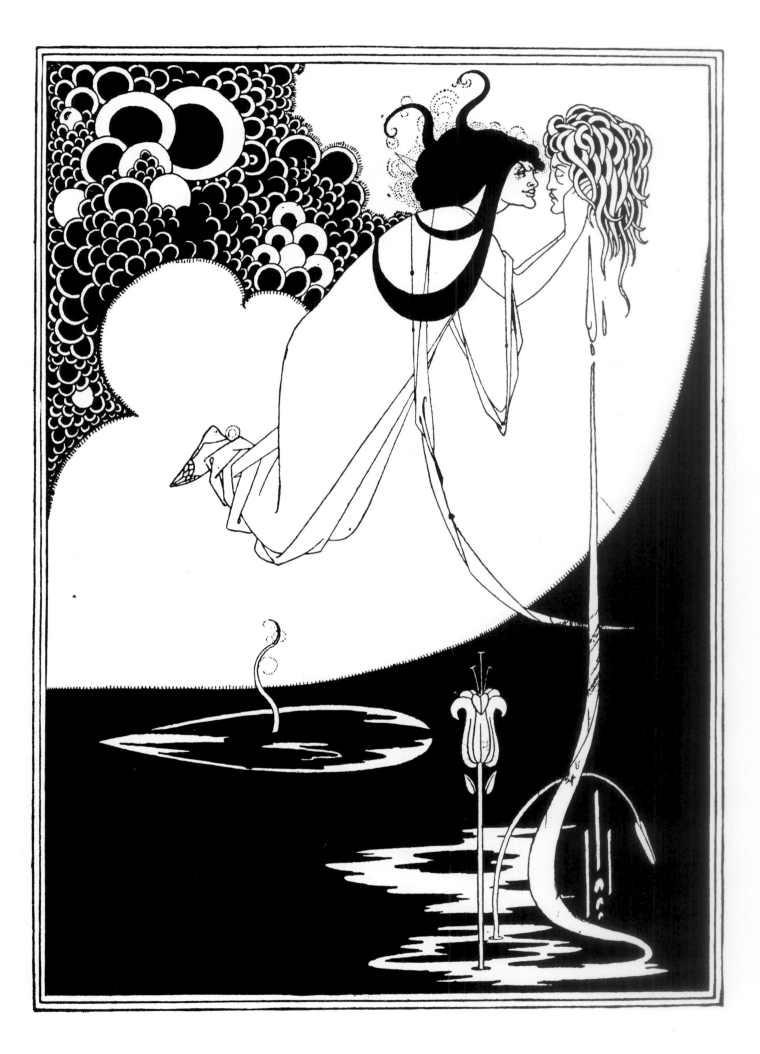

THE SPIRIT OF BEARDSLEY

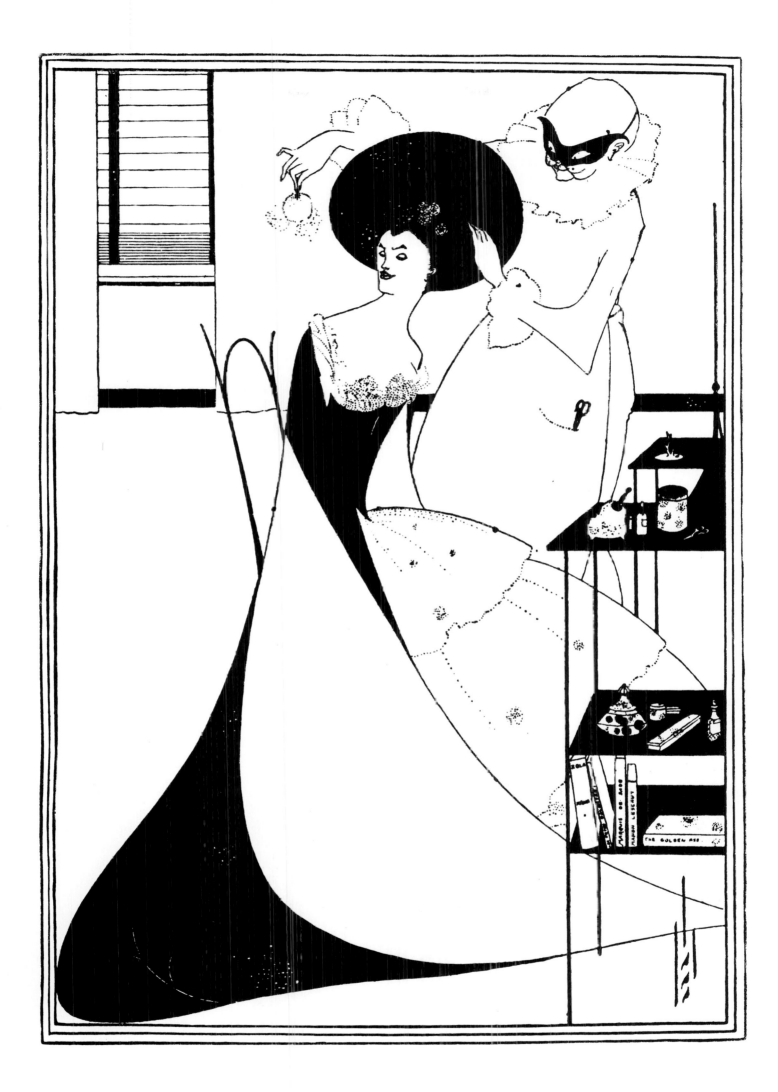

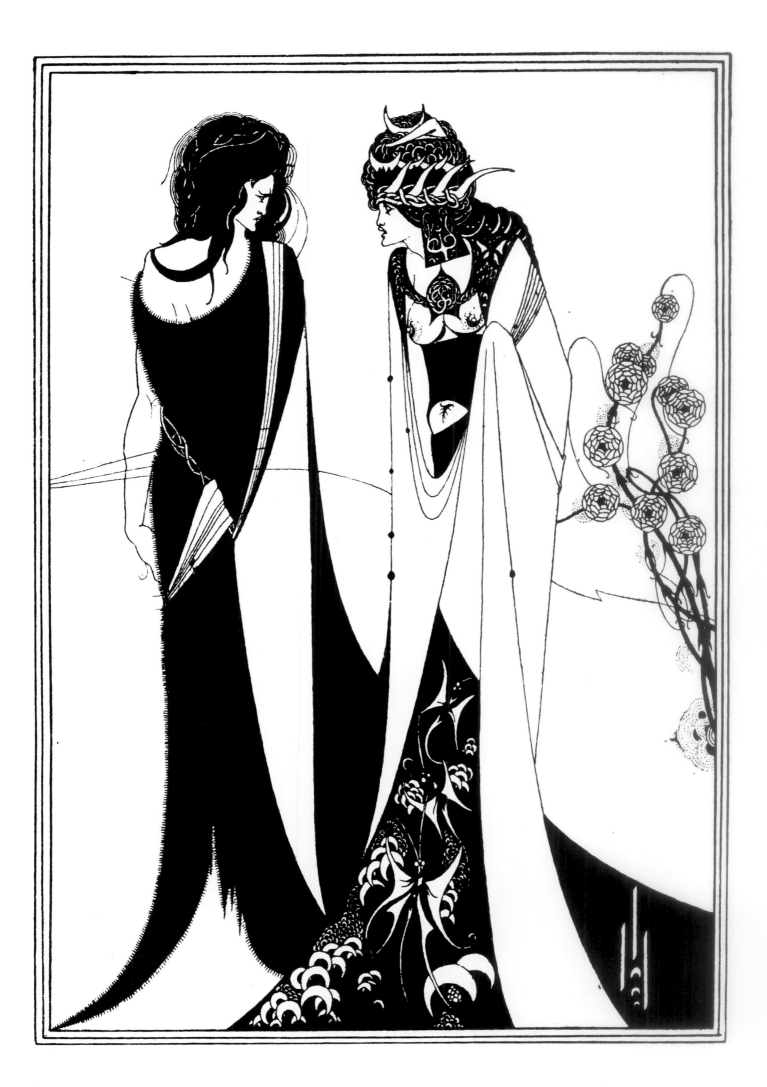

THE SPIRIT OF BEARDSLEY

Left: JOHN AND SALOME, 1893-4. This powerful drawing was also excluded from the 1894 edition of *Salome*, possibly due to the naked breasts and sensuously indented navel, but perhaps also because of the effeminized representation of John the Baptist (left). Here John and Salome resemble each other, although conventionally one symbolizes lust and decadence and the other celibacy and virtue; the Victorians had fixed expectations of Biblical depictions.

Below: THE BURIAL OF SALOME, 1893-4. This is the tailpiece to *Salome*. D. H. Lawrence wrote about this drawing in his first novel, *The White Peacock*: 'I came upon reproductions of Aubrey Beardsley's tail piece to *Salome*. I sat and looked and my soul leaped out upon the new thing. I was bewildered, wondering, grudging, fascinated. I looked a long time, but my mind, or my soul, would come to no state of coherence.' The pose of Salome's limp body and the

tenderness of the line with which it is drawn recall the treatment of Pietà figures (the Dead Christ) in Renaissance art. The combination of the sacred and the profane is a distinct characteristic of Beardsley's work, and accounts in part for the bewilderment of Lawrence and many other contemporary viewers.

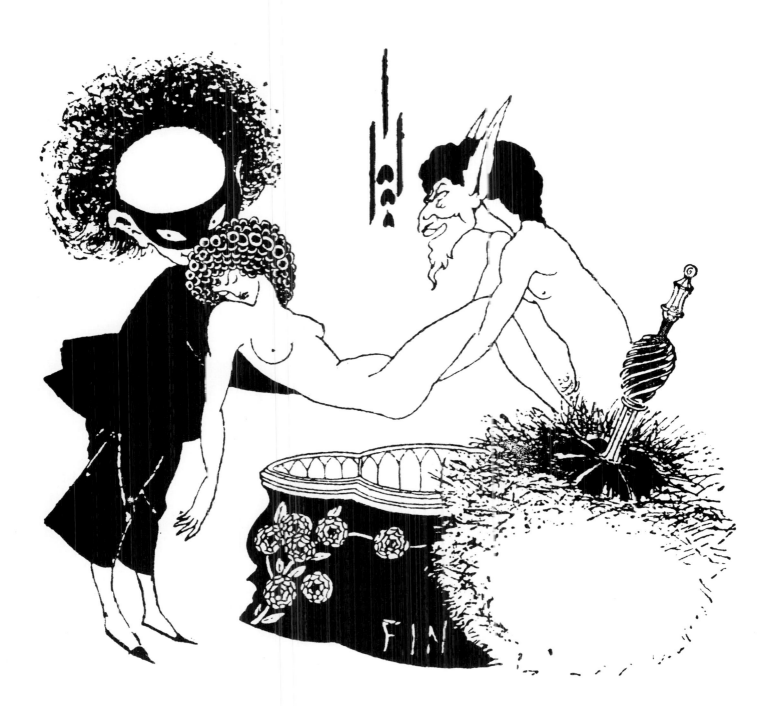

Right: SALOME ON SETTLE,
OR MAITRESSE D'ORCHESTRE,
1893-4. This Japonesque picture,
featuring a voluminously clothed
seated woman with a strange
hairstyle, looks far from obscene.
Apart from the trailing tassel,
which for Beardsley often had
sexual significance, nothing could
seem more innocent. Nevertheless,
the drawing was suppressed, as it
was feared that the baton the
woman wields might be thought to
be a dildo. This work was
produced independently of the
Salome commission, being based on
an earlier *Bon-Mots* sketch.

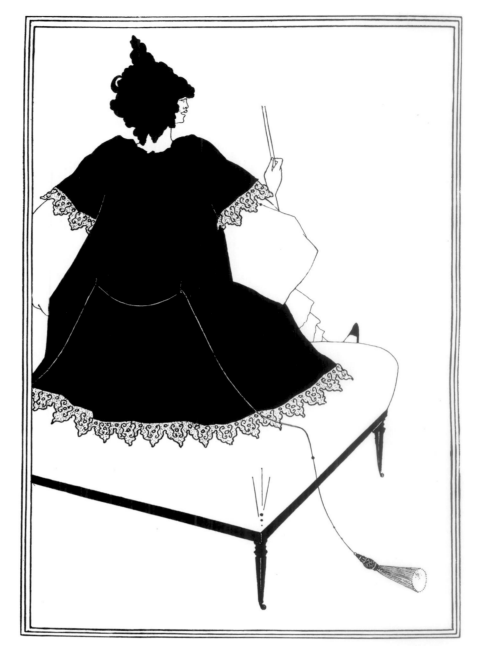

Right: COVER DESIGN FOR
SALOME, 1893-4. Not used at the
time, this design ornamented the
1907 re-issue of *Salome*, blocked in
gold on light green cloth. The same
design had been blocked in gold on
blue cloth for the binding of
Beardsley's elaborate novel, *Under
the Hill*, in 1904. Independent of
Whistler's influence, the peacock
feather symbol appealed to
Beardsley's decorative sense, and
had for him literary associations, as
an emblem of vainglory and also of
the Evil Eye.

THE SPIRIT OF BEARDSLEY

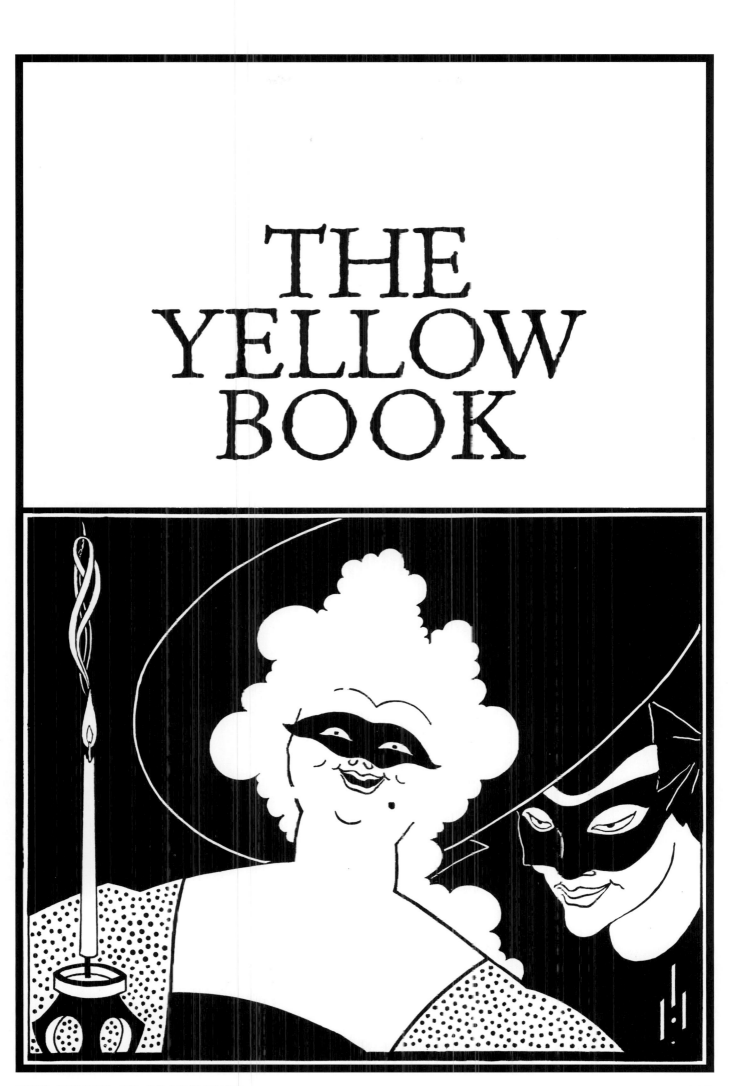

Right: PROSPECTUS FOR *THE YELLOW BOOK*, 1894. *The Yellow Book* was a quarterly periodical conceived by Beardsley and his friend Henry Harland primarily as a vehicle for their own work, but also as a quality publication to represent a new modernism in art. Harland was literary editor and Beardsley art editor. Interestingly, the design shows the woman buyer out at night alone, the independent selector of her own reading-matter. The old Pierrot eyeing her is said to resemble Elkin Mathews, the more prudish of the two publishers, Mathews and Lane.

Below right: POSTER FOR *THE YELLOW BOOK, c.* 1894. This poster betrays the influence of French poster art — a stylized line and boldly blocked, strongly contrasting, areas — but the whole is unmistakably a Beardsley, with its suggestion of a slightly sinister complicity between the woman and the little devil who leads her on. Japanese influence is also apparent in the flattened forms of the geisha-like woman. Ultimately, the poster was never used to advertise *The Yellow Book*.

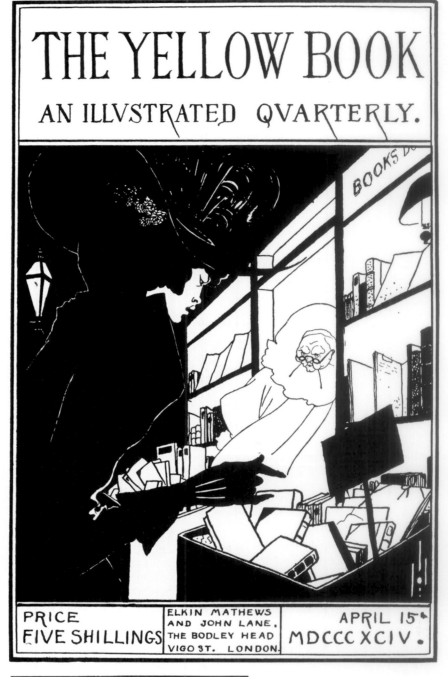

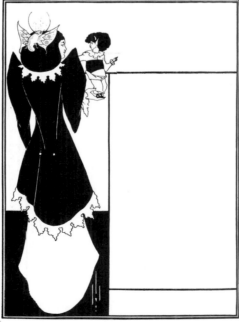

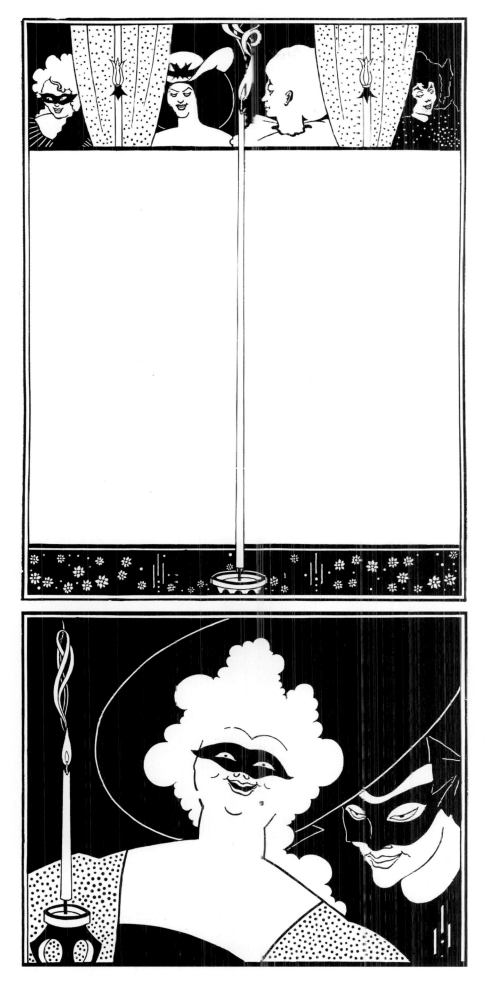

Left: BACK COVER DESIGN OF *THE YELLOW BOOK*, 1894. This design slipped through the net of censorship of Beardsley's work when the Oscar Wilde scandal caused him to be sacked as art editor of *The Yellow Book* — Beardsley mistakenly being thought to be part of Wilde's 'unnatural' clique. The women are provocatively screened within the candle-divided space, as if their activities cannot be revealed. Those on the extreme left and right look outwards for company, while the woman in the hat, who seems to be naked, smirks at the androgyne in a clown's collar.

Below left: COVER DESIGN OF *THE YELLOW BOOK*, VOLUME I, 1894. The colour of the books was chosen for its association with French 'yellow-back' novels, and it was said of the first issue that 'London went yellow overnight'. Yellow became connected with the Decadent movement in art, and the period was afterwards referred to as 'The Yellow Nineties'. This design was printed in black on a flaming yellow cover, and its bold, graphic style was like nothing ever published before. The masked woman laughs provocatively in the light of a smoking candle, and the sinister man behind her wears Beardsley's Japonesque mark like a brooch.

Below: L'ÉDUCATION
SENTIMENTALE, 1894. *The
Yellow Book* featured this
illustration of Flaubert's novel of the
same name. It aroused controversy,
chiefly because of the cynical
attitude of the young woman, which
allows the image to be read as a
bawd's lecture to a young whore.
There was shock, too, at the
suggestion of blasphemy in the
contrast between the older woman's
priest-like garment and her
overblown hat. If examined closely,
she appears quite literally 'two-
faced', revealing a double profile.

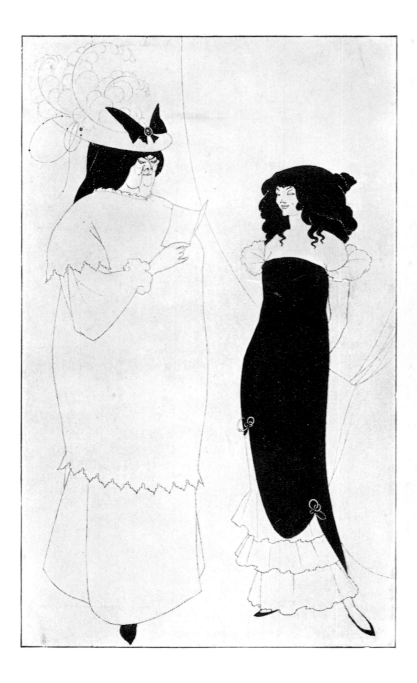

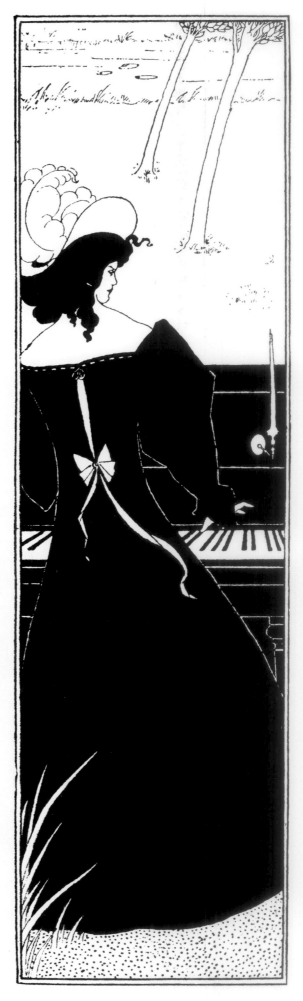

THE SPIRIT OF BEARDSLEY

Far left: TITLE-PAGE FOR
VOLUME I OF *THE YELLOW
BOOK*, 1894. Beardsley based his
Singer sewing machine poster
(p. 87) on this drawing. Criticized
in *The Pall Mall Budget* for the
incongruity of setting a piano in a
field, Beardsley invented a
musicologist to testify that the
composer Gluck, in order to gain
inspiration, had ordered his piano
to be carried into the fields, where
he sat composing with a champagne
bottle at either side.

Left: A NIGHT PIECE, *THE
YELLOW BOOK*, VOLUME I.
This drawing owes much to the
'Nocturnes' of Whistler. Like 'Les
Passades' (p. 94), it is in Indian ink
and wash, and shares the
implications of its title, 'A *Night
Piece*' also having the meaning of a
nocturnal prostitute. However, the
character in this drawing has a
dignity untypical of Beardsley's
portrayal of women. The dimness of
the building in the background
throws the startling white of the
woman's face and neck into finer
contrast.

Right: PORTRAIT OF MRS PATRICK CAMPBELL, 1894. This drawing, an illustration in Volume I of *The Yellow Book*, caused much derision to be heaped upon Beardsley, *The Westminster Gazette* commenting that a 'short act of Parliament' should be brought in 'to make this kind of thing illegal'. *The World* complained about the 'black sticking-plaister [*sic*] hat, hunchy shoulders, a happily impossible waist, and a yard and a half of indefinite skirt.' Beardsley replied, 'It is just like her', and, as he was a great admirer, there is little doubt that the work was lovingly drawn.

Far right: DESIGN FOR A BOOK PLATE, 1894. Reproduced in the first volume of *The Yellow Book*, this plate was originally designed for John Lumsden Propert, about whom little seems to be known. The diagonal pose of the woman is balanced by the strange thistle-like plant that hangs over her, the movement of which is in turn echoed in the diagonal of the Pierrot's arm and hands. He raises his eyes to her in supplication, while she stares malevolently at the viewer.

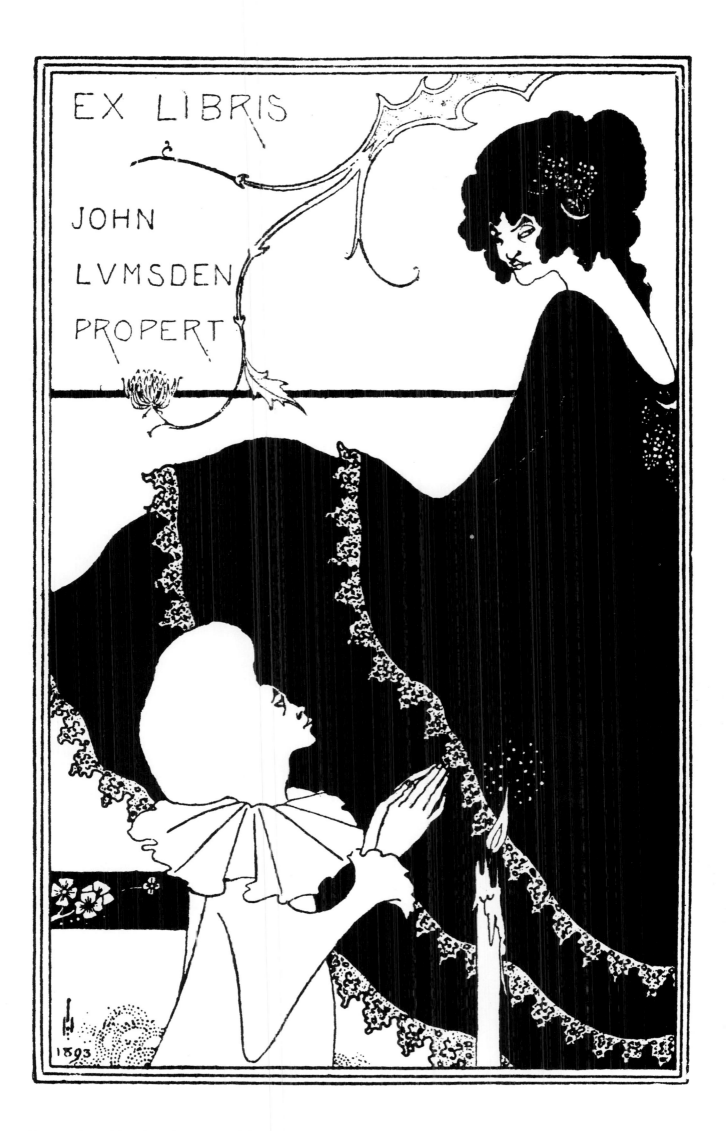

EX LIBRIS

JOHN
LVMSDEN
PROPERT

1893

Below: TITLE-PAGE ORNAMENT
FOR *THE YELLOW-BOOK*,
VOLUME II, 1894. The visual wit of
this design was unique for its time.
The demure attitude of the
conventionally pretty, corseted and
bustled young woman is subtly
undermined by her contemplation of
the inverted naked female figure
suggested by the tree-trunk, the
attitude of which implies sexual
coyness. It is typical of Beardsley that
an apparently anodyne drawing
should have disturbing intimations.

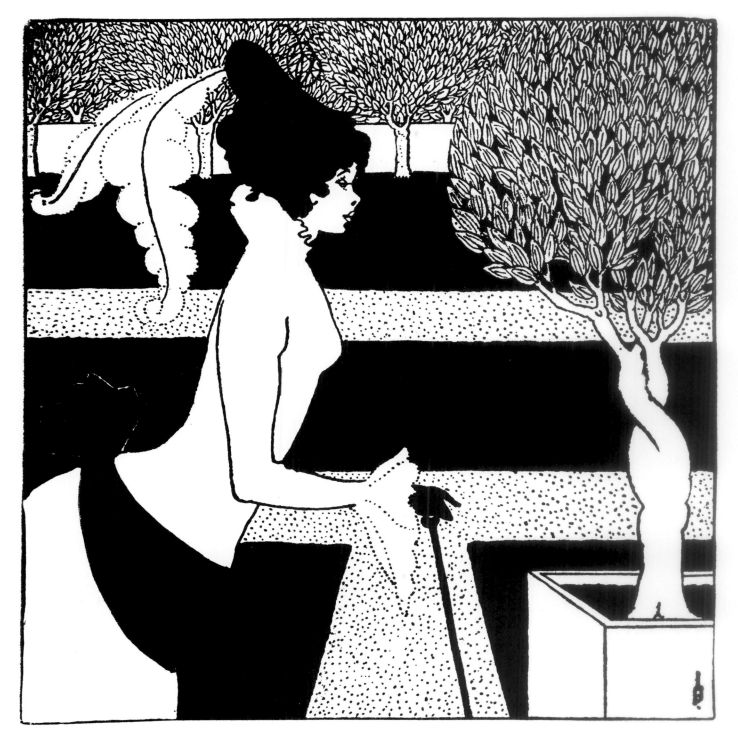

THE SPIRIT OF BEARDSLEY

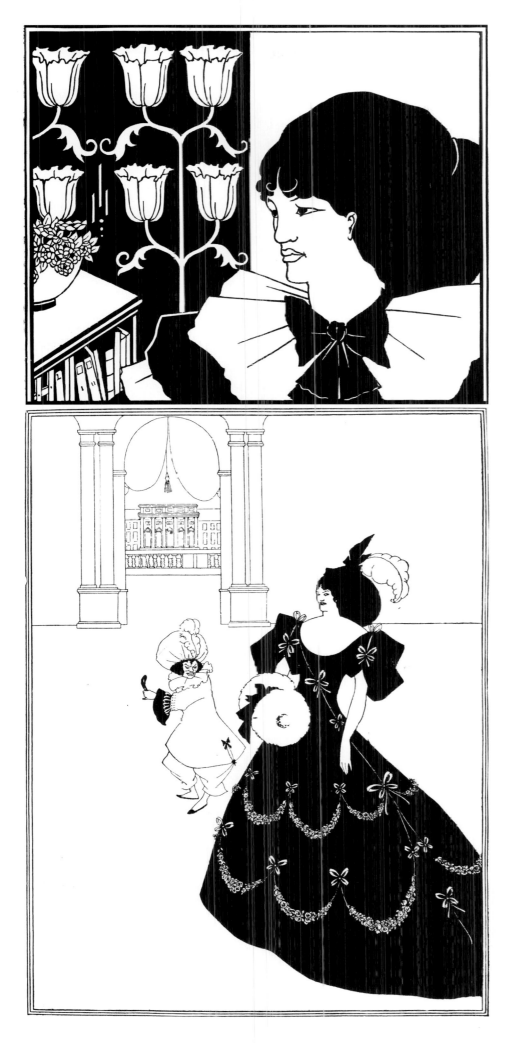

Left: COVER DESIGN FOR
VOLUME II OF *THE YELLOW
BOOK*, 1894. The woman in this
drawing resembles Beardsley's
sister Mabel, who was very good-
looking and may have served as a
mental model for the emancipated
young woman in his work. The
figure looks determinedly to her
right, against an almost precisely
halved background of empty white
space and boldly flowered
wallpaper, on which is Beardsley's
Japonesque mark.

Left: THE COMEDY-BALLET OF
MARIONETTES, I, 1894. The
first of three mysterious drawings
published in the second volume of
The Yellow Book, Beardsley added
to its title, 'as performed by the
troupe of the Theatre-Impossible,
posed in three drawings'. Always
passionately theatrical, Beardsley
created his own 'Theatre
Impossible' in his art. Here a
lustful dwarf draws a woman
towards some unknown experience
in a composition extremely similar
to that of 'A Caprice', one of his
only two known oil paintings.

THE SPIRIT OF BEARDSLEY

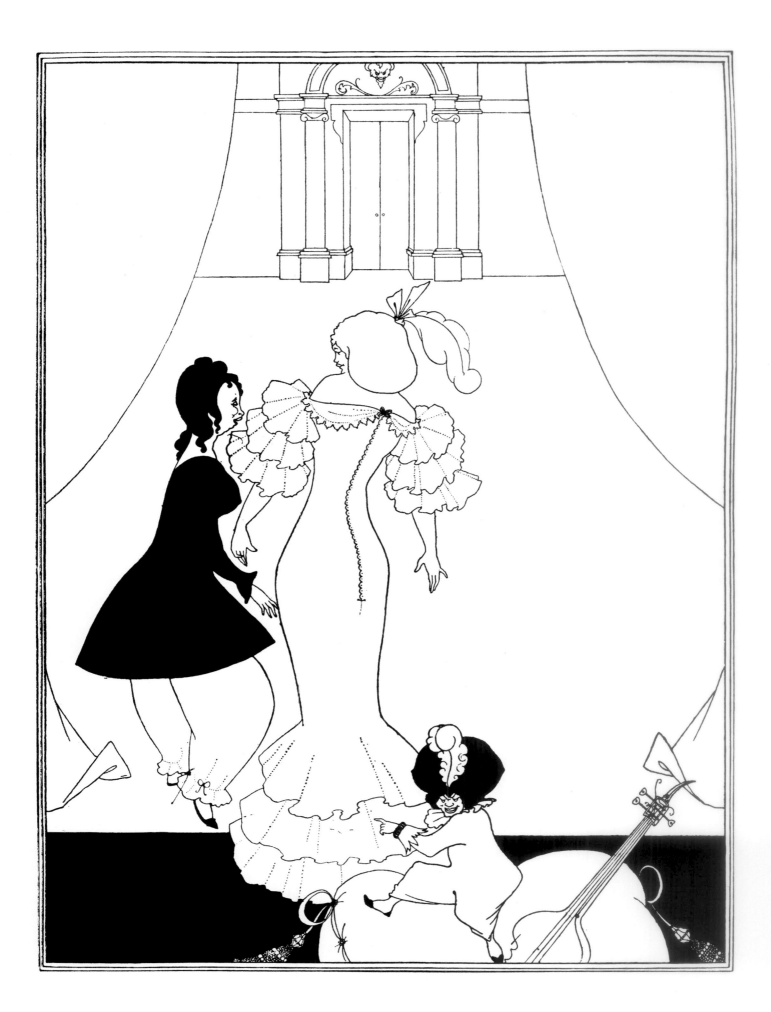

THE SPIRIT OF BEARDSLEY

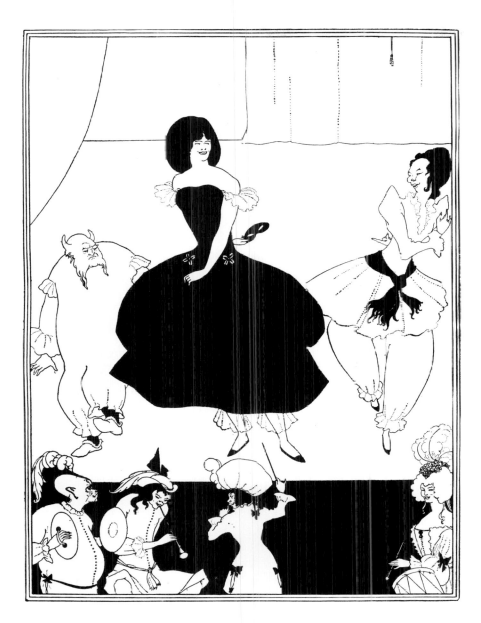

Far left: THE COMEDY-BALLET OF MARIONETTES, II, 1894. This is the second of three drawings, and shows a dwarf exultantly pointing at a creature who is propositioning a woman. The former is clearly denoted as being a lesbian by her frilly 'bloomers', which Beardsley often used as a sign of Sapphism. In this drawing the scene has become a stage, with curtains pulled aside to reveal the scenery of a doorway guarded by a devil-head. The dwarf with musical instrument is seated in a kind of orchestra pit. The receding chin of the lesbian was in accordance with nineteenth-century ideas of the link between moral and physical degeneracy.

Left: THE COMEDY-BALLET OF MARIONETTES, III, 1894. This third drawing in the sequence represents a third 'act' in the comedy-ballet. It would seem here that an act of another kind has been accomplished, judging by the looks of smug satisfaction on the faces of the women and the 'bloomers' now showing beneath the skirt of the heroine, which denotes her conversion to Sapphism. The diminished and horned figure of the cuckolded husband clownishly cavorts to the music of four dwarfs.

Left: GARÇONS DU CAFÉ, 1894. Much influenced by, and perhaps in homage to, the woodcut style of the French artist Félix Vallotton, this masterly drawing appeared in Volume II of *The Yellow Book*. It is one of Beardsley's most successful compositions of figures, the waiters having both a monumental solidity and a precariousness in their stance that suggests arrested movement.

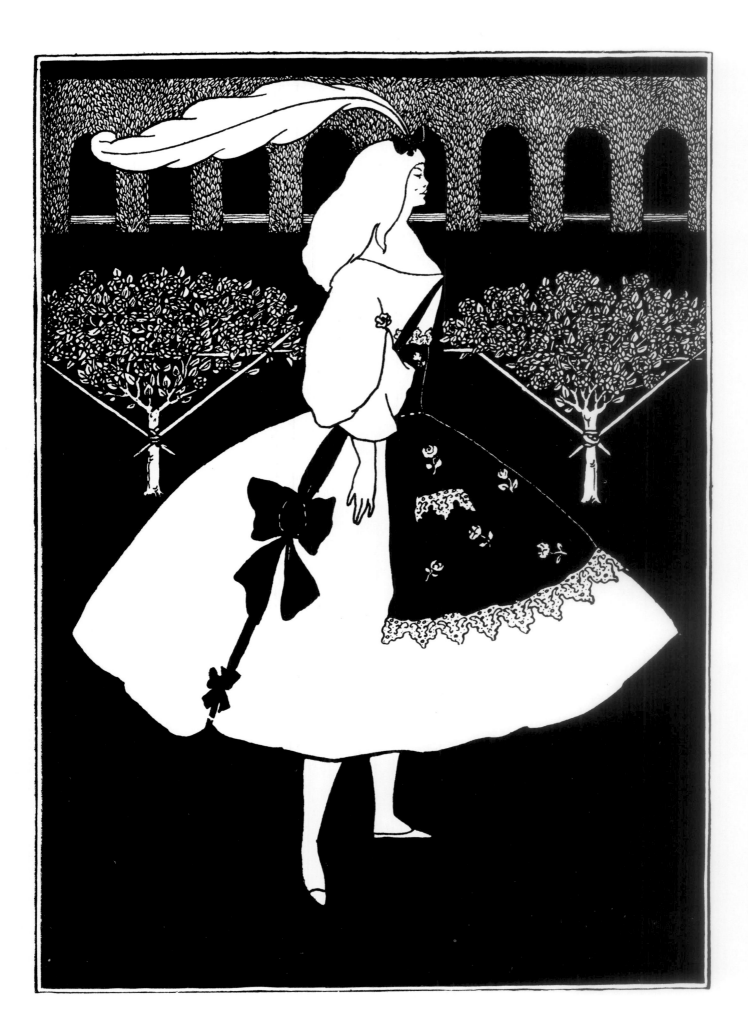

THE SPIRIT OF BEARDSLEY

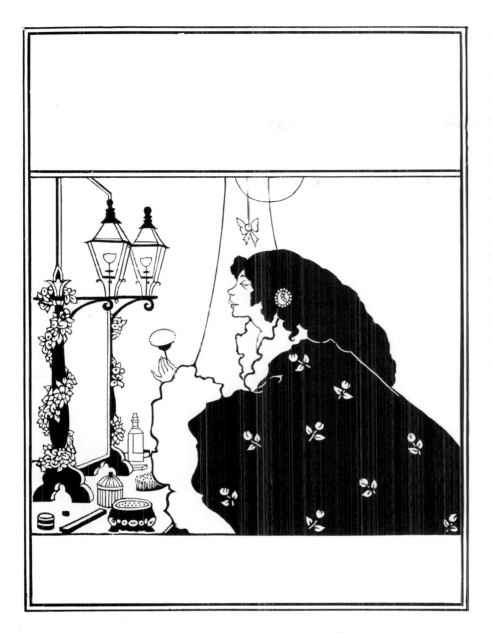

Left: COVER DESIGN FOR THE *YELLOW BOOK*, VOLUME III, 1894. There was general mockery of Beardsley's depiction of street lamps as the dressing-table lights of this self-regarding woman, but it was by just such touches as these that the artist made an apparently simple composition pose complex questions. Do the lamps imply that she is a street-walker preparing herself for business or do they simply suggest an over-indulgence in night life by this slightly decadent beauty, whose incipient bags-under-eyes and double chin she is preparing to disguise?

Left: THE SLIPPERS OF CINDERELLA, 1894. In this pen-and-ink work, which was reproduced in the second volume of *The Yellow Book*, Cinderella is drawn in profile against a highly symmetrical design of yew hedge and bushes. She is one of Beardsley's 'ten-feet high' women, which affords her an almost *Alice in Wonderland* appearance. The inverted crown on her apron hints at her usurpation by her sisters, and the umbrella-like shape of her skirt emphasizes the smallness of the slippers of the title.

Left: PORTRAIT OF MADAME RÉJANE, 1894. This line drawing from Volume II, in which the different textures of the actress's garments are rendered simply but subtly, is one of several that Beardsley made of Madame Réjane. He greatly admired her acting, and it was said of her that she was the 'one woman in the world with a Beardsley mouth'. In June 1894 she had made her first appearance on the London stage, as 'Catherine' in *Madam Sans Gêne* at the Gaiety Theatre.

THE SPIRIT OF BEARDSLEY

Right: TITLE-PAGE DESIGN FOR
THE YELLOW BOOK, VOLUME
III, 1894. Always a master at
creating a theatrical atmosphere,
Beardsley here depicts an encounter
offstage. The extravagantly hatted
woman and her Harlequin
companion watch the action on
stage, but are physically engaged
with each other, the angle of his
knee suggesting their sexual
intimacy.

Far right: PORTRAIT OF HIMSELF,
1894. From Volume III of *The
Yellow Book*. The night-capped head
of the artist is askew so that he
seems to peep at the viewer from
behind the bed curtains. This is a
poignant but mocking self-portrait of
a man obliged to spend a great deal
of time in bed because of his
tubercular condition, and who
therefore knew that 'all the monsters
are not in Africa' — in the deliriums
of his disease he may have seen
monstrous creatures.

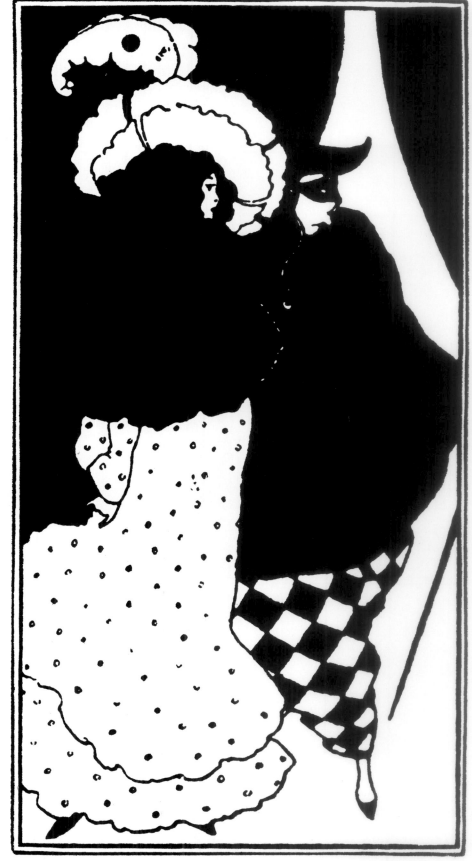

THE SPIRIT OF BEARDSLEY

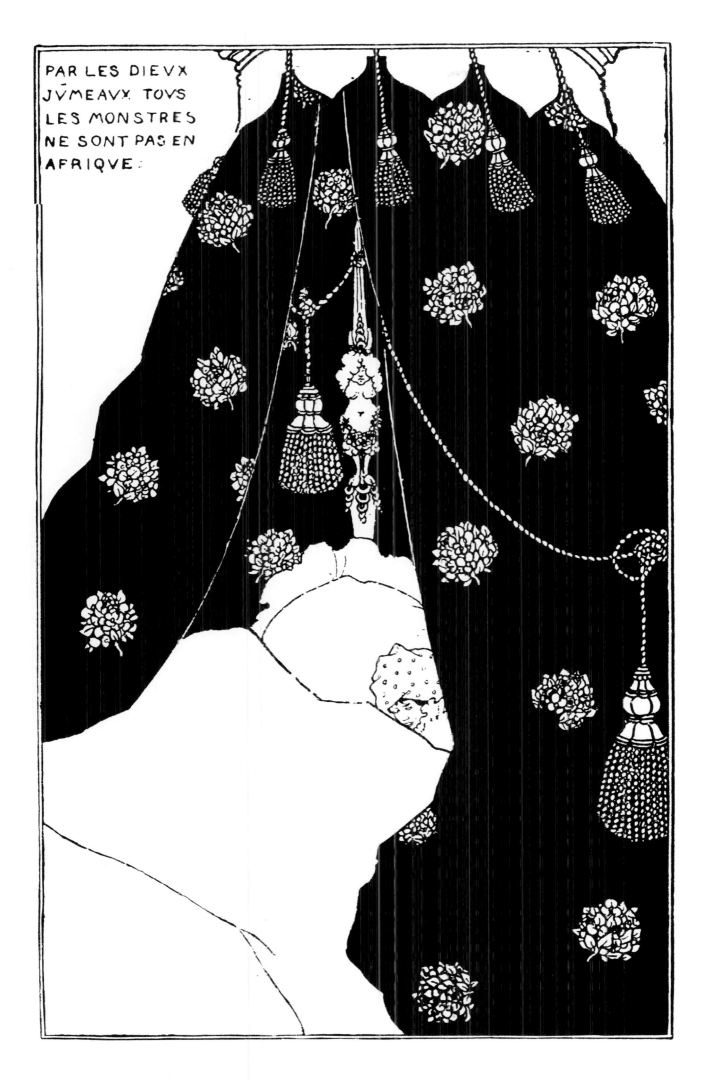

PAR LES DIEVX
JVMEAVX. TOVS
LES MONSTRES
NE SONT PAS EN
AFRIQVE.

Right: LADY GOLD'S ESCORT,
THE YELLOW BOOK, VOLUME
III, 1894. In this cynical nocturne
the swollen, dissolute figures of the
rakes dwarf and yet are subservient
to 'Lady Gold', whose name stands
for the lust they all have in
common. The elderly female
degenerate who can pay for gigolos
galore is, despite their sycophantic
smiles and painstaking obeisances,
totally aloof from them. Beardsley
has achieved the moral comment of
a Hogarth engraving in what was
then an ultra-modern drawing.

Far right: THE WAGNERITES,
THE YELLOW BOOK, VOLUME
III, 1894. Inspired by a visit to
Tristan und Isolde at the Paris
Opéra in 1893, this is one of
Beardsley's most famous drawings.
The enormous black area, with faint
outlines in Chinese white,
dramatically contrasts with the faces
and shoulders of the listeners in the
stalls and the economically drawn
figures in the boxes. Beardsley
included the name of the opera on
the discarded programme at the
bottom right, highlighting the irony
of this pure and lyrical love theme
being played to such a vicious and
worldly audience.

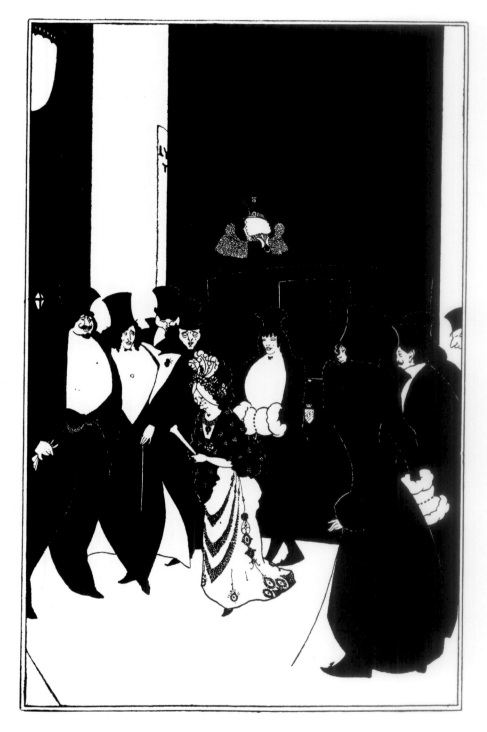

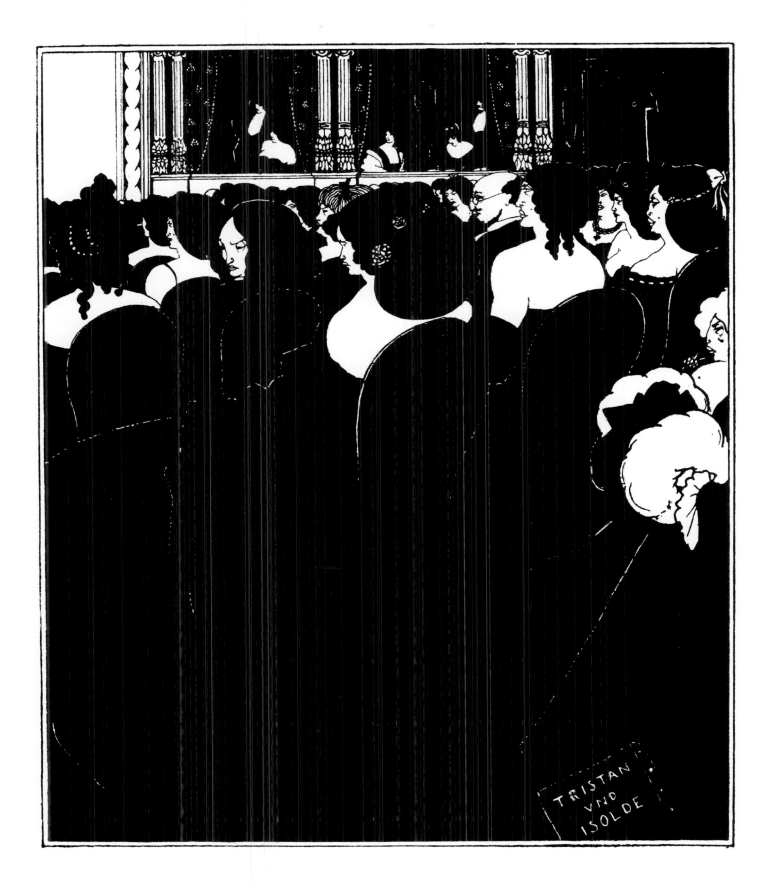

Right: LA DAME AUX
CAMÉLIAS, *THE YELLOW
BOOK*, VOLUME III, 1894.
Women's dressing-tables were
almost fetishistic objects for
Beardsley, appearing regularly
throughout his work during the
mere six years in which he was
active as an artist. It is not difficult
to imagine him, brought up as he
was in an almost entirely female
environment, sitting watching his
mother and sister Mabel beautifying
themselves. First reproduced as 'Girl
at her Toilet', doubts have been
expressed as to whether the artist
ever intended this Indian ink and
watercolour drawing to be 'La
Dame aux Camélias'.

Right: DESIGN FOR THE FRONT
COVER OF *THE YELLOW
BOOK*, VOLUME IV, 1895. In this
apparently innocent drawing there
is the suggestion of some kind of
conspiracy between a woman and
the small creature, in this case not a
grotesque but a rather good-looking
child with a pouting mouth, who
intently offers a flower. The right
side of the woman's feathered cap
may be read as a weird profile.

THE SPIRIT OF BEARDSLEY

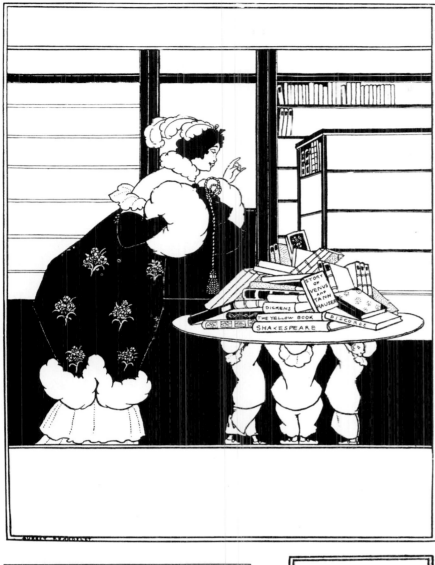

Left: COVER FOR *THE YELLOW BOOK*, *c.* 1895. This cover was never used, possibly because it was considered self-promoting, one of the books the hobble-skirted woman contemplates being Beardsley's own unfinished novel, *The Story of Venus and Tannhäuser*, or *Under the Hill*, as it was later called. Three little Pierrot figures hold up a selection of reading-matter, like a meal on a plate, with *The Yellow Book* prominently displayed on top of Shakespeare.

Below left: THE MYSTERIOUS ROSE GARDEN, *THE YELLOW BOOK*, VOLUME IV, 1895. Asked to explain the meaning of this pencil and Indian-ink drawing, Beardsley insisted that it represented an Annunciation, though this explanation has been widely disputed. However, it would appear to be more pagan than Christian. Amid a Pre-Raphaelite rose-trellis, symbolic of love, an elongated 'Mary' figure toys with a lock of hair, signalling her sexuality, and the mustachioed Hermes, with winged sandals, *caduceus* and lamp, whispers to her of delights as yet unknown.

Left: DESIGN FOR A TITLE-PAGE, *THE YELLOW BOOK*, *c.* 1895. In this surprisingly loose drawing Beardsley has used two of the Japonesque design elements of which he was extremely fond: the long rectangular border and the rear view. This well-dressed woman appears to be more in the style of the early nineteenth century, with her almost Regency hairstyle and a stole, although the ribboned waist of the gown is too low for that period.

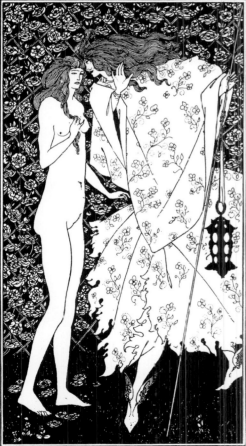

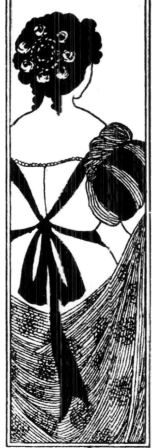

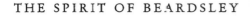

THE SPIRIT OF BEARDSLEY

THE REPENTANCE
OF M^{RS}

THE SPIRIT OF BEARDSLEY

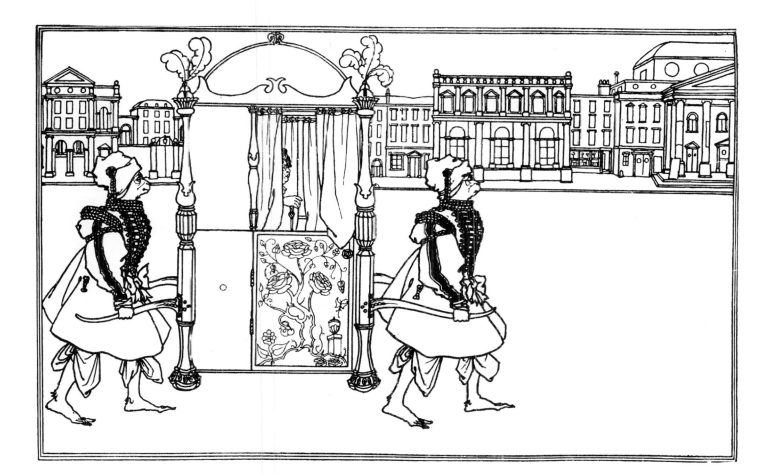

Left: THE REPENTANCE OF
MRS . . . ,*THE YELLOW BOOK*,
VOLUME IV, 1895. This reworking
of a much earlier drawing, *The
Litany of Mary Magdalen* (p. 32),
owes less to the influence of
Mantegna. Far from being a
Christian altar, the table before which
'Mrs . . . ' kneels has the cloven
hooves of a satyr; the salacious dwarf
is more prominent in this version, the
central male figure is missing, and the
only seemingly compassionate
witness of the repentance is
marginalized to the right.

Above: FRONTISPIECE FOR
JUVENAL, *THE YELLOW BOOK*,
VOLUME IV, 1895. This double-
page illustration was the last of
Beardsley's works to be published in
The Yellow Book, after which the
Oscar Wilde scandal broke and
Beardsley was dropped from his post
as art editor. Juvenal, the great
Roman satirical poet, dwelt on the
vices of contemporary society, and
here Beardsley has set the action in
nineteenth-century London, showing
a decadent man-about-town being
carried by haughty monkey flunkies.

Right: PORTRAIT OF MISS
WINIFRED EMERY, *THE
YELLOW BOOK*, VOLUME IV,
1895. Elegantly placed within an
elongated rectangular frame,
Winifred Emery is depicted in this
print as a dignified and stately
young woman, whose dress, hair
and face are drawn without
caricature. The dark mass of her
hair, and the firm drawing of her
features serve to focus the viewer's
eye on their beauty. The crisp
outline of her gown contrasts
strikingly with the stippled
treatment of her fichu and sleeve,
brilliantly conveying the different
textures of the fabrics she wears.

Far right: POSTER FOR *THE
YELLOW BOOK*, 1894. Issued to
advertise the first volume, this
poster was printed in dark blue on
light yellow, which allowed
Beardsley to use a third colour,
green, for the daffodils growing in
the corner. The low viewpoint was a
device often used by the artist to
elongate figures, making them
appear more elegant. The outline of
the girl's sash is visible to avoid the
effect of her lacking a waist.

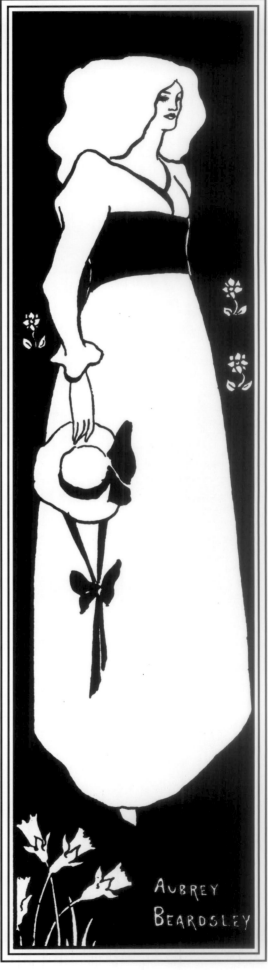

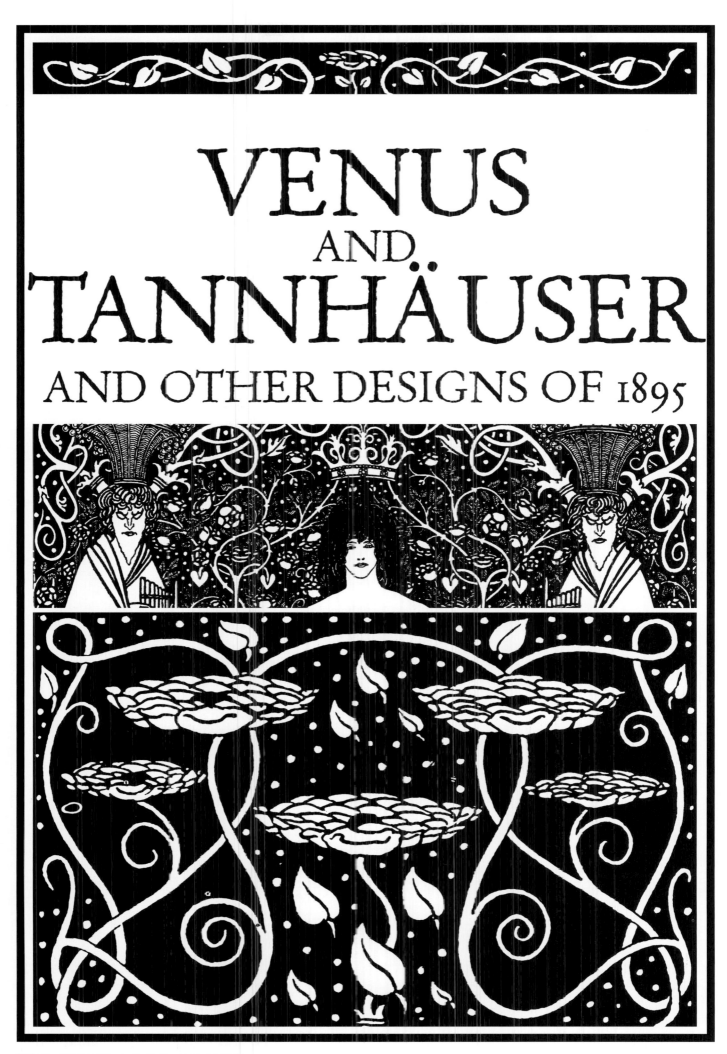

VENUS AND TANNHÄUSER

AND OTHER DESIGNS OF 1895

Below: FRONTISPIECE AND TITLE-PAGE FOR *THE STORY OF VENUS AND TANNHÄUSER*, *c.* 1894-5. Intended for an erotic novel that Beardsley never finished, these designs were never published, not even in *The Yellow Book*, because of the artist's dismissal as art editor. In this neo-classical design, a vignette from *Le Morte Darthur* appears through the arched windows, and a Renaissance-inspired Venus, with quiet satisfaction, regards the elaborate covered cup in seventeenth-century style, and candlestick, and the turtle doves on her altar of love.

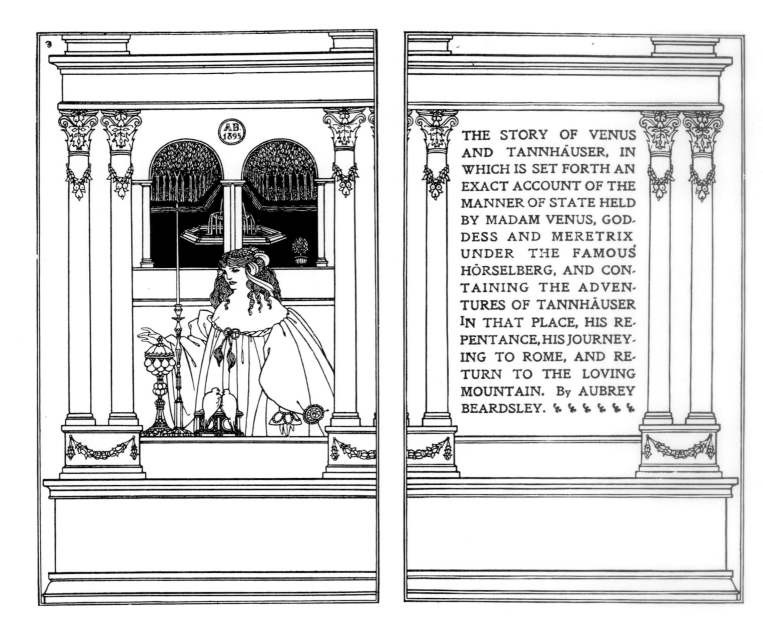

THE STORY OF VENUS AND TANNHÄUSER, IN WHICH IS SET FORTH AN EXACT ACCOUNT OF THE MANNER OF STATE HELD BY MADAM VENUS, GODDESS AND MERETRIX UNDER THE FAMOUS HÖRSELBERG, AND CONTAINING THE ADVENTURES OF TANNHÄUSER IN THAT PLACE, HIS REPENTANCE, HIS JOURNEYING TO ROME, AND RETURN TO THE LOVING MOUNTAIN. By AUBREY BEARDSLEY.

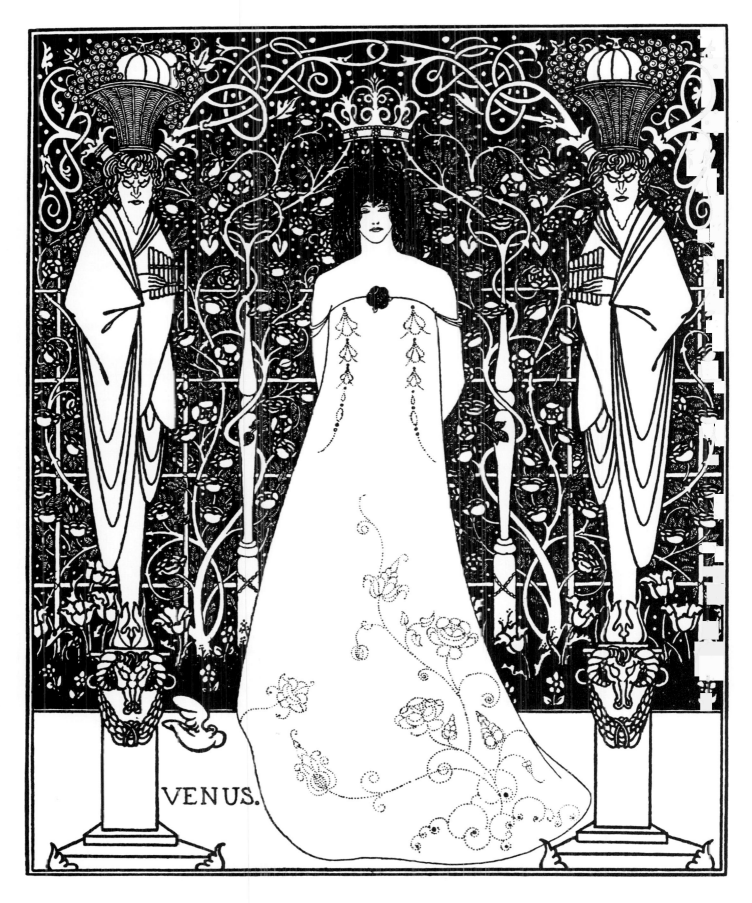

VENUS.

Above: FRONTISPIECE FOR *THE STORY OF VENUS AND TANNHÄUSER*, *c.* 1894-5. That Beardsley was fascinated by this legend is hardly surprising since his major preoccupations — the opposition of the flesh and the spirit and of life and death — are its principal themes. Here stands a desirable Venus, crowned as the queen of sensual pleasure, but flanked, in sinister contrast, by two forbidding terminal gods, who serve as a reminder of death as the ultimate boundary of life.

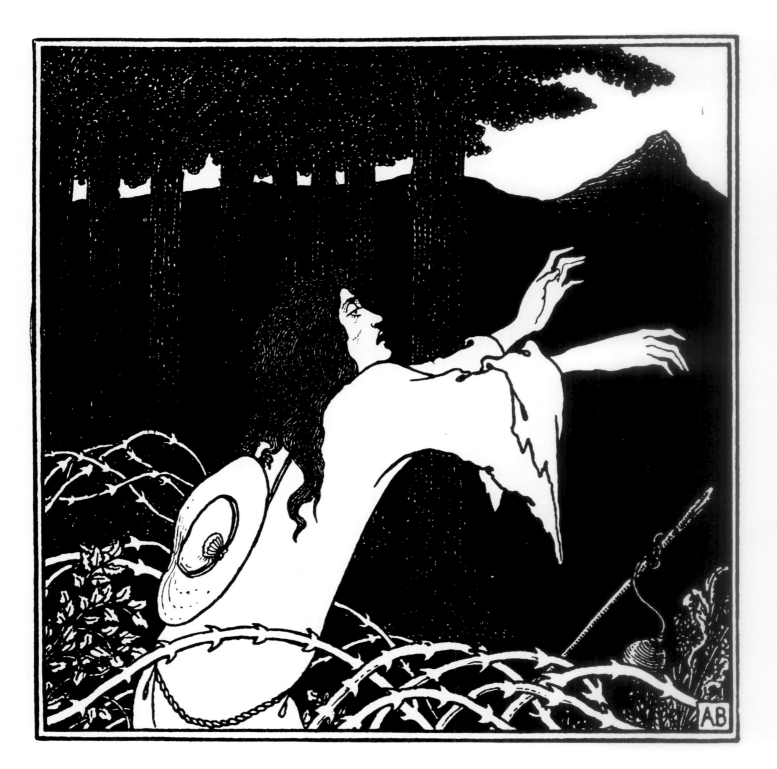

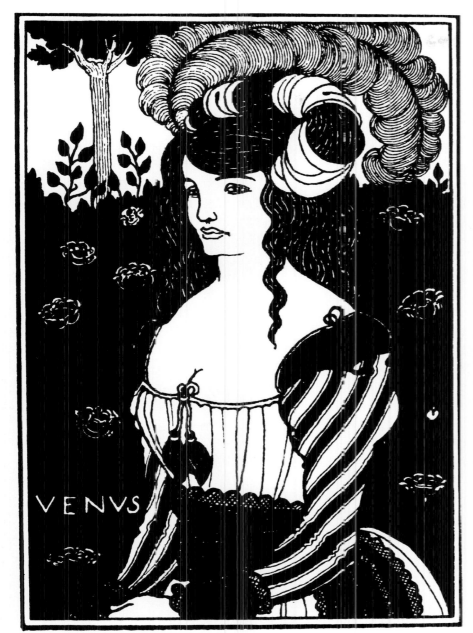

Far left above: THE RETURN OF TANNHÄUSER TO VENUSBERG, c. 1894-5. Here Beardsley depicts a desperate Tannhäuser, entangled in restraining briars, struggling to return to Venus who lives under the breast-shaped hill. After living with her for years in sensual delight, Tannhäuser had repented and gone to Rome for absolution, but had been told by the Pope that it was as likely for him to be forgiven as for his staff to burst into flower. Three days later the stick blossomed, but the hero could not be found. He had returned to Venusberg.

Far left below: DESIGN ON THE COVER OF *TRISTAN UND ISOLDE*, c. 1893-4. In Indian ink and Chinese white, this design was drawn on a brown paper cover Beardsley made for his copy of the vocal score of *Tristan und Isolde*, one of his favourite Wagner operas. The beautiful lettering is accompanied by the artist's hybrid of passion flower and clematis blooms, which he often used to denote ardour. The legend of Tristan and Isolde interested him throughout his life, probably because both stories explore the theme of forbidden love.

Above: VENUS, c. 1894-5. This design was intended for Beardsley's unfinished novel, *The Story of Venus and Tannhäuser*, but not, in fact, published until 1898, when it appeared in *The Studio*. Beardsley invariably portrayed Venus as attractive and desirable, with no hint of the degeneracy he was so adept at conveying, perhaps because of his frank approval of fleshly pleasure (which, because of his illness, he could only entertain in his mind). This Venus, in fantasized Renaissance garments, sits serenely against a black background strewn with roses — a universal symbol of love.

Left: DESIGN FOR THE COVER OF *TRISTAN UND ISOLDE*, c. 1893-4. Beardsley drew this cross-section of a seed in Indian ink and Chinese white on the corner of the brown paper cover he made for his vocal score of this opera. Possibly because of his fascination with human foetuses, he has represented flowers within the seeds like embryos in the womb, suggesting incipient passion ready to burst forth.

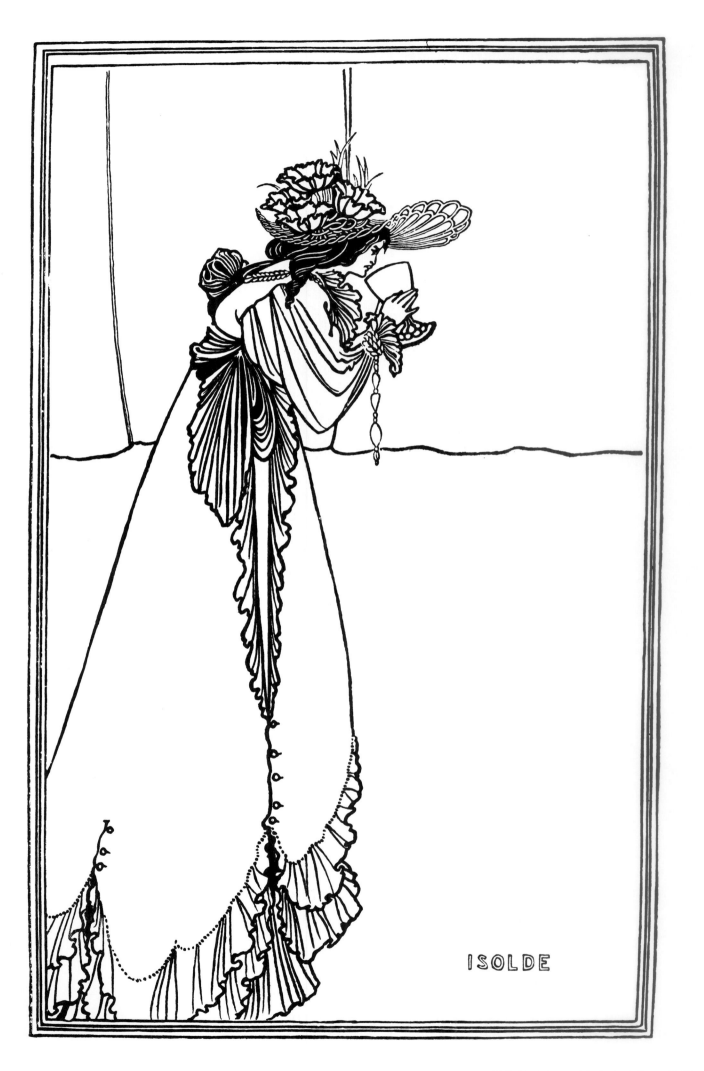

ISOLDE

THE SPIRIT OF BEARDSLEY

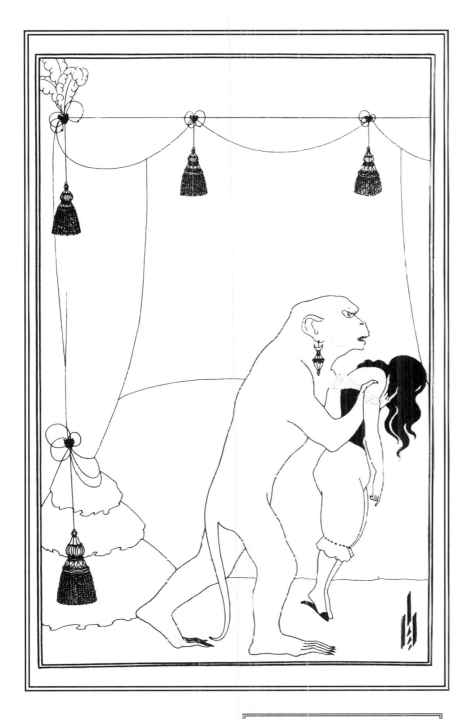

Far left: ISOLDE, 1895. This drawing was reproduced as a colour lithograph (in green, red, black and grey) in *The Studio* magazine. Here pictured with the cup she supposes to be poisoned, Isolde, one of Beardsley's favourite operatic heroines, wears an amalgam of styles, topped by a hat that combines flowers and butterfly wings. Her posture over the goblet captures the dramatic import of the moment.

Left: THE MURDERS IN THE RUE MORGUE, *c.* 1894-5. From childhood, the author Edgar Allan Poe was a favourite of Beardsley, probably because of their shared taste for the grotesque. When commissioned to produce four drawings illustrating *Tales of Mystery and Wonder*, Beardsley wrote, 'I feel that Poe's tales would give me an admirable chance for picture making.' This image is one of surreal horror, presenting the victim as a rag-doll, helpless in the grip of the savage beast that, with its earringed lobe, seems to 'ape' a degenerate dandy.

Below left: THE BLACK CAT, *c.* 1894-5. Also an illustration for *Tales of Mystery and Wonder* by Edgar Allan Poe, this bizarre composition is both nightmarish and humorous. The black cat of the title sits on the head of a dissolute-looking woman, ready to dig its vicious claws into her. A startling detail is the piercing gaze of the cat's single eye, the other presumably having been lost in battle.

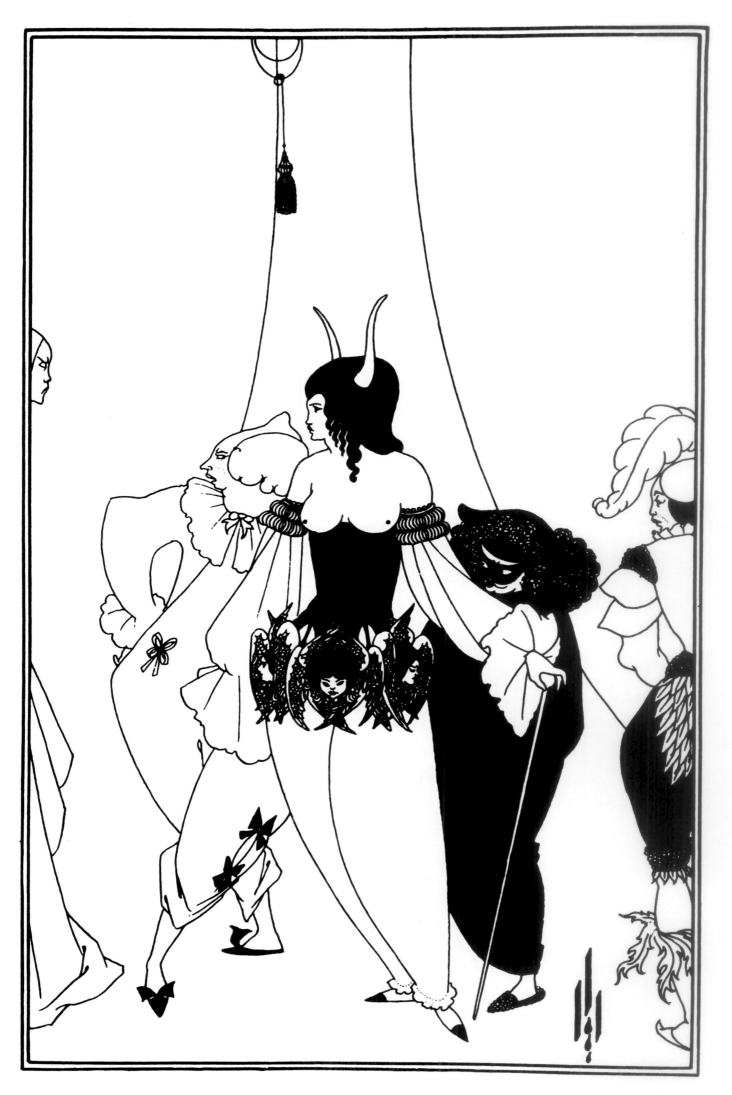

THE SPIRIT OF BEARDSLEY

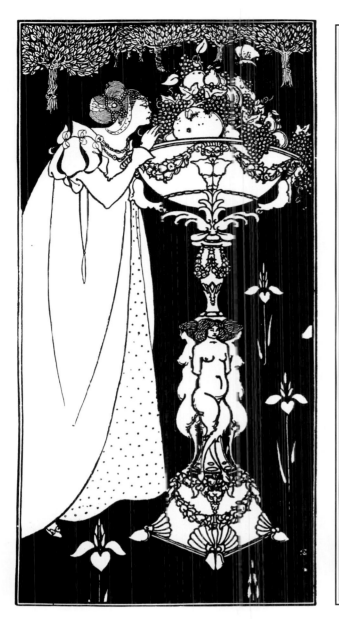

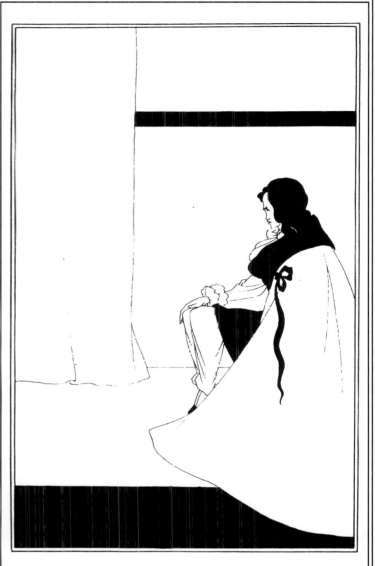

Left: THE MASK OF THE RED
DEATH, c. 1894-5. In this
illustration of, or fantasy upon, a
story by Edgar Allan Poe, the only
creature who seems afraid of the 'Red
Death' (barely visible on the left) is
the masked figure hiding behind the
horned she-devil. The latter, bare-
breasted and wearing angel heads
from her garter-belt like scalps, stares
defiantly at the intruder, as does her
'camp' clown companion. The figure
half-seen on the right seems merely
distracted from some guilty act.

Above: CALENDAR DESIGN,
AUTUMN, c. 1894-6. This drawing
does not appear ever to have been
used for a calendar and was not
published until 1899 in *The Early
Works of Aubrey Beardsley*, a book

that, in fact, includes works from the
entire six years of the artist's
professional career. The woman, in
medieval garb, appears to dote on an
enormous dish of fruit, which is
supported by three voluptuous female
satyrs. Beardsley must have liked the
image since he later re-used it for a
front cover (p. 179).

Above right: THE FALL OF THE
HOUSE OF USHER, c. 1894-5. The
placement of the figure in this
otherwise Japonesque drawing owes
a distinct debt to the work of
Whistler. This illustration is a
reworking of a drawing of Chopin
made in 1892, but here Beardsley
shows his skill in depicting
degeneracy, conveyed by the man's
slightly over-large cranium and

raddled face. There is a touch of
androgyny in the breast-like bulge of
the coat, the closed legs and the
flowing ribbon on the cloak.

Overpage: A SUGGESTED REFORM
IN BALLET COSTUME, c. 1895.
This satirical sketch illustrates a
poem, *At A Distance*, by Justin
Huntly McCarthy, that was written
in mockery of contemporary outrage
at diaphanous ballet dresses.
Beardsley revelled in such
controversy, and has endowed his
ornately covered-up ballerina with
skirts that swell out to form a female
breast on the right and a penis on the
left. The face of the dancer has a look
of his *Rape of the Lock* heroines
in particular in the beauty spot on
her cheek.

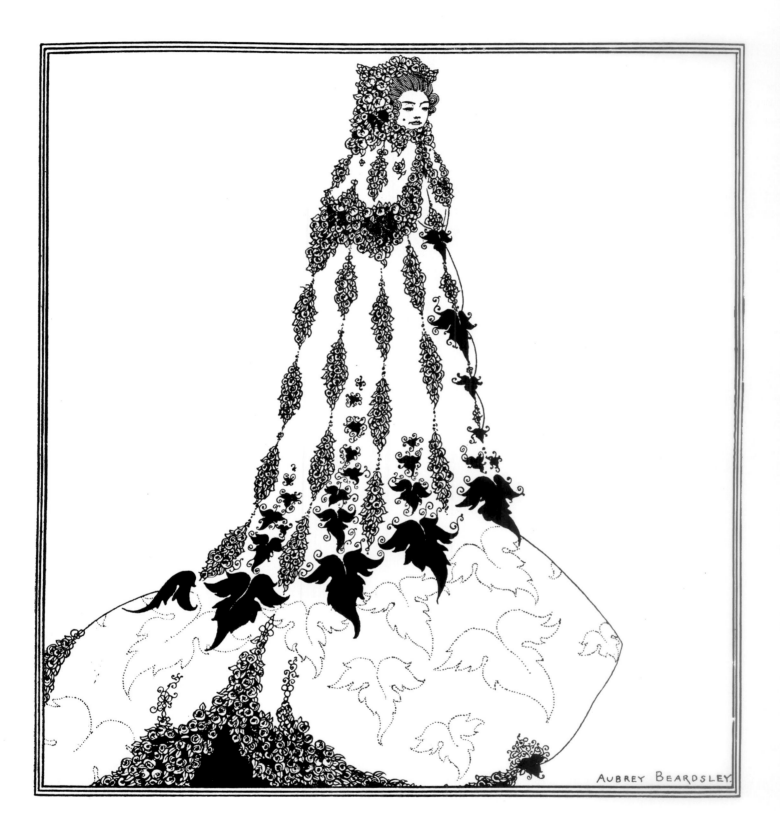

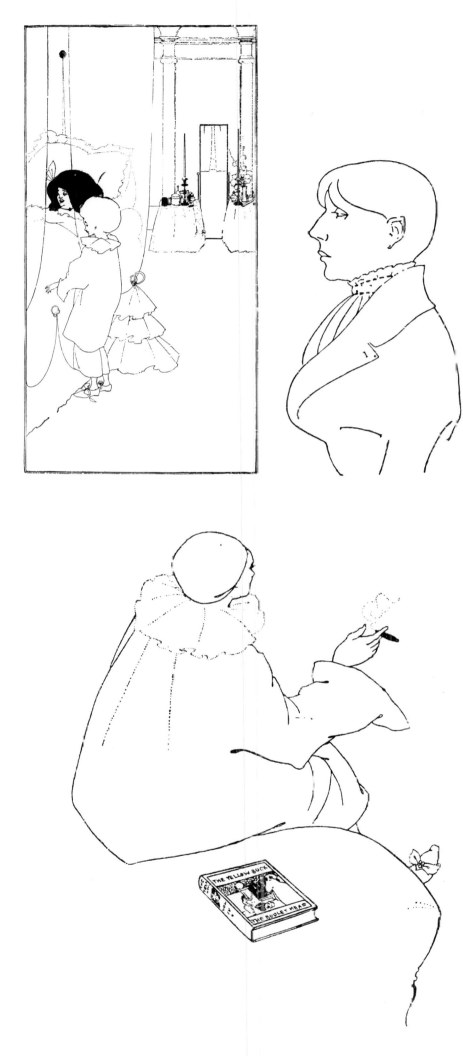

Far left: A CHILD STANDING BY ITS MOTHER'S BED, 1895. First published in *The Sketch*, this drawing may have been based upon a recollection of childhood. The delicate-looking little boy stands patiently beside the curtained bed where his mother lies apparently oblivious of his existence. Beardsley's mother developed puerperal fever after his birth and was intermittently quite ill throughout his childhood, although she survived both of her children by many years.

Left: OUTLINE PORTRAIT OF HIMSELF, *c.* 1895-6. An exquisite example of Beardsley's economy of line, this self-portrait is not self-mocking, being, on the contrary, slightly idealized. The style of the jacket and frilled jabot would suggest the character of a Regency dandy, in the peak of youth, health and beauty, and Beardsley has fleshed out his face to make it appear more handsome. This drawing was first published in 1896 in America, appearing in Percival Pollard's *Posters in Miniature*.

Left: DESIGN FOR AN INVITATION CARD, 1895. Beardsley drew this card for his friend and publisher John Lane, as an invitation to a select literary gathering called a 'Sette of Odd Volumes Smoke', the 'O.V.' on either side of *The Yellow Book* standing for 'Odd Volumes'. The cover of *The Yellow Book* is that of the most recent volume — January 1895. The resemblance between this urbane, cigar-smoking Pierrot and many graphic and fashion designs of the 1920s is a clear indication of the immense influence Beardsley's work had on later artists and on the development of a modern graphic style.

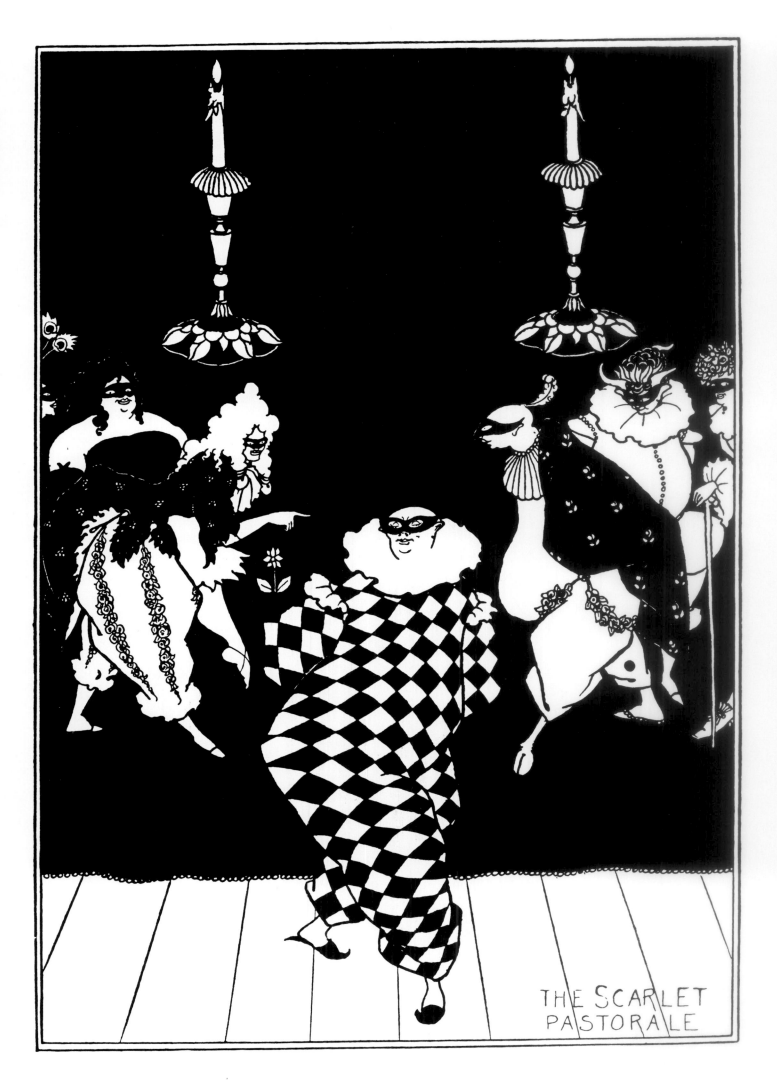

THE SCARLET PASTORALE

THE SPIRIT OF BEARDSLEY

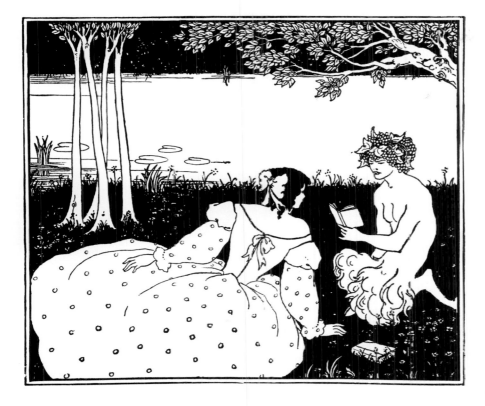

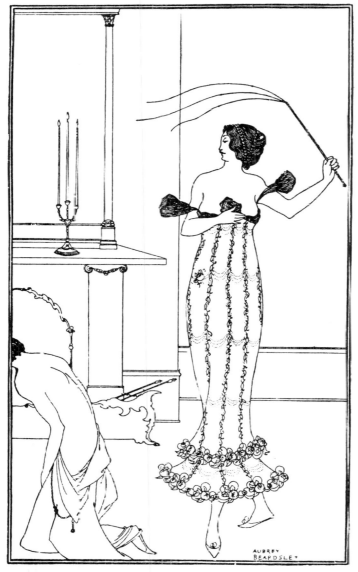

Far left: THE SCARLET PASTORALE, 1895. This title was not given by the artist himself because the work was only printed in scarlet when published in *The London Year Book* in 1898, where it accompanied an article on Beardsley's recent death. The central Harlequin's domino is a masterpiece of arrested motion, and the composition makes effective use of visual ambiguity, posing the question of whether or not the posturing grotesques and candlesticks are painted on a back-cloth.

Above left: DESIGN FOR THE PROSPECTUS AND FRONT COVER OF *THE YELLOW BOOK*, VOLUME V, 1895. Destined never to be published, this drawing survived on the cover of an advance proof of the withdrawn book. The attractive girl, in a voluminous dress of an earlier period, leans over intently, as if entranced by the young Pan figure who, with vine-leaves in his hair, reads to her, possibly of pagan delights. Also bending towards him is the overhanging tree, the crossed branches of which resemble a naked female torso like that in a title-page ornament for *The Yellow Book* (p.116).

Left: DESIGN FOR A FRONTISPIECE TO *A FULL AND TRUE ACCOUNT OF THE WONDERFUL MISSION OF EARL LAVENDER*, 1895. Illustrating a perverse but humorous book on flagellation by John Davidson, this drawing is delicate and elegant, bringing a sort of gentility to a coarse subject that makes it amusing rather than shocking. The prostitute, holding up her dress with her right hand and flourishing the whip in her left, resembles a figure on a Greek vase, and the kneeling youth's face is tactfully not revealed, leaving to the imagination his reception of such treatment.

Right: CHOPIN BALLADE III, 1894.
This drawing in Indian ink and
watercolour wash shows Beardsley in
serious, lyrical mood, a side of himself
that he usually kept carefully hidden,
even from close friends. The work may
be intended as a visual analogue of
Chopin's music — Beardsley was
intensely musical — but the musical title
may also have been suggested by those
of Whistler's studies and paintings. The
use of wash allows the work to be more
tonal than Beardsley's line drawings, the
monumentality of the equestrian figure
being enhanced by modelling.

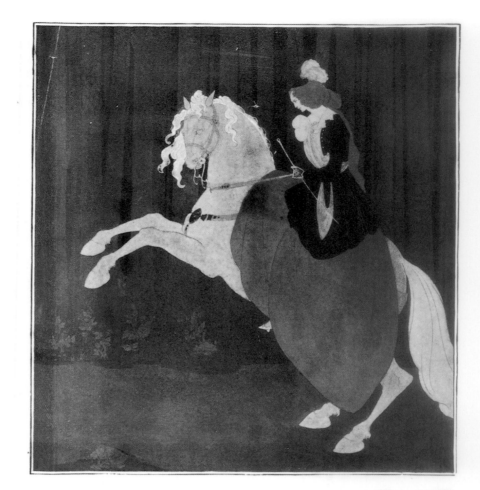

Right: PORTRAIT OF MISS LETTY
LIND, 1895. Letty Lind, a young actress
of the time, is here depicted in costume
for her appearance in the play *The
Artist's Model* — though she is dressed
more like an artist than a model. The
drawing is distinguished by deft human
touches, like the undone shoelace, and
the white space punctuated by items that
economically set the scene in an artist's
studio: easel, canvasses and model's
chair.

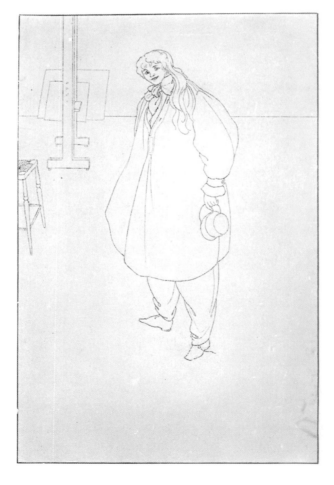

144

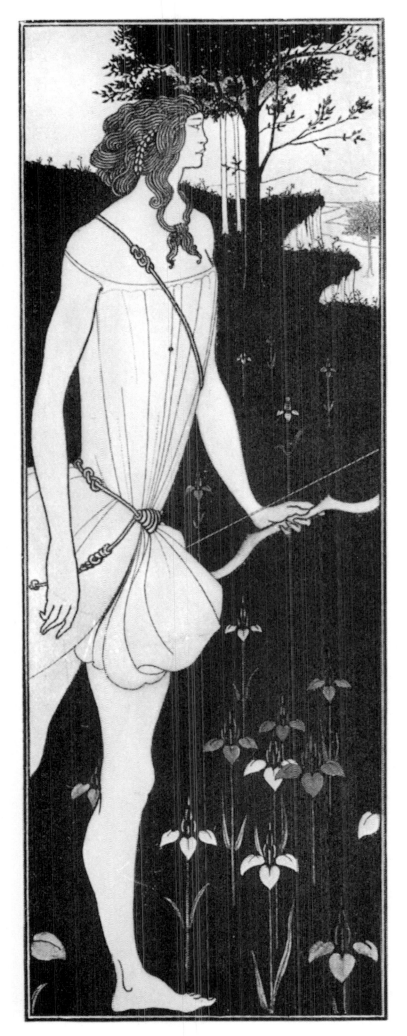

Left: ATALANTA IN CALYDON, 1895.
Intended for the fifth volume of *The Yellow Book*, this is one of two drawings Beardsley made of the huntress Atalanta, to illustrate Algernon Charles Swinburne's poetic drama of the same name written in classical Greek style. Many *fin-de-siècle* artists were inspired by Swinburne's rich verse, but Beardsley particularly so. Here the Arcadian huntress, with bow in hand, strides on to the page on short, rather masculine legs, wearing a peculiar, corset-like garment that flattens her breasts.

Overpage. Top left: DESIGN FOR SPINES OF *SCENES OF PARISIAN LIFE*, *c.* 1896. Blocked in gold, this mask design embellished the spines of eleven volumes of Balzac's novels, which were published by Leonard Smithers, the man who came to Beardsley's rescue by commissioning work from him after his dismissal from *The Yellow Book* in 1895. This striking mask, with horned cap, hovers over two breast-like shapes that may be read as being looked down upon, and therefore belonging to, the viewer, so drawing one into an unholy league with this grinning devil.

Overpage. Right: TITLE-PAGE ORNAMENT, *c.* 1895. Little is known of the provenance of this design, which seems not to have been published until 1899 in *The Early Works of Aubrey Beardsley*. It is in the classical Greek style adopted (and adapted) by Beardsley after long periods in the British Museum spent studying Grecian vases, to which the artist's debt is obvious. When it was eventually published the public were shocked by the erotic implications of a naked man fingering, and playing upon, the feminine forms of the instrument.

THE SPIRIT OF BEARDSLEY

Below: HEAD OF BALZAC, *c.* 1896. This saturnine portrait was for the front cover of *Scenes of Parisian Life* from Balzac's *La Comédie Humaine*. The French novelist was one of Beardsley's literary heroes and, when he was only nineteen, he astonished an expert on the subject with his amazing knowledge of Balzac's work. He once told a friend, 'I suppose my favourite authors are Balzac, Voltaire, and Beardsley.' There is an enormous energy of line in this portrait, which brilliantly conveys the virility and intelligence of the great French writer.

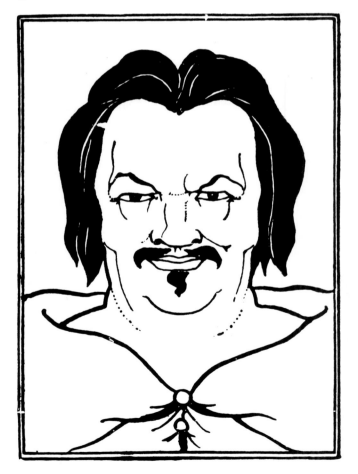

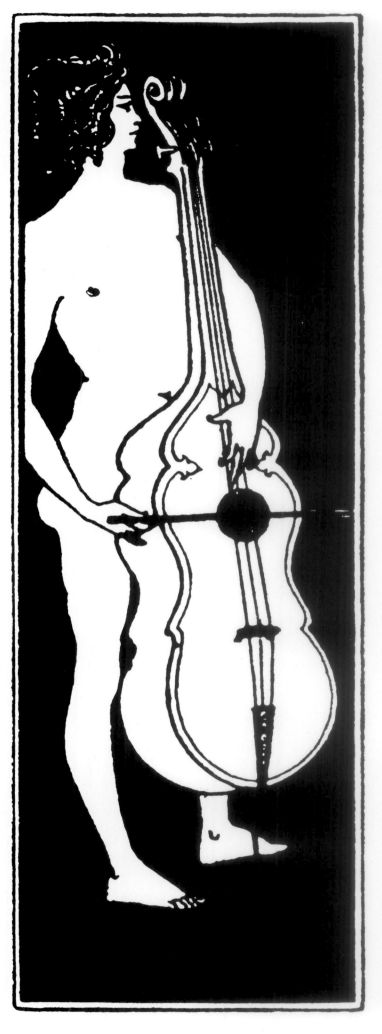

THE SPIRIT OF BEARDSLEY

LYSISTRATA

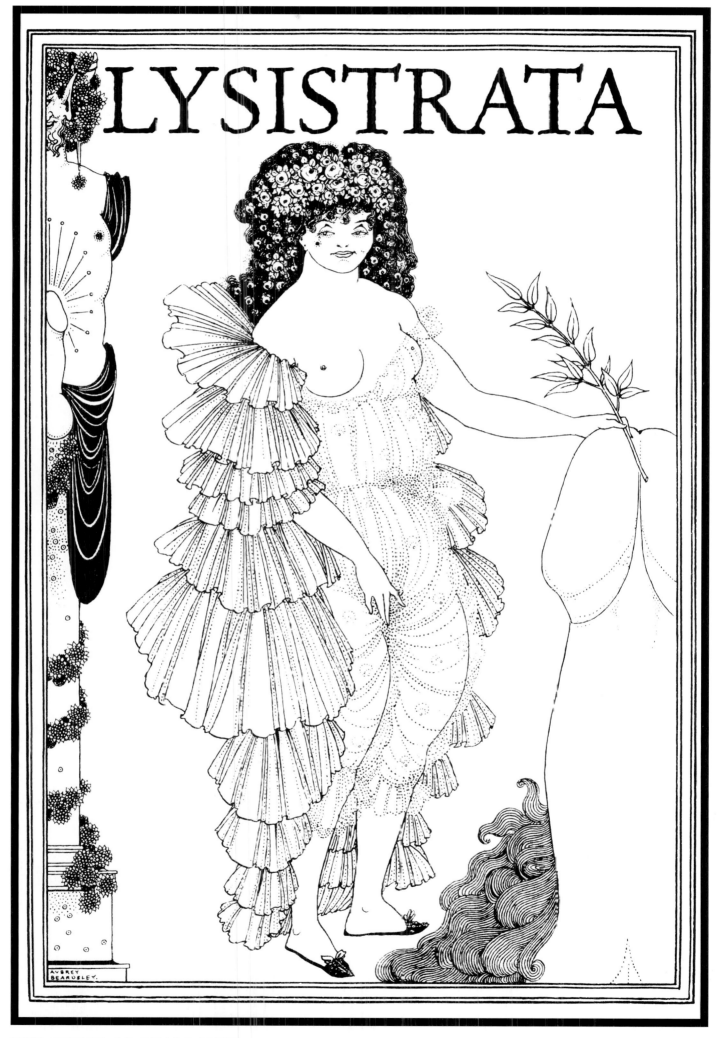

Right: THE TOILET OF LAMPITO, *LYSISTRATA*, 1896, This is one of eight drawings illustrating Aristophanes's great comedy, the theme of which is the Athenian and Spartan women's refusal to have sex with their husbands in protest against war. In this imaginary scene, Lampito, one of the Spartan women summoned by Lysistrata to the strike-meeting, prepares for the day, assisted by an excited little cupid. Published by Leonard Smithers for private distribution, the explicit erotic content of these designs has distracted attention from their aesthetic excellence.

Far right: LYSISTRATA HARANGUING THE ATHENIAN WOMEN, 1896. Here Lysistrata, wearing an extravagantly ruched cloak and bloomers, hand-in-pocket like a boy, exhorts the women, 'Well, we must abstain from — Penis', in the belief that by refusing sex they will persuade their men to stop waging war. One of the women addressed demonstrates what they can do as a substitute. It is interesting that Beardsley includes a middle-aged woman among the sexually empowered.

Page 150: LYSISTRATA DEFENDING THE ACROPOLIS, 1896. According to the text, a chorus of 'old' women put out the flames kindled by 'old' men to smoke the sex-strikers out of the Acropolis, which they are occupying. In this amusingly bawdy illustration, the fleeing man is old — reduced and shrivelled — but the women defenders young and plump (and wearing provocative stockings like those of the women in Félicien Rops's prints). The bending woman might be more likely to cause an explosion than to put out the fire.

Page 151: TWO ATHENIAN WOMEN IN DISTRESS, 1896. The unusual composition of this design, and especially the hand reaching into the frame, has been much discussed. Here, as the sex-strike continues and the men refuse to end the war, the women themselves begin to feel the effects of enforced abstinence, and Lysistrata discovers some of them trying to escape. Beardsley has chosen to interpret quite literally her lines in the play about finding one of them 'slipping down by pulley', and the surreal image of stopping another by dragging her 'off a sparrow by the hair'.

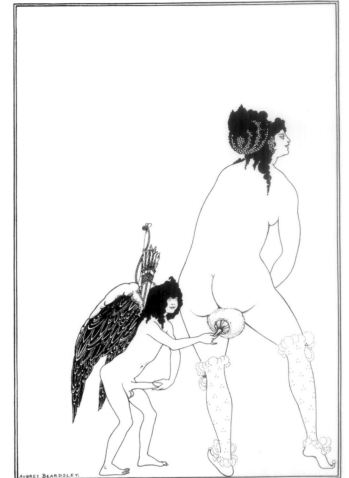

Page 152: CINESIAS ENTREATING MYRRHINA TO COITION, 1896. In this illustration Myrrhina, one of the women on sexual strike, has been encouraged by Lysistrata to drive her husband Cinesias to distraction by teasing him, then denying him sex at the last moment. Hardly able to see over his enormous erect penis, he is literally blinded by desire, and can only catch at her all-revealing gown as she flees, laughing at her power. The towering feathers that crown the husband's head augment the impression of overpowering tumescence.

Page 153: THE EXAMINATION OF THE HERALD, 1896. The herald has brought news that the women's denial of marital rights, headed by Lysistrata, has been so successful that the Spartans are frustrated enough to make peace.

Beardsley's magistrate, who is too old and withered to be actively involved, examines the herald physically rather than verbally, to see if the news is true. The magistrate wears heart-earrings and his facial expression is lascivious, but the artist has been careful to depict his unaroused state.

Page 154: THE LACEDAEMONIAN HERALDS, 1896. Here the Spartans, or Lacedaemonians as they were also known, come to make peace at last, bringing physical proof of their readiness to 'Make love, not war'. The tiny grotesque with the huge phallus that bumps against his nose, and the figure on the right, peculiarly tufted with body hair and wildly squinting at his own erection, are both so comic as to negate the potentially pornographic nature of the image.

THE SPIRIT OF BEARDSLEY

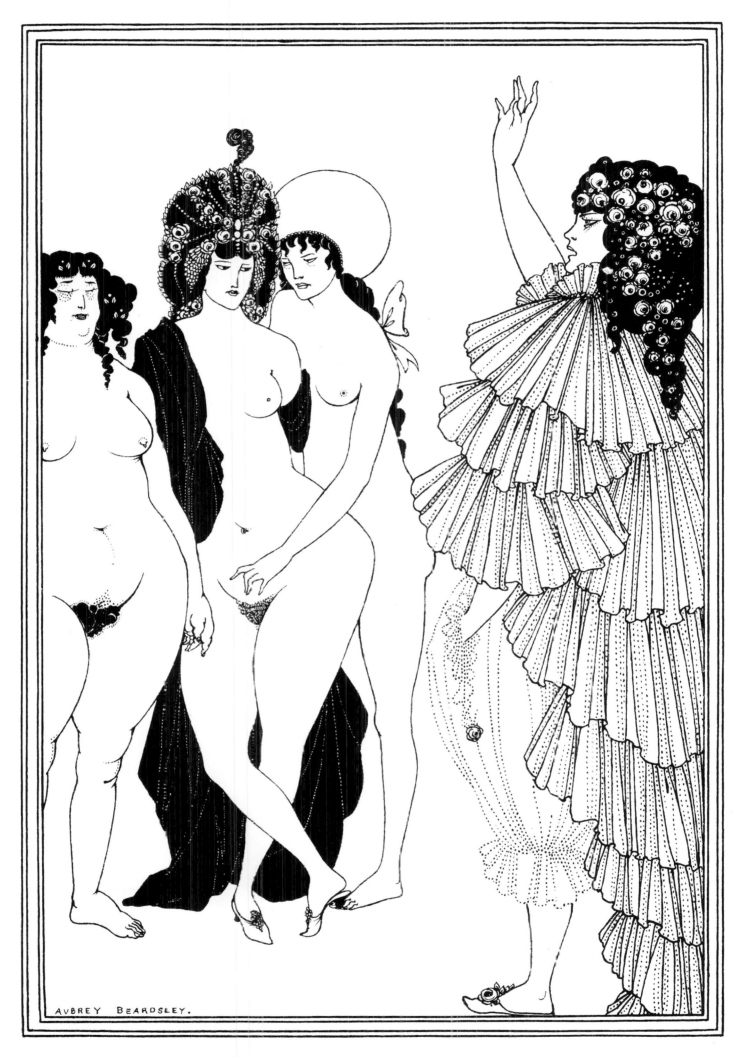

AVBREY BEARDSLEY.

THE SPIRIT OF BEARDSLEY

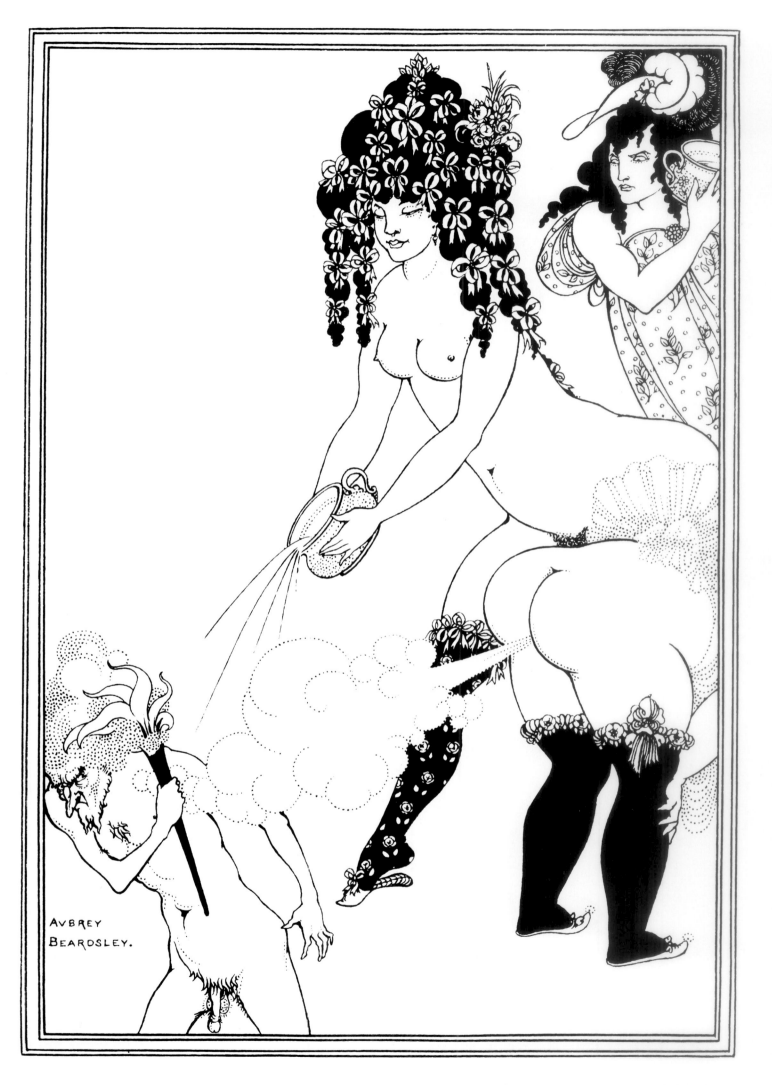

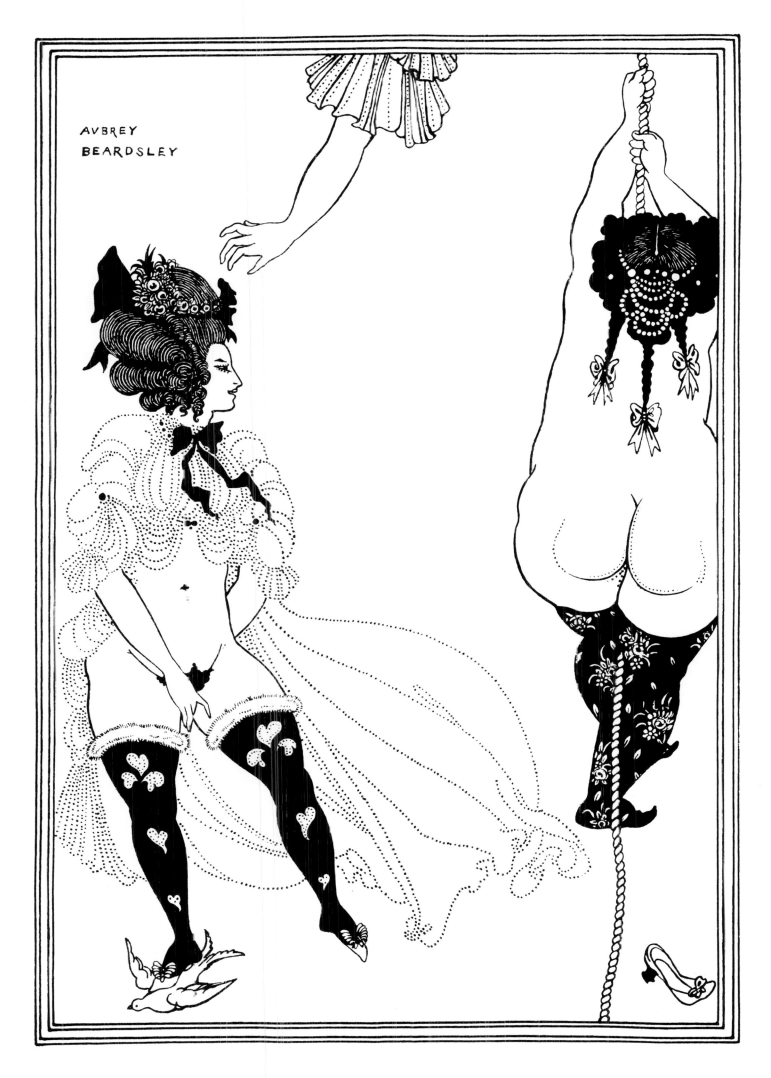

AUBREY
BEARDSLEY

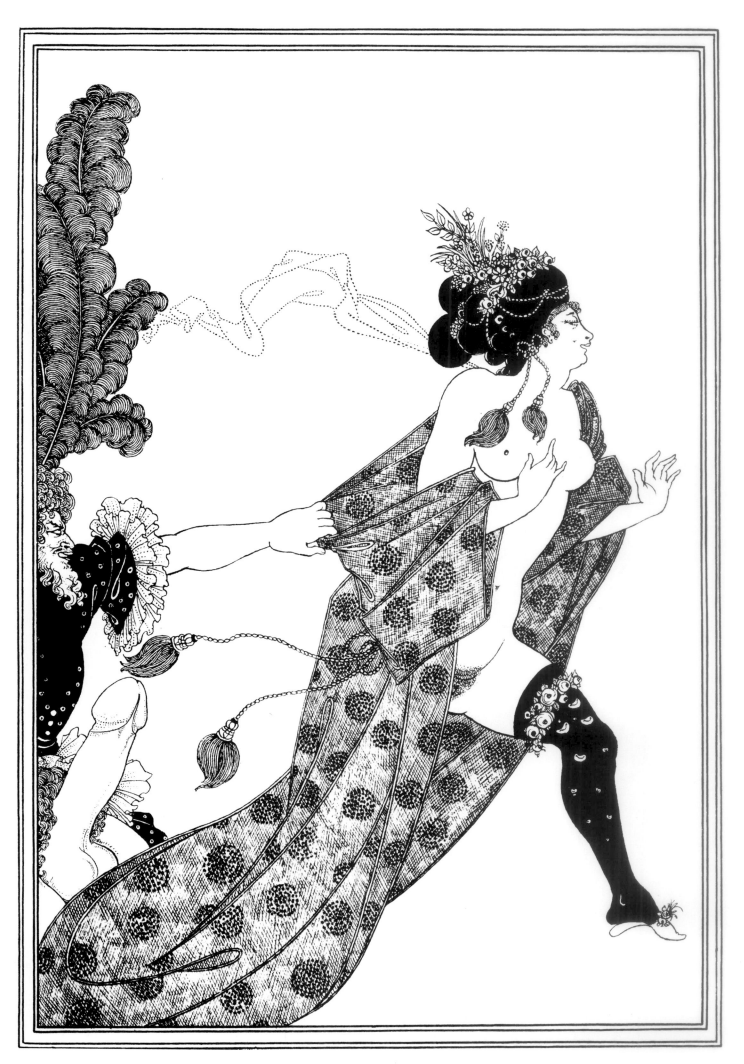

THE SPIRIT OF BEARDSLEY

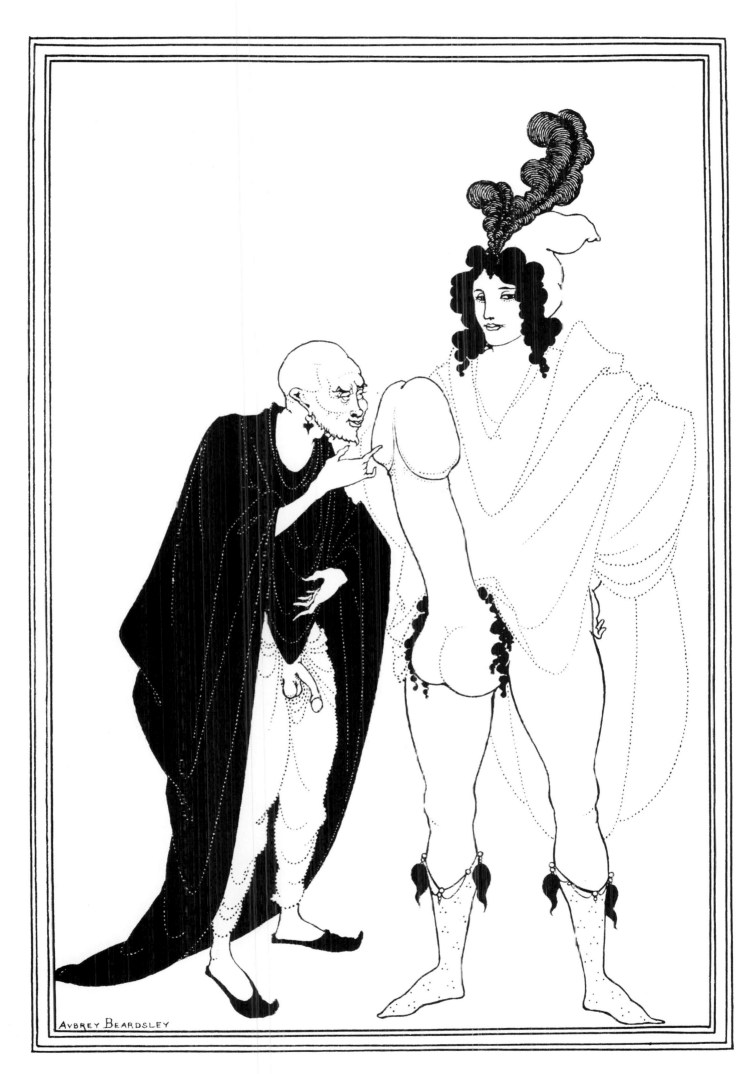

THE SPIRIT OF BEARDSLEY

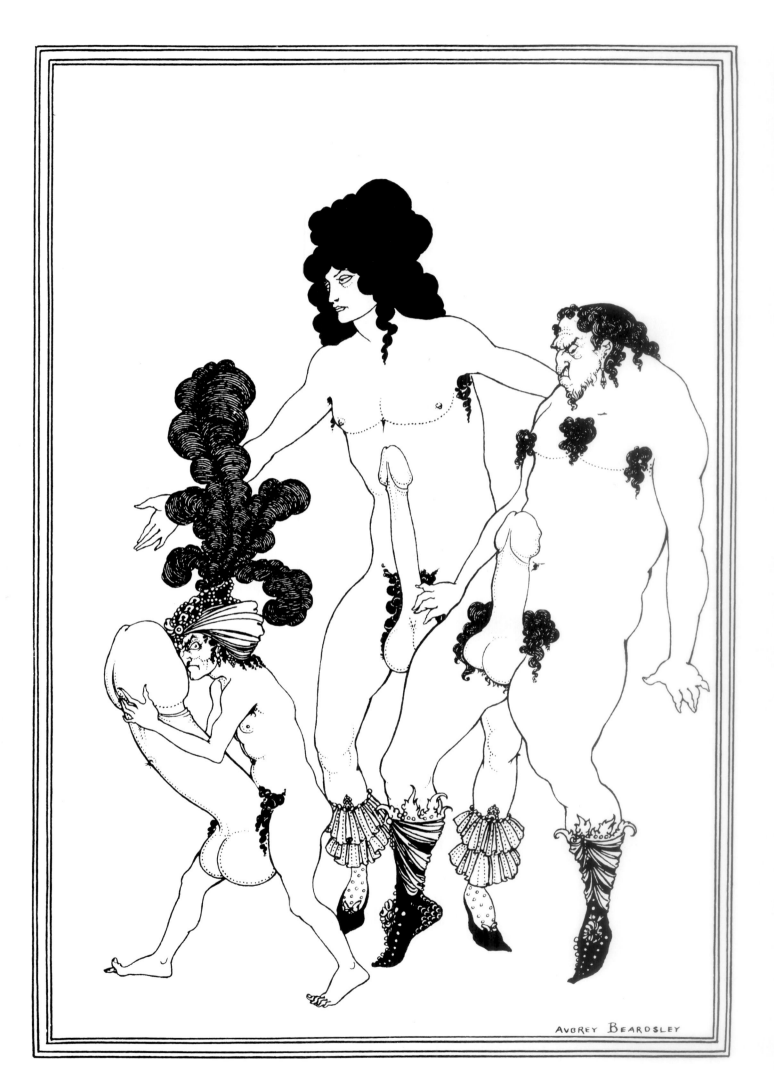

THE SPIRIT OF BEARDSLEY

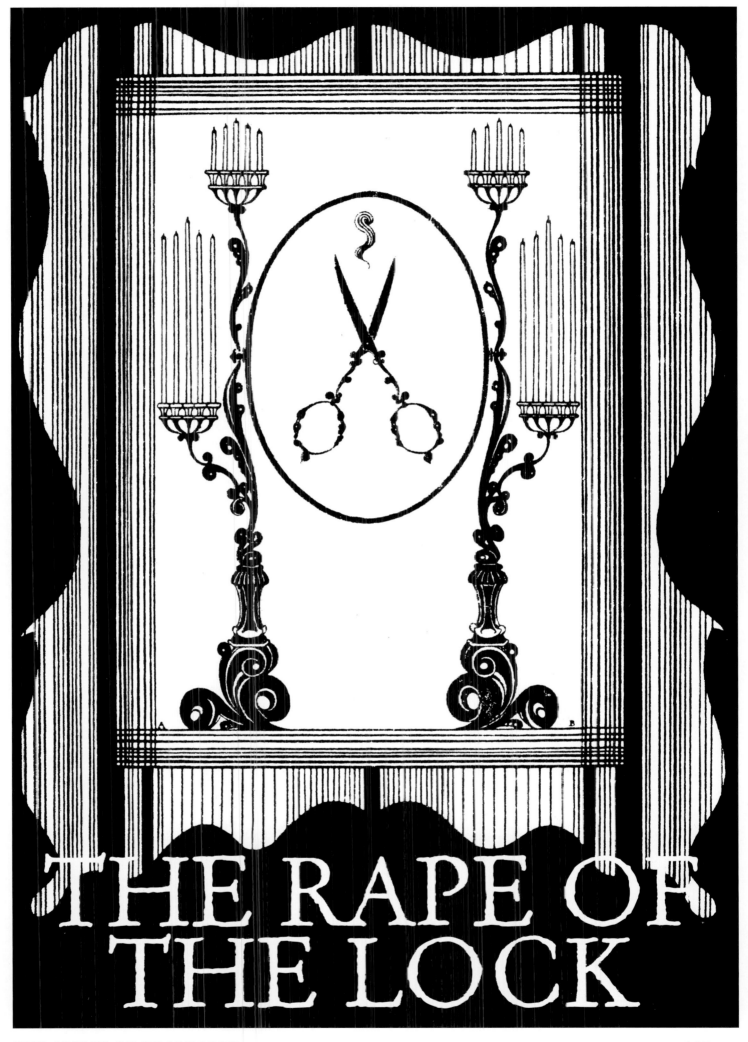

THE RAPE OF THE LOCK

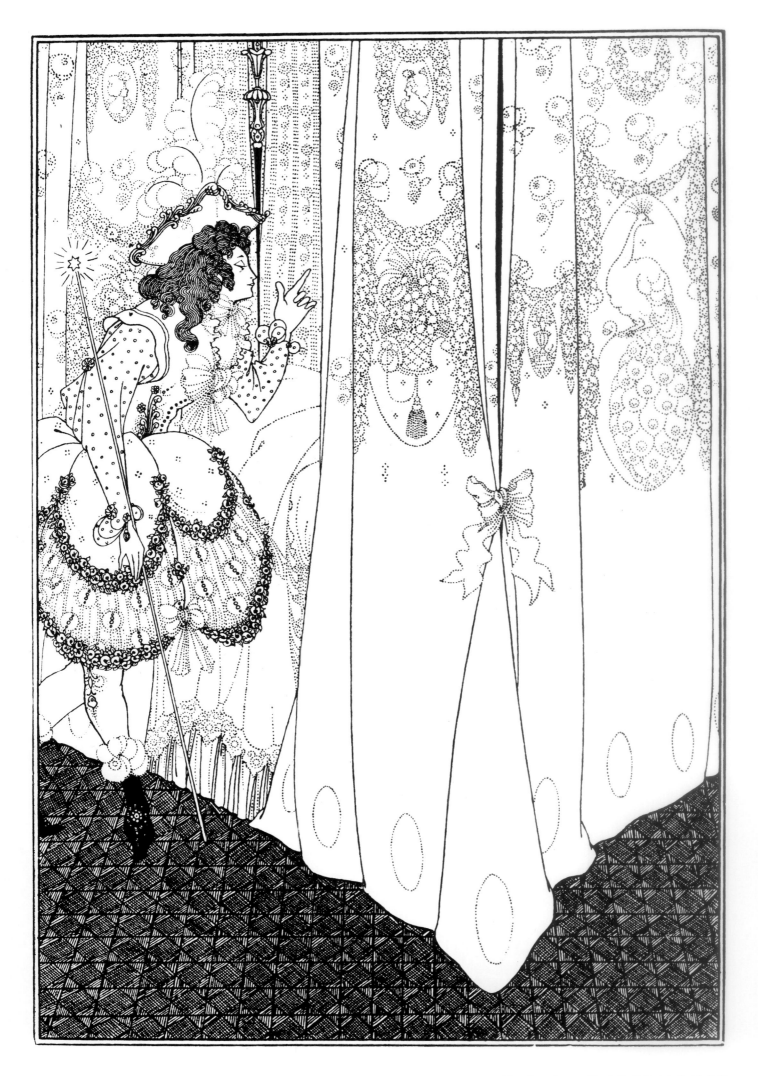

THE SPIRIT OF BEARDSLEY

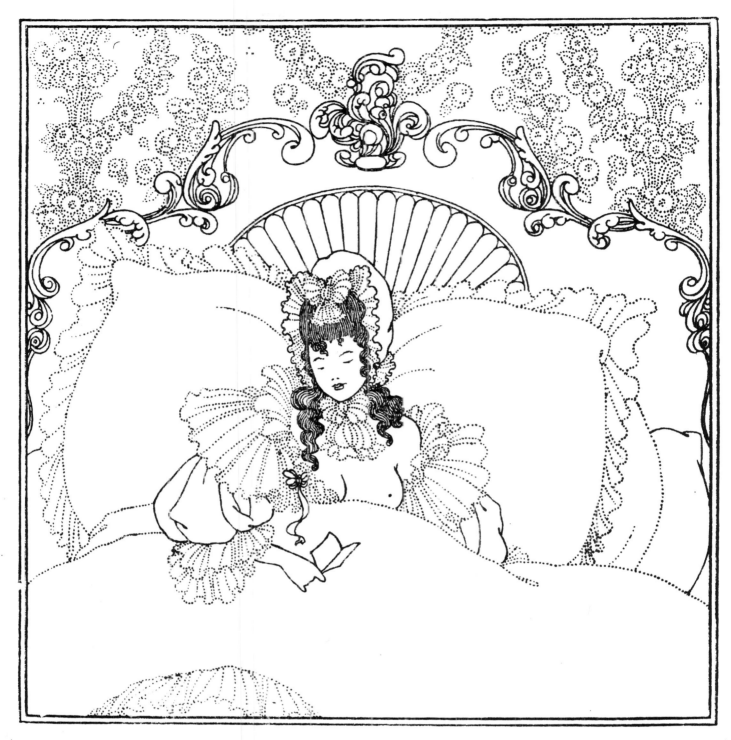

Above: THE BILLET-DOUX, 1896. To dismiss this drawing as merely pretty — as has often been the case — is to misunderstand its context. The prettiness is essential to the satirical point that Belinda, having had the warning-dream to 'Beware of all, but most beware of man!', no sooner looks upon her love-letter than she utterly forgets the admonishment. Instead she lies in a sensuous dream, her exposed 'soft bosom' and exquisite befrilled body transforming her into a sweetmeat in delicate wrappings, irresistible to the male appetite.

Left: THE DREAM, 1896. This is the first of nine lacy masterpieces, which Beardsley called 'embroideries', that illustrate Alexander Pope's mock-heroic poem *The Rape of the Lock* (1714). Here Belinda's guardian sylph summons for her a 'morning dream' to protect her honour. Beardsley revered Pope, saying that he had, 'more virulence and less vehemence than any of the great satirists'. It is easy to see that Beardsley was attracted to Pope's work because, like his own, it used surface artifice to conceal a serious art.

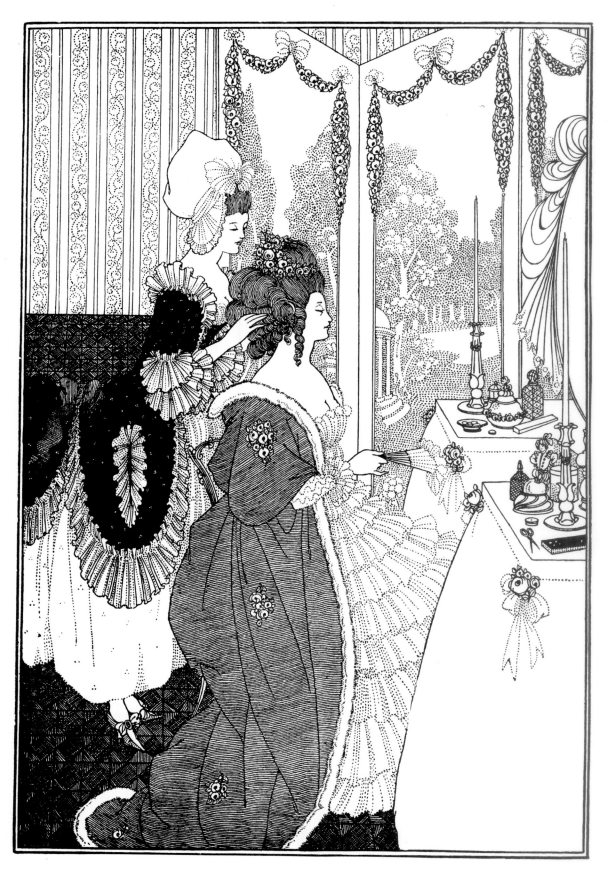

Above: THE TOILET, 1896. The female dressing-table as altar was a subject Beardsley depicted almost obsessively, and Pope's descriptions of women's ritual objects offer an insight into the nature of this fascination. Lines like, 'And now, unveiled, the toilet stands displayed,/ Each silver vase in mystic order laid', had been pored over by Beardsley as a child. No-one can read, 'Here files of pins extend their shining rows,/ Puffs, powders, patches, bibles, billet-doux', and the rest of Pope's description of 'The Toilet', without hearing, in literary form, Beardsley's visual treasury.

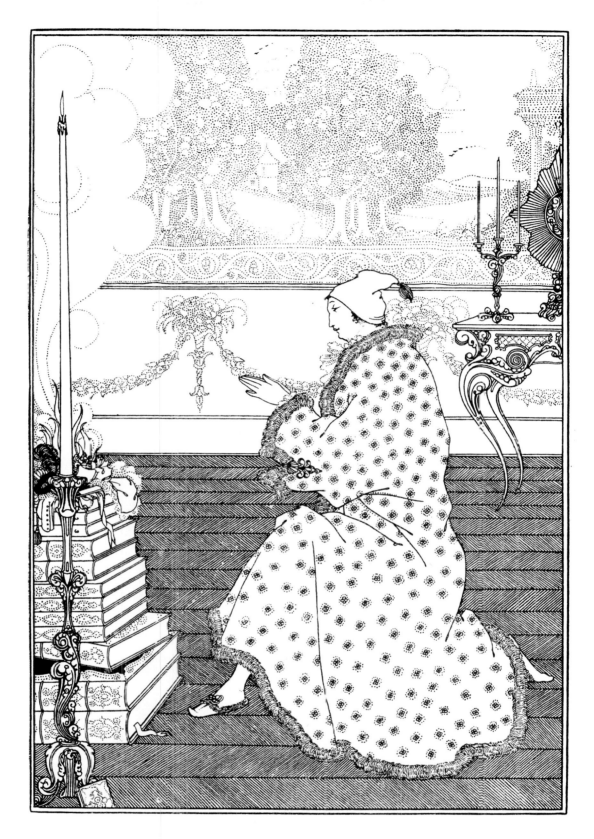

Above: THE BARON'S PRAYER, 1896. The contrast of line and stippling in *The Rape of the Lock* drawings give them a delicacy unlike any other works in Beardsley's *œuvre*. In this scene 'Th'adventr'ous baron' kneels before his own altar, on which he is burning 'all the trophies of his former loves', while praying to obtain a lock of Belinda's hair. The subversion of using the image of an altar in this way delighted Beardsley as much as it had Pope.

Overpage: THE BARGE, 1896. Here Belinda, 'launched on the bosom of the silver Thames', wears 'on her white breast a sparkling cross' — again a subversive use of Christian iconography. Accompanying her in the barge are the 'well-dressed youths' of the poem, whom Beardsley has made foppish and degenerate. According to Pope, Belinda's guardian sylph is worried, as well he might be, for in the guise of a page, and regarding Belinda proprietorially, is the Gnome, who represents the dangers that lie in wait for any beauty who becomes too proud.

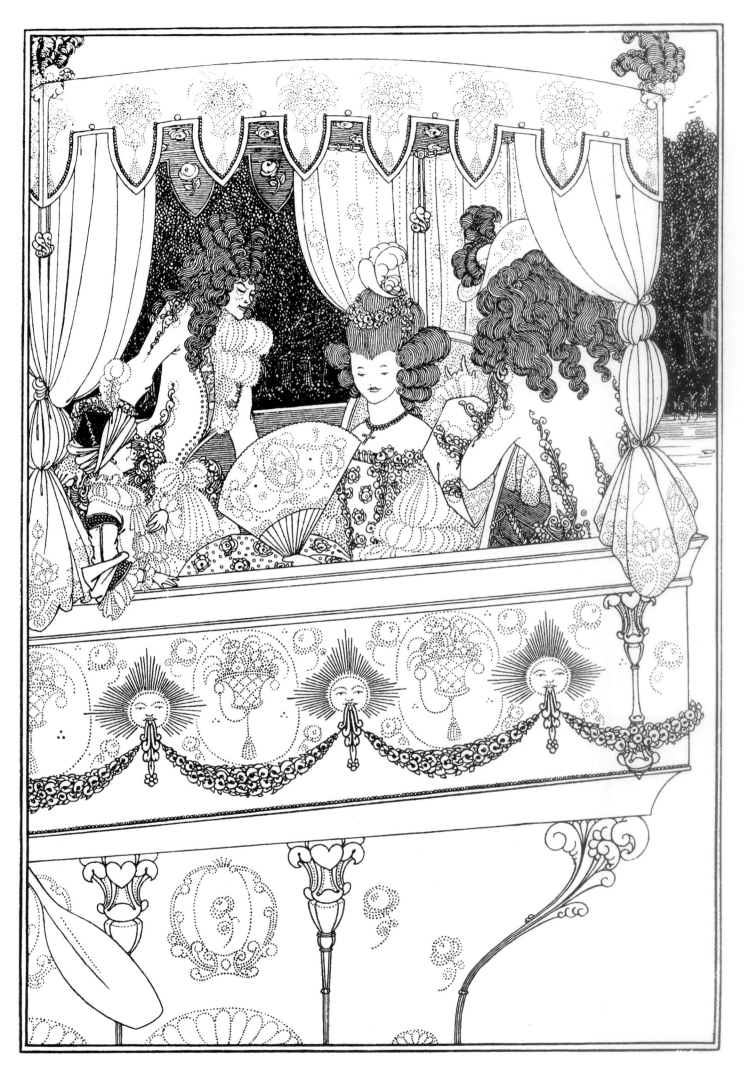

THE SPIRIT OF BEARDSLEY

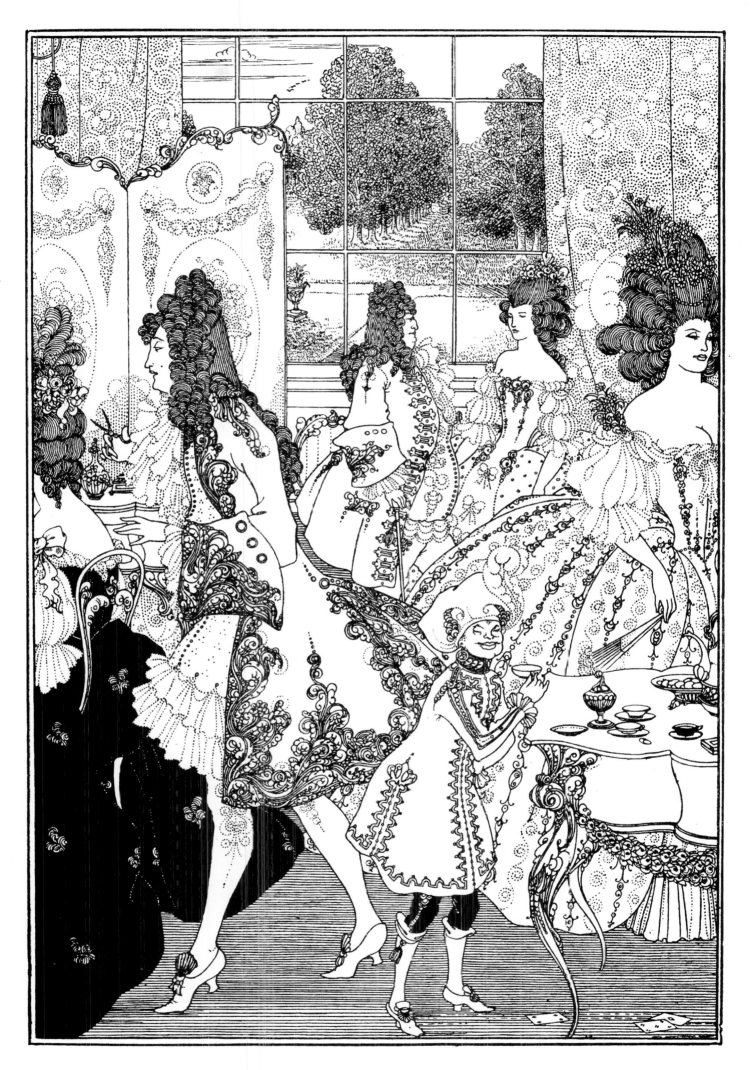

Previous page: THE RAPE OF THE
LOCK, 1896. It is difficult to believe that
the illustrations for *The Rape of the Lock*
were made by a desperately ill young man
— Beardsley had less than two years to
live. Here the artist depicts the central
event of the poem, the snipping of the
ringlet, but marginalizes it, making it just
one action among many. Indeed the
Baron seems more intent upon scissoring
Belinda's hair decorations than cutting the
lock at the nape of her neck, which,
according to the poem, was the one he
chose. In the foreground the sinister, page-
like Gnome smirks with the success of his
schemes.

Right: THE CAVE OF SPLEEN, 1896.
Beardsley's tendency was to interpret a
text loosely, adapting it to reflect his own
visual imagination, but in this drawing
every detail of Pope's poetic description
has been included. The 'dusky,
melancholy sprite', Umbriel, with his
'branch of healing spleenwort in his
hand', addresses 'Ill-nature', the 'ancient
maid' who clutches prayers and
lampoons, while 'Affectation' languishes
to her right. 'Men prove with child'
appears at the bottom left (note the
embryo), and, with typically Beardsleyan
panache, the 'living teapot' in the
foreground wears the laced cuffs of a
dandy.

Right: COVER DESIGN OF THE BIJOU
EDITION OF *THE RAPE OF THE
LOCK*, 1896. In 1897 Leonard Smithers
published a smaller volume of the poem,
and this design was stamped in gold on
the red cloth cover. It is a simple,
symmetrical decoration, but distinguished
by the same stippled technique as is used
to such effect in the illustrations.
Beardsley, always the perfectionist, took
care to send Smithers an example of the
lettering he required for the title.

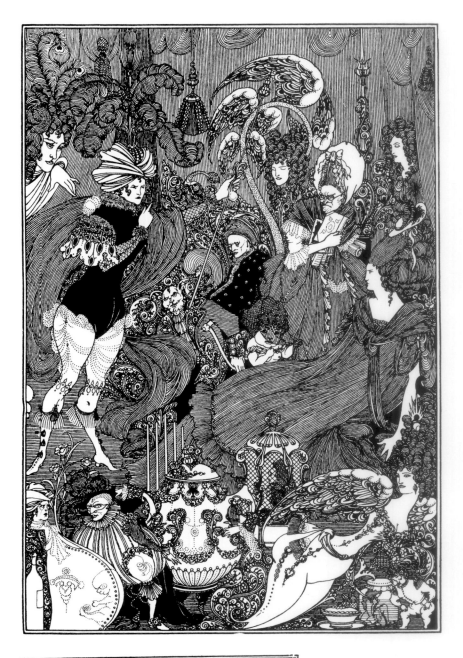

162

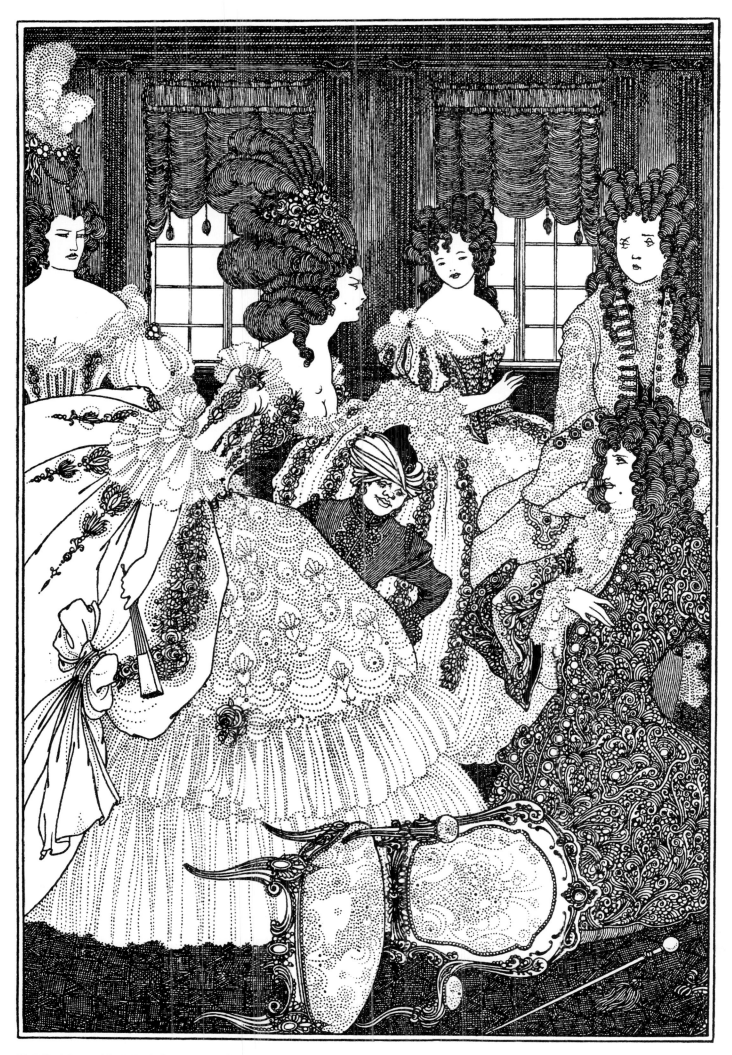

THE SPIRIT OF BEARDSLEY

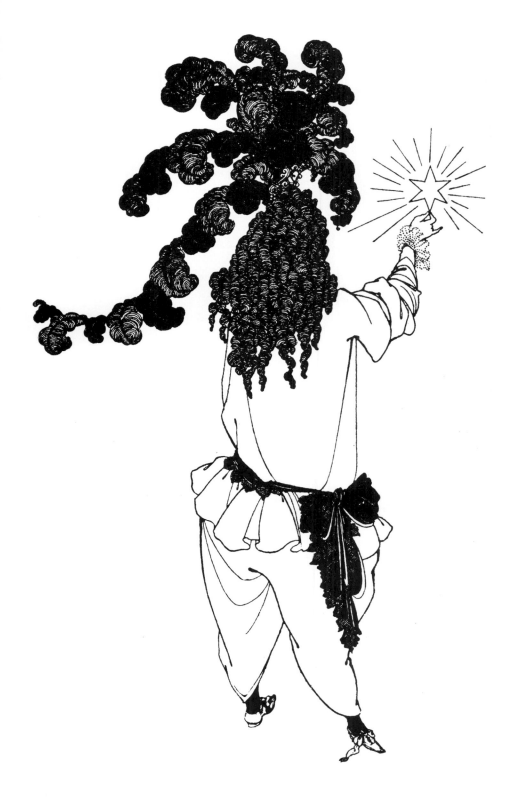

Previous page: THE BATTLE OF
THE BEAUX AND THE BELLES,
1896. Umbriel, 'the hateful gnome',
having emptied a bag of chagrin from
the 'Cave of Spleen' over the Belles'
heads, battle commences — 'Fans
clap, silks rustle, and tough
whalebones crack', and 'fierce Belinda
on the Baron flies, / With more than
usual lightening in her eyes.' Beardsley
has included every detail of the poem,
including the overturned chair and the
baron on his knees, but has added the
malign dwarf who peeps smugly from
behind the heroine's skirts.

Left: THE NEW STAR, 1896. This
cul-de-lampe for *The Rape of the
Lock* shows Belinda's lost lock
transformed into 'a sudden star', a
satire on the convention in epic poems
whereby dead heroes (like Troilus in
Chaucer's *Troilus and Criseyde*)
appear in the heavens. To emphasize
the comedy of the situation, Beardsley
makes the Muse who holds the star a
ridiculous figure, with a voluminously
plumed wig, an ungainly body and
short legs that taper to tiny loose-
bowed shoes.

THE SPIRIT OF BEARDSLEY

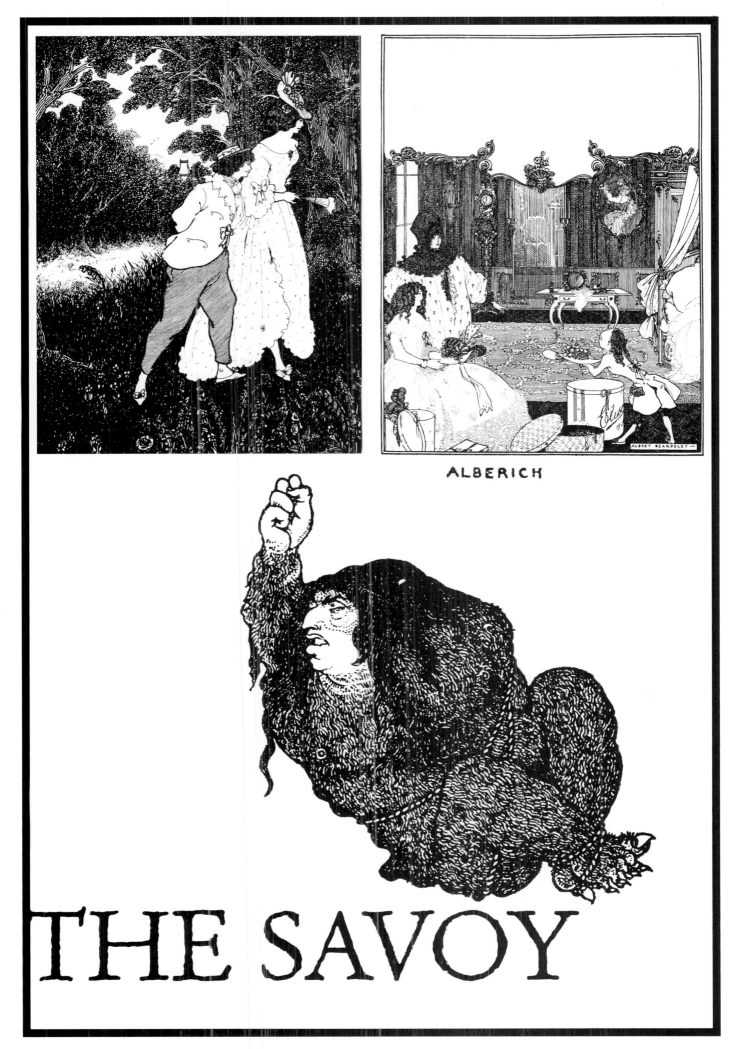

ALBERICH

THE SAVOY

Right: DESIGN FOR THE PROSPECTUS
OF *THE SAVOY*, 1895. Beardsley's
dismissal from *The Yellow Book* threw him
into limbo, from which he was rescued by
Leonard Smithers, a man whom Oscar
Wilde described as 'the most learned
erotomaniac in Europe'. Smithers published
The Savoy magazine as a vehicle for
Beardsley's work, although it was soon to
attract other talented contributors. This
drawing shows a comical pierrot, parading
on to the stage on winged feet. Smithers
complained that the image trivialized the
content of the magazine, and suggested the
substitution of a John Bull figure, a criticism
resented by Beardsley, and so mischievously
sent up by him (see p. 167).

Below right: INITIAL LETTER FROM
THE PROSPECTUS OF *THE SAVOY*,
1895. It is in such small designs as this that
Beardsley's attention to detail is particularly
apparent, and he was especially meticulous
when his enthusiasm was aroused, as it was
for *The Savoy* venture. Deeply mortified at
being dropped from *The Yellow Book,* and
identified with Wilde as a disciple of 'the
love that dare not speak its name', he dearly
wanted the new magazine to succeed. Here,
perhaps for good luck, he used his favourite
motif of the trailing rose, a debt to his early
mentor, Edward Burne-Jones.

Far right: DESIGN FOR THE
PROSPECTUS OF *THE SAVOY* , 1895.
This is Beardsley's riposte to Smithers's
criticism of his first drawing for the
prospectus (above). Keeping every other
detail practically the same, the artist
substituted a fat John Bull in place of the
pierrot figure, and impishly drew a
suspicious bulge in his trousers beneath the
distended stomach. Other contributors
demanded that this image be withdrawn, and
Smithers, knowing that the prospectus had
already been circulated, agreed. Rumours of
the argument only added to sales of *The
Savoy*. An expurgated version of this
drawing appeared as the title-page (p. 170).

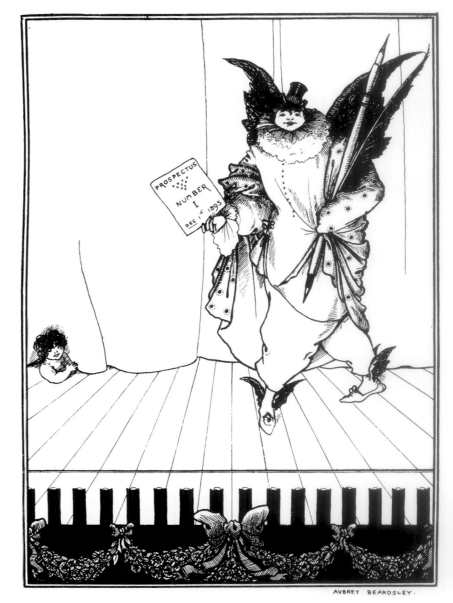

THE SPIRIT OF BEARDSLEY

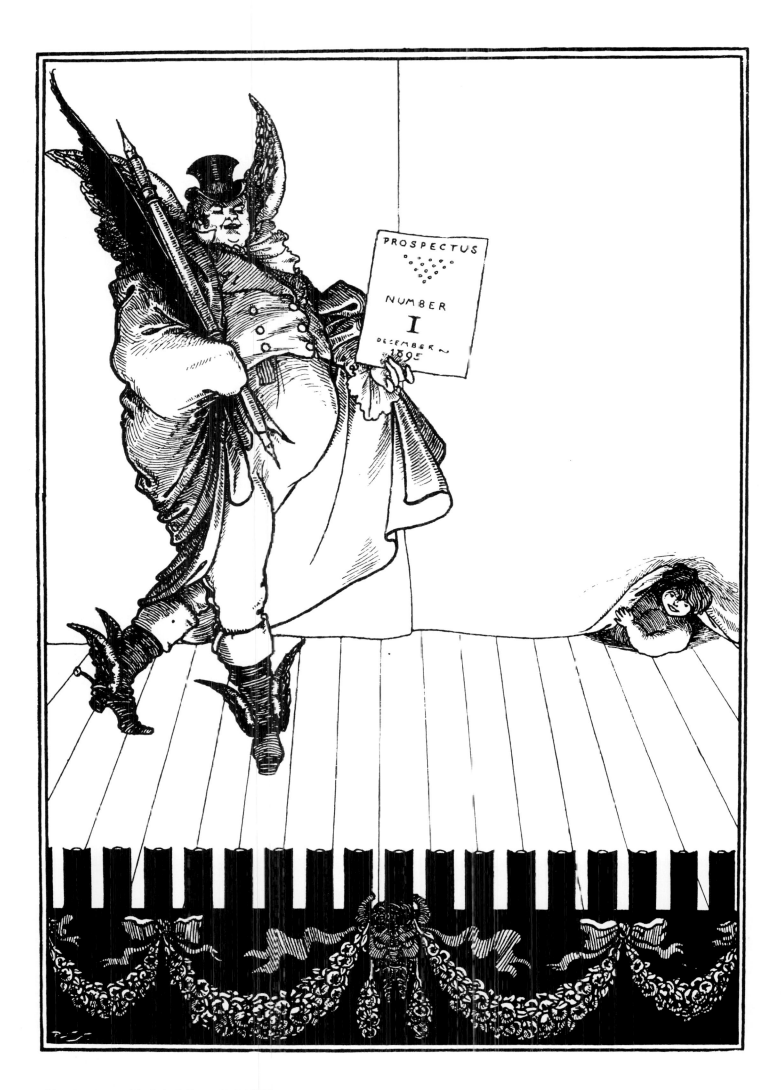

Right: SIEGFRIED, 1896. This is the
imprint design of the publisher Leonard
Smithers. It first appeared in the prospectus
for *The Savoy* magazine and was
reproduced in *The Later Work of Aubrey
Beardsley* with the title 'Siegfried'. The
upper space featured the name 'Leonard'
and the lower, 'Smithers'. It anticipates
Beardsley's moving 'Ave Atque Vale'
(p. 180) in its concentration on the
beauty of the human arm. Beardsley
portrays the hero 'Siegfried' re-forging the
sword, Nothung, with which he will first
kill the dragon, Fafner, then his secret
enemy, Mime.

Below right: TITLE-PAGE OF *THE
SAVOY*, NO. 1, 1896. Unusually,
Beardsley's use of white space is here
unsuccessful. The drawing looks
unfinished, as if he had forgotten to put in
the legs of the dressing-table, and, although
all the most characteristically Beardsleyan
elements are included — the mysterious
figures, the candlesticks and the masks —
the work has a forced theatricality. Even
erotic details look awkward, especially on
the left figure, whose dress has three breast
shapes in its outline.

Far right: COVER DESIGN OF *THE
SAVOY*, NO. 1, 1896. Never one to
forgive easily, Beardsley tried to use the
front cover of the first issue of *The Savoy*
to wreak revenge upon *The Yellow Book*,
which he placed in the foreground of the
picture with the little putto about to
urinate over it. Other contributors to *The
Savoy* objected, and this version of the
drawing subsequently appeared. In their
satisfaction over this expurgation, few
noticed other erotic implications, such as
the phallic herm just behind the young
woman's rear, her outfit and crop,
suggestive of flagellation, and the sensual
forms on the sun dial.

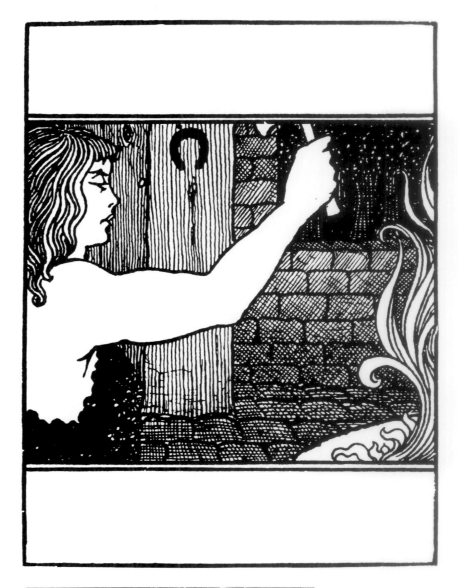

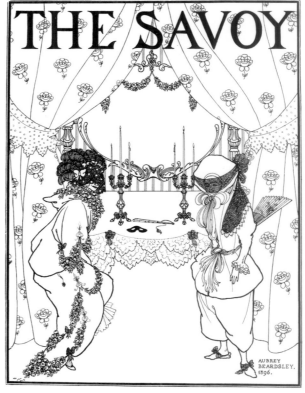

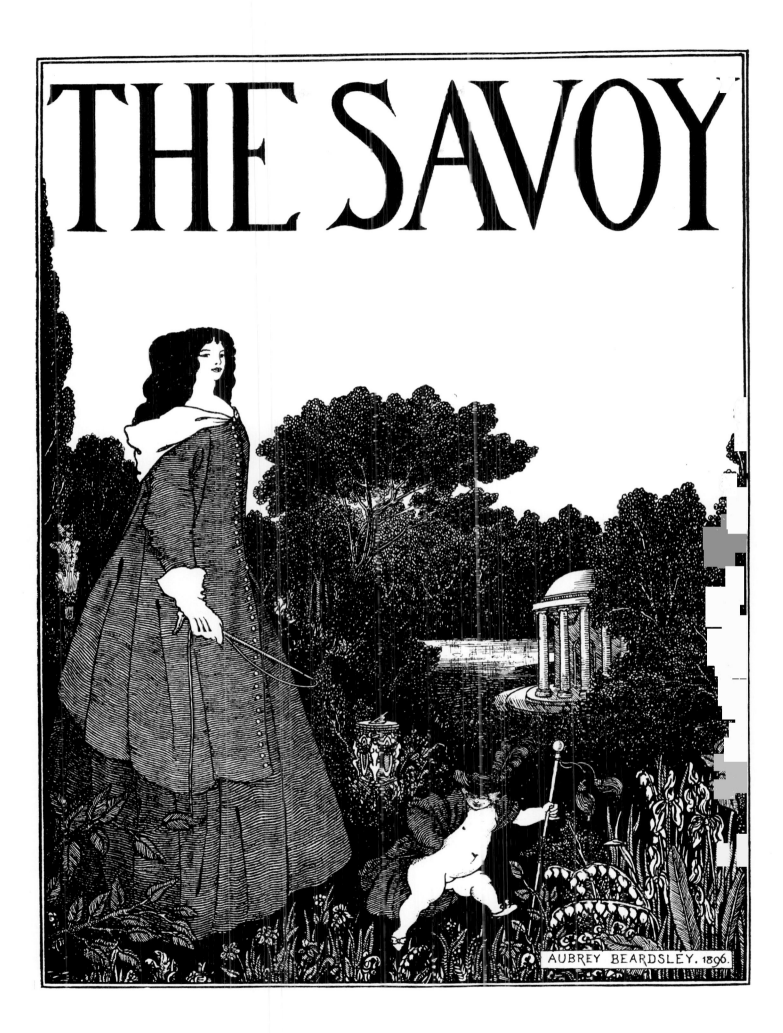

THE SAVOY

AUBREY BEARDSLEY. 1896.

Right: CONTENTS PAGE OF *THE SAVOY*, NO. 1, 1896. Here stands the expurgated John Bull, a third and final version of the controversial drawing originally intended for the prospectus for the magazine (see pp. 166-7). It is fascinating to spot the similarities and differences between the three designs. This version differs from the second in that the stage setting and peeping cherub have disappeared, the wings are smaller and have migrated from shoulder to hat, a bull-dog's head and paw now appear at the bottom left, and John Bull's crotch is concealed by his cloak — with characteristic stubbornness Beardsley avoided drawing him minus his genital bulge.

Below right: THE THREE MUSICIANS, 1895. The drawing illustrates a poem by Beardsley, written while he was in Dieppe with his co-editor of *The Savoy*, Arthur Symons. It was published in January 1896 in the first issue of the magazine. The poem concerns a 'soprano, lightly-frocked', 'a Polish pianist' and 'a slim and gracious boy' who is in love with the soprano. Writing to his sister Mabel, Beardsley confided that the soprano was in reality the actress Sophie Menter, so he perhaps pictured himself as the boy, who, in the poem, enjoys the favours of the singer. Another version of this drawing that mildly implied this was suppressed.

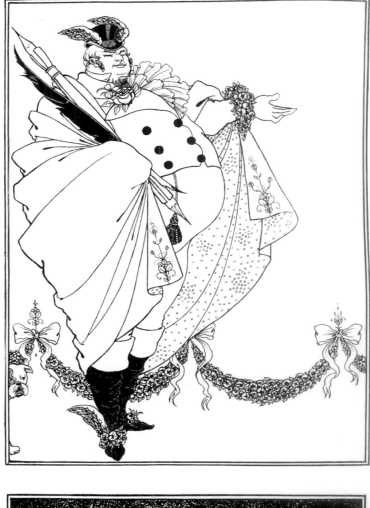

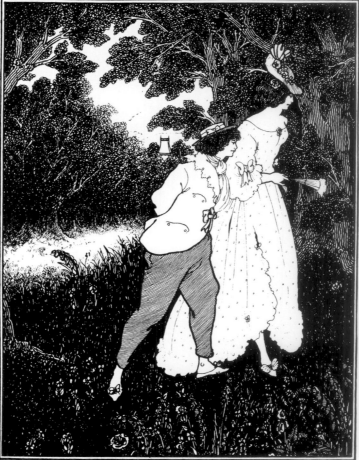

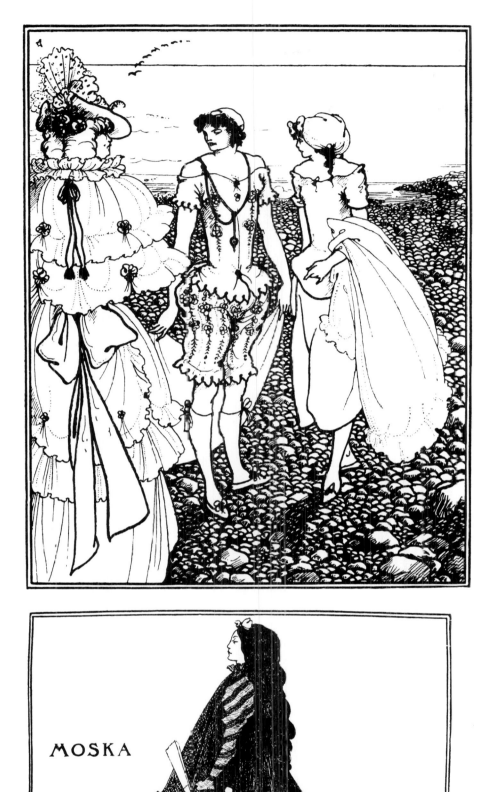

MOSKA

Left: THE BATHERS, OR ON DIEPPE BEACH, 1895. The summer that he produced this work, Beardsley, according to Arthur Symons, hardly ever went near the sea. The strange study accompanied an article by Symons on Dieppe that appeared in the first volume of *The Savoy*. The androgynous central figure is the actress Cléo de Mérode, who always wore a gold chain over her bathing-dress — a habit that Beardsley thought extremely bizarre — and is here depicted in an odd corseted bodice and bulging knickerbockers. More outlandish still is the ornately dressed figure to the left, the identity and significance of which is not known.

Below left: MOSKA, 1895. The Moska was a dance performed in the Bal des Enfants at the Dieppe casino, where Beardsley and his friend Arthur Symons spent a great deal of time. These children's dances fascinated the artist, and Symons reported that 'Beardsley would glide in every afternoon, carrying his large, gilt-leather portfolio with the magnificent old, red-lined folio paper.' Removed from its setting, this little figure has the appearance of a ballet costume design, an effect reinforced by the inclusion of the title of the work.

THE SPIRIT OF BEARDSLEY

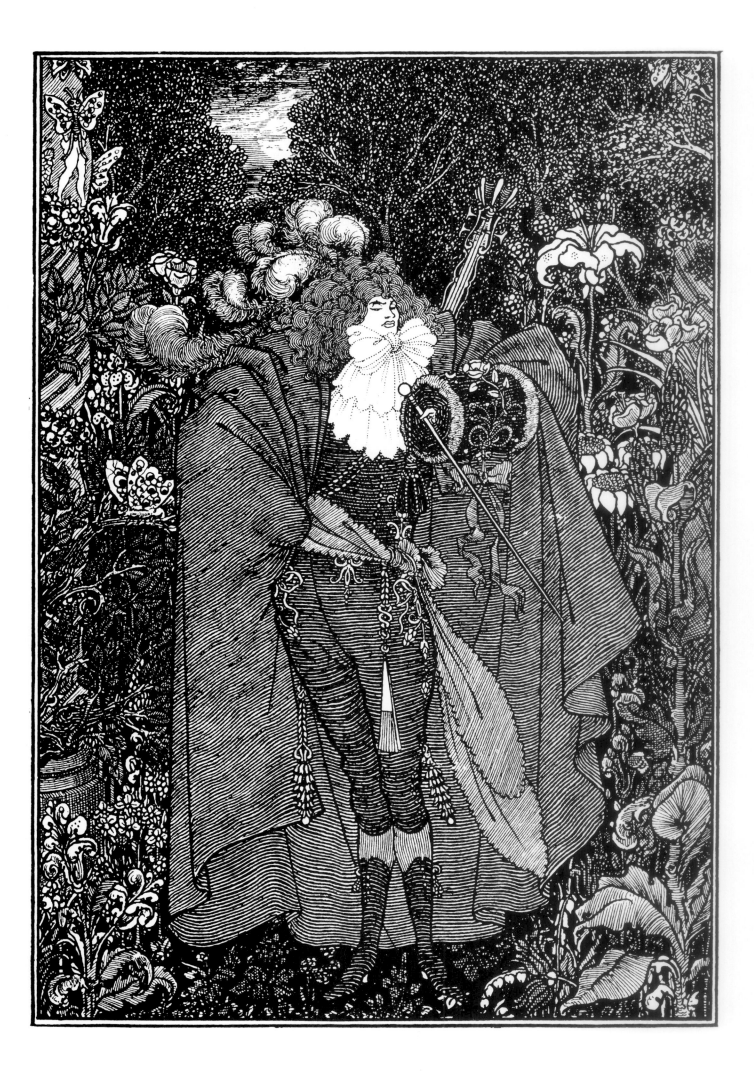

THE SPIRIT OF BEARDSLEY

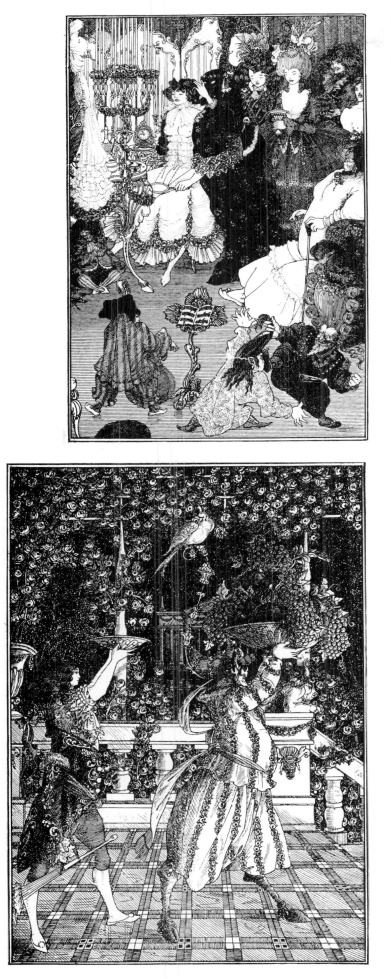

Far left: THE ABBÉ, *c.* 1896. This elaborate drawing shows the 'Abbé Fanfreluche', hero of Beardsley's experimental erotic novel *Under the Hill*, fragments of which were published in *The Savoy*. 'Abbé' stood for Beardsley's initials in French, and 'Fanfreluche' was French slang for copulation. Here the Abbé has come to court Helen and is 'troubled with an exquisite fear lest a day's travel should have too cruelly undone the laboured niceness of his dress.' He stands, 'quelling the little mutinies of cravat and ruffle', and notices that 'a wild rose had caught upon the trimming of his muff'. The prose of the novel is as magniloquent as this drawing is elaborate.

Above left: THE TOILET OF HELEN, *c.* 1896. In illustrating his own novel, *Under the Hill*, Beardsley was more faithful to his text than he had been to those of most others. Here Helen is being prepared for her orgy with the Abbé, 'In a flutter of frilled things'. 'Her neck and shoulders were wonderfully drawn and the malicious breasts were full of the irritation of loveliness that can never be entirely comprehended, or ever enjoyed to the utmost.' Words and drawings dovetail, too, in the foreground figures, which Beardsley described as 'doubtful creatures, pinching each other and behaving oddly enough'.

Left: THE FRUIT-BEARERS, *c.* 1896. In this sumptuous illustration for his novel, *Under the Hill*, Beardsley makes word and drawing vie for richness of detail. He described Helen's supper as 'a veritable *tour-de-cuisine*', 'served by satyrs dressed in white', and here a satyr on gaitered hooves bears a massive, overflowing platter. Other details are suitably enigmatic and disconcerting. The other servant wears his frock-coat at half mast, a pig-like sphinx smirks on the balustrade, and it is not clear whether the bird is sitting on the trellis or is an extension of the satyr's hat.

Right: CHOOSING THE NEW HAT, 1896. This cover design for the second volume of *The Savoy* magazine is much influenced by Beardsley's study of late eighteenth-century French prints: the interior, furnishings, and the costume of the hatter, are faithful to that period. Beardsley described the little figure as 'not an infant, but an unstrangled abortion' and, accordingly, it has a foetal head shape. The seated woman could be of the eighteenth century, although her companion belongs very much to the 'Beardsley Period', a phrase coined by Max Beerbohm.

Below right: A FOOTNOTE, 1896. In this drawing Beardsley stands, pen under arm, in front of a broken column. In the original drawing, which was expurgated, he was tethered by the ankles to a herm of the great god Pan, which implied his allegiance to pagan rather than to Christian values. Thus a work vital to an understanding of the artist was censored.

Below far right: A CHRISTMAS CARD, 1896. Beardsley very much disliked this design, which was inserted into the first issue of *The Savoy*, perhaps because he was not allowed to include any of his usual ironies and therefore found it sentimental. However, the theme of mother and child was one that fascinated him, not surprisingly, since as a life-long invalid he had always been very much under the influence of his mother. Whether he resented her dominance is not certain, but often when he represented this relationship he subverted it in some way.

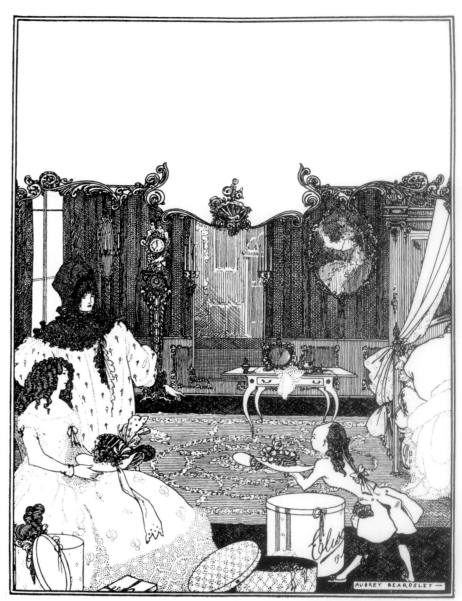

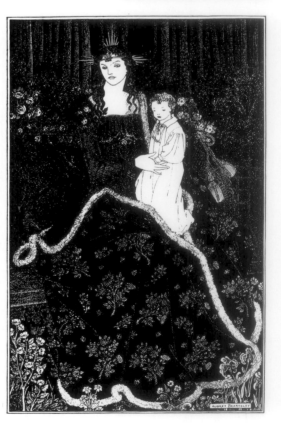

THE SPIRIT OF BEARDSLEY

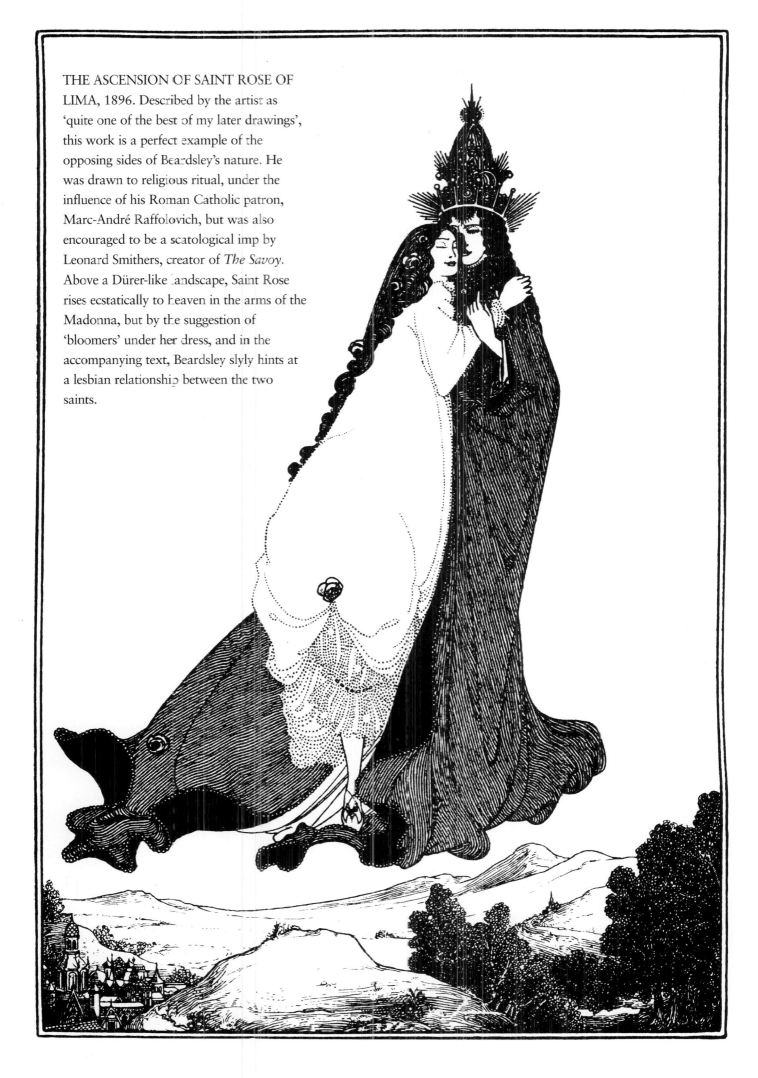

THE ASCENSION OF SAINT ROSE OF
LIMA, 1896. Described by the artist as
'quite one of the best of my later drawings',
this work is a perfect example of the
opposing sides of Beardsley's nature. He
was drawn to religious ritual, under the
influence of his Roman Catholic patron,
Marc-André Raffolovich, but was also
encouraged to be a scatological imp by
Leonard Smithers, creator of *The Savoy*.
Above a Dürer-like landscape, Saint Rose
rises ecstatically to heaven in the arms of the
Madonna, but by the suggestion of
'bloomers' under her dress, and in the
accompanying text, Beardsley slyly hints at
a lesbian relationship between the two
saints.

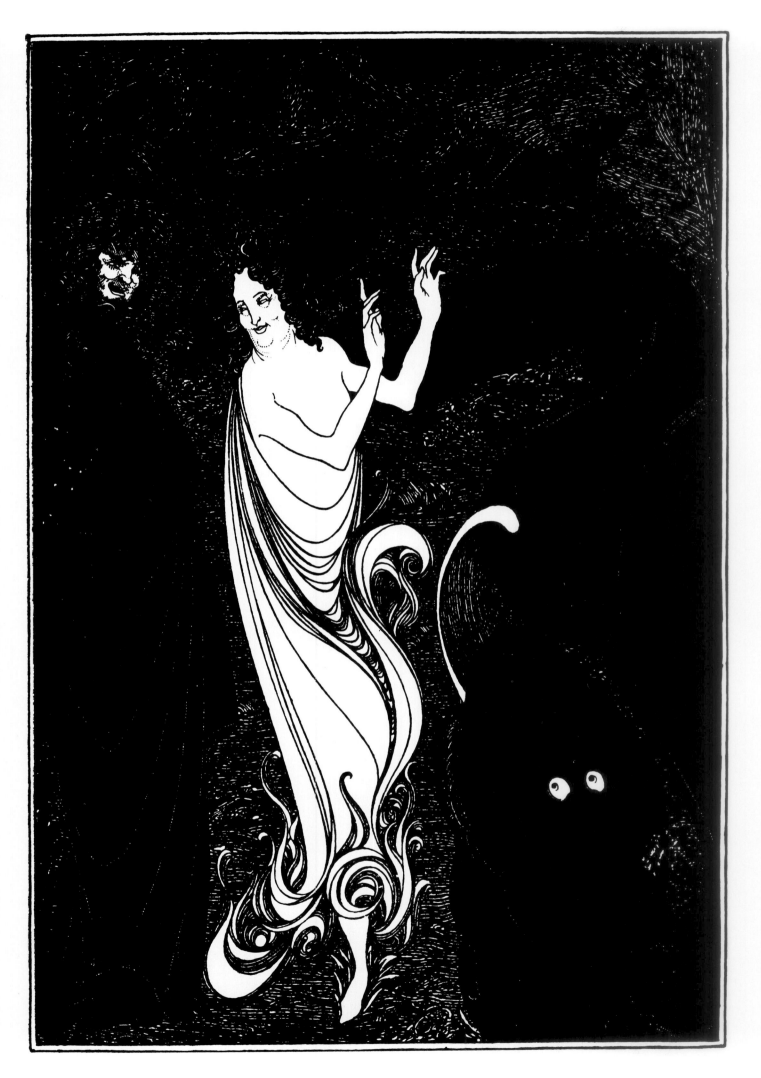

THE SPIRIT OF BEARDSLEY

Left: COVER DESIGN FOR *THE SAVOY*, NO. 3, 1896. Entitled 'The Driving of Cupid from the Garden', this design was printed in black on light blue, the title filling the upper space. A little Cupid in mourning creeps away under the glare of the old man in cuckold's cap, the implication being that young love cannot exist near senile lust. There is irony in the placing of the fountain's phallic shower so near to the dried-up lover, the object of whose attentions seems quite sanguine about love being expelled from this eighteenth-century garden of Eden. Note also the joke in the signature.

Below left: THE COIFFING, 1896. In this illustration for one of his own poems, 'The Ballad of a Barber', which appeared in the third issue of *The Savoy*, Beardsley has carefully portrayed the delicate prettiness of the thirteen-year-old virgin princess, while also giving her the knowing look of a much older woman. Attracted and repelled by her, the carefully coiffed barber, Carrousel, breaks a cologne bottle: 'The princess gave a little scream/ Carrousel's cut was sharp and deep.' The image of love and safety epitomized by the Virgin and Child is here subverted in the horrible contrast of dangerous adult and virgin as victim.

Far left: CUL-DE-LAMPE, 1896. This malign, gibbet-carrying cupid provided an end-note to Beardsley's poem 'The Ballad of a Barber', in which the lustful barber Carrousel slits the throat of the girl whose hair he is dressing. The message, of both the poem and of this silhouette, is that love can be lethal. Beardsley's maternal grandmother was an accomplished silhouettist, although it is not clear whether or not he knew her work.

Left: THE THIRD TABLEAU OF *DAS RHEINGOLD*, 1896. Published in the second issue of *The Savoy*, this drawing is one of a series inspired by Wagner's operatic cycle, *The Ring*. Here the central figure, Loge, the god of Fire, with garments and hair aflame, acts as go-between for Wotan (left), ruler of the gods, and the dragon, Fafner (right). By keeping the overall tone extremely dark, Beardsley has emphasized the burning figure of the fire-god, and contrived a comic effect with the bright eyes and lolling tongue of the dragon. The latter's serpentine coils and the folds of Wotan's cloak are achieved by fine white dotted lines.

THE SPIRIT OF BEARDSLEY

THE
SAVOY

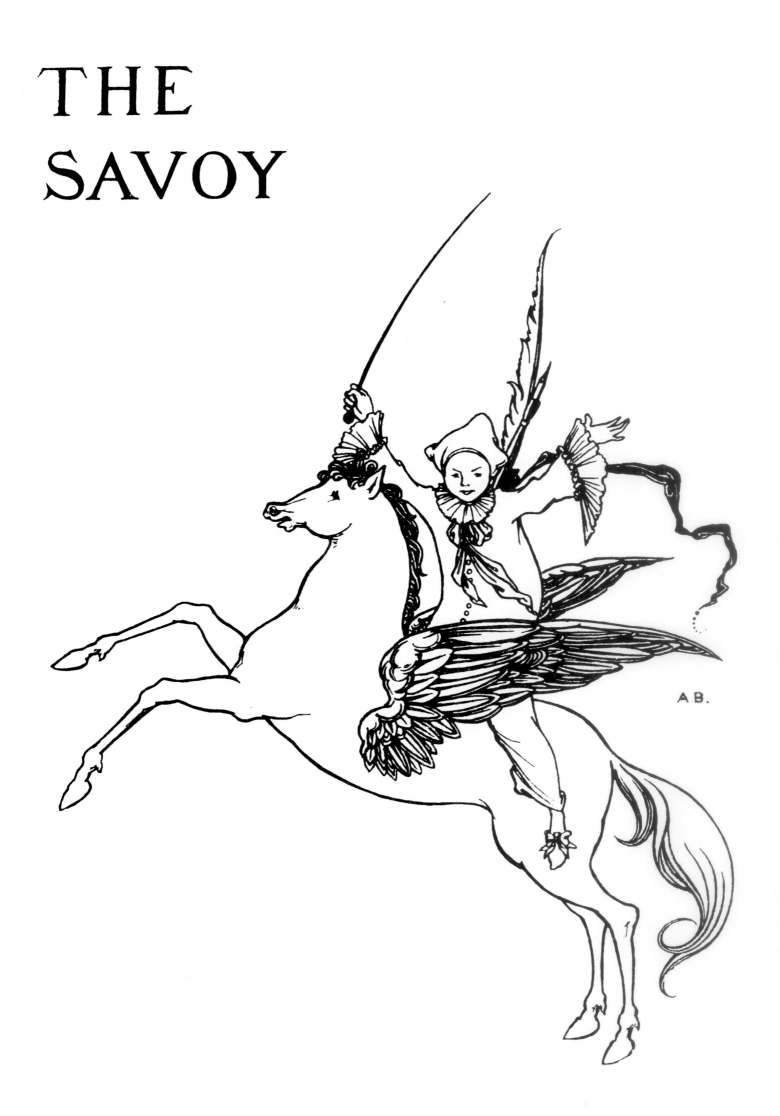

THE SPIRIT OF BEARDSLEY

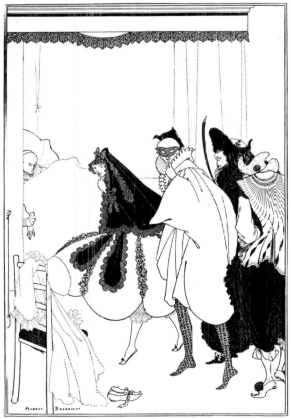

Far left: PUCK ON PEGASUS, 1896. This drawing was used for the title-page of *The Savoy*, issues 3-8, and Leonard Smithers, its creator and editor, also printed a smaller version on several of the books he published. The Puck-Pierrot-Cupid-Clown character is born of all the previous hybridized figures in Beardsley's work. That he identified himself with this diminutive creation is clear, not only from the details of pen and quill seen here, but also from the fact that he wanted to write and illustrate a sequence called 'Masques', with 'a prologue to be spoken by Pierrot (myself)'.

Left: DESIGN FOR THE FRONT COVER OF *THE SAVOY*, NO. 4, 1896. Beardsley had used the image of a woman worshipping fruit on an ornate stand in *Autumn* (p. 139), and a transparent spotted curtain in the poster for *A Comedy of Sighs* (p. 85). Given his urgent need of income to support his unavailing search for health, it is hardly surprising that he should recycle old images. This design has been thought one of his least impressive, but it may have been more successful printed in colour as a cover.

Left: THE DEATH OF PIERROT, 1896. In this drawing for the sixth issue of *The Savoy* Beardsley alludes to his own death in the context of the Commedia dell'Arte tradition. Columbine, Harlequin, Pantalone and The Doctor, all Commedia characters, tiptoe in, hushing the viewer. Through his use of texture the artist contrasts the solidity of these fictitious creations with the frailty of humanity. The clown costume in the foreground hunches in pale emptiness, and Beardsley on the pillow looks faded too. The sagging lace frill of the bed-head suggests it may have been torn at in the desperate last throes of death.

Right: THE FOURTH TABLEAU OF *DAS RHEINGOLD*, 1896. Chosen for the cover of the sixth issue of *The Savoy*, this illustration of Wagner's operatic cycle was one of a series that Beardsley was unable to finish. Here Wotan, ruler of the Gods, refuses to return the ring, stubbornly turning his back. Loge, god of fire, who recognizes the law of change, smiles with a mixture of compassion and cynicism, and the flames that leap upwards from his garments break out in fiery body hair. The rising points of flame, hair and mountains are balanced by the falling lines of cloak and arm.

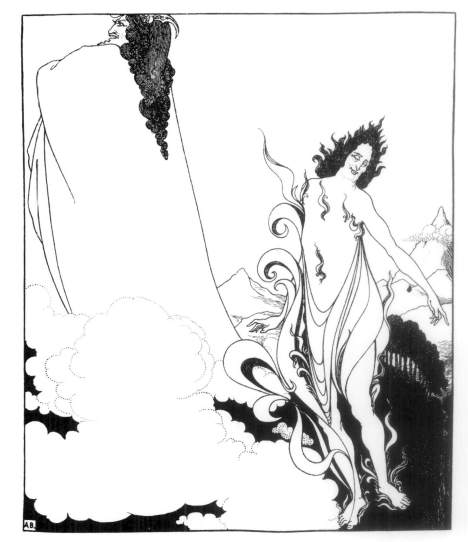

Below right: AVE ATQUE VALE, 1896. Published in the seventh issue of *The Savoy*, this beautiful drawing accompanied Beardsley's translation of 'Carmen CI' by Catullus, a valedictory poem by a Roman to his dead brother, which ends, 'There'll be no other/Meeting; and so hail and farewell, my brother.' Read by many as a work anticipating his own death, and praised for its poignancy and simplicity, it went unnoticed for years that if the navel is read as an eye, Beardsley's profile can be seen in open-mouthed caricature, contrasting with the noble Roman profile above.

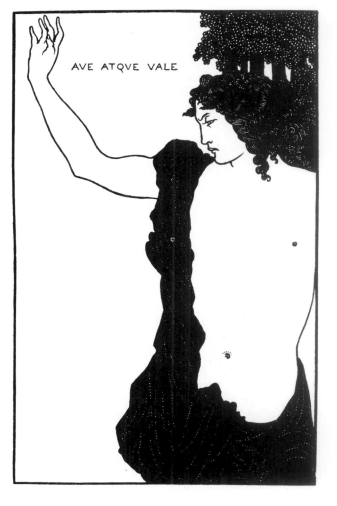

AVE ATQVE VALE

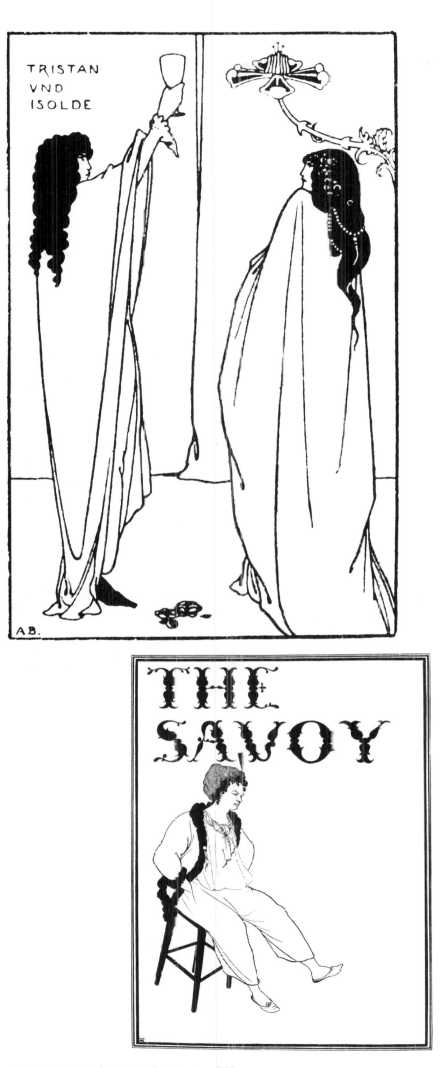

Left: TRISTAN UND ISOLDE, 1896. In this reworking of 'How Sir Tristram Drank of the Love Drink' (p. 55) from *Le Morte Darthur*, there is a strong similarity between hero and heroine, a particular feature of *fin-de-siècle* art. In the words of Mario Praz, in *The Romantic Agony*, 'it is hardly possible to distinguish at the first glance which of the two lovers is the man, which the woman . . . lovers look as though they were related . . . men have the faces of virgins, virgins the faces of youths; the symbols of Good and Evil are entwined and equivocally confused.'

Left: COVER DESIGN FOR *THE SAVOY*, NO. 8, 1896. The drawing was adapted and printed in scarlet and green as a poster to advertise *The Savoy* magazine. Its Eastern mood may have been due to Beardsley planning at the same time a sequence of illustrations of *Ali Baba and the Forty Thieves*, which he was never to complete. The figure rocking forward on the chair has androgynous features and, whatever its gender, looks extremely disgruntled. The lettering contrives to be both plant-like and architectural.

Below: *A RÉPÉTITION OF TRISTAN UND ISOLDE*, 1896. Beardsley was careful to write 'Répétition' in the French way for this illustration, which appeared in the eighth number of *The Savoy* magazine, thus highlighting shades of meaning in the word, such as 'rehearsal' or even 'tuition'. The thrust-out pelvis of the musician on the right, whose male attire covers an extremely feminine body, immediately opens the design to erotic interpretation. The mesmerized and sensuous gaze of the two women, their décolleté style of dress, and the roses on the gowns and instrument, bear out such a reading.

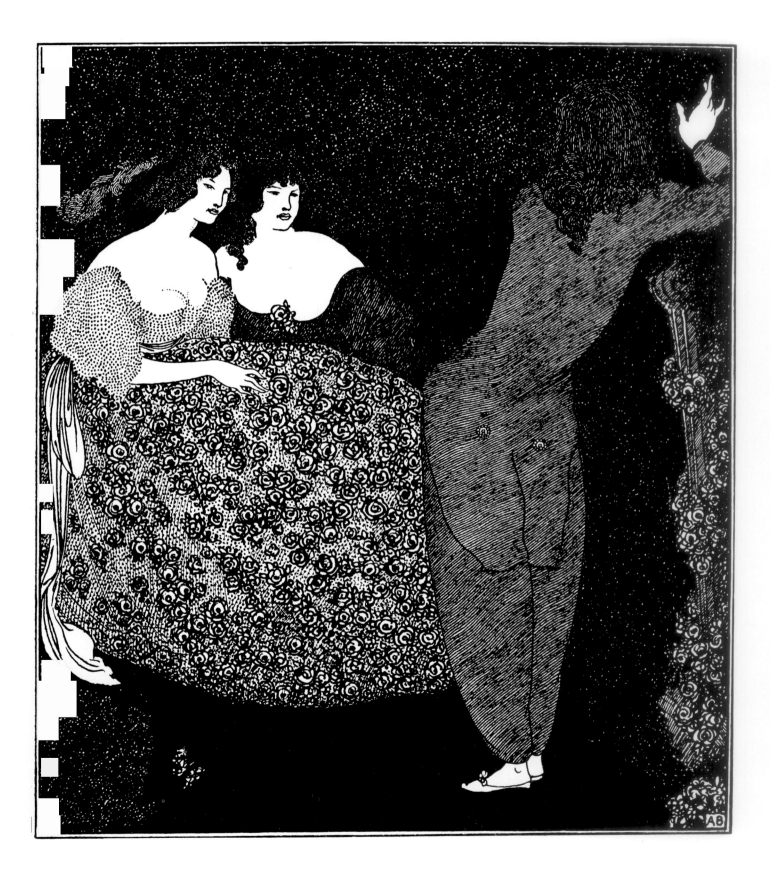

THE SPIRIT OF BEARDSLEY

Below: DON JUAN, SGANARELLE AND THE BEGGAR, 1896. This drawing, which appeared in the eighth issue of *The Savoy*, combines two of Beardsley's major influences, the subject of the illustration being inspired by Molière's *Don Juan*, and the position of the two figures on the left by Watteau's painting *The Italian Comedians*. If the Pierrot-like Don Juan can be read as the artist himself (and Beardsley encouraged this), then again he has portrayed himself as insubstantial by means of his use of the dotted line. The coin in his outstretched hand could also signify the stigmata of his disease, which was considered shameful at the time.

THE SPIRIT OF BEARDSLEY

Right: MRS PINCHWIFE, 1896. Mrs
Margery Pinchwife, from William
Wycherley's *The Country Wife*, was an
ideal subject for Beardsley, given his
mastery of portraying transvestism and
androgyny. The artless young wife,
driven to distraction by her husband's
excessive suspicion of what may happen
to her now they are in town, dresses in
male clothing in order to deceive him.
The eager angle of her body and her
mischievous expression perfectly convey
the cheeky, sensuous nature of the
character and her enjoyment of her
freedom as a man.

Far right: FRONTISPIECE TO *THE
COMEDY OF THE RHINEGOLD*,
1896. This work was intended as one of
a series of illustrations to a volume of
Wagner's *The Comedy of the Rhinegold*,
which was never published. Several
drawings from the series were, however,
printed in *The Savoy*, including this
image of the Rhine maidens who guard
the gold. Beardsley has drawn their
tresses to represent both hair and river
water, so that the leading maiden's left
arm disappears into it and the face of the
second is half submerged. Similarly, the
dotted line suggests either drapery or
foam. The river below flows over linked
golden rings, a reminder that this is part
of the *Ring* cycle.

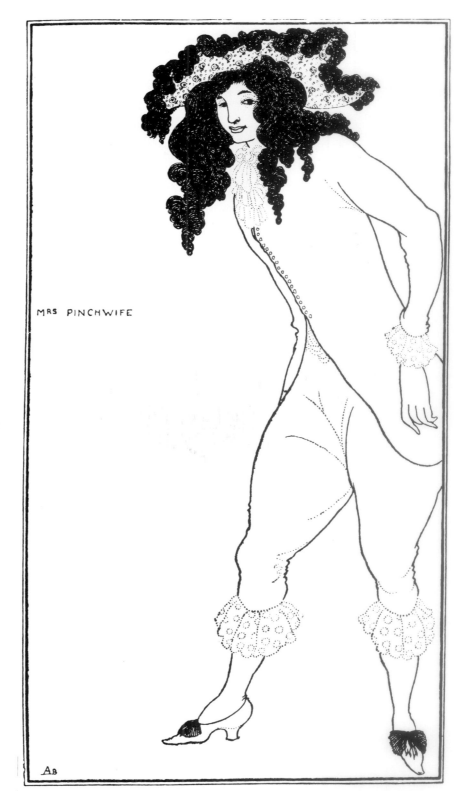

MRS PINCHWIFE

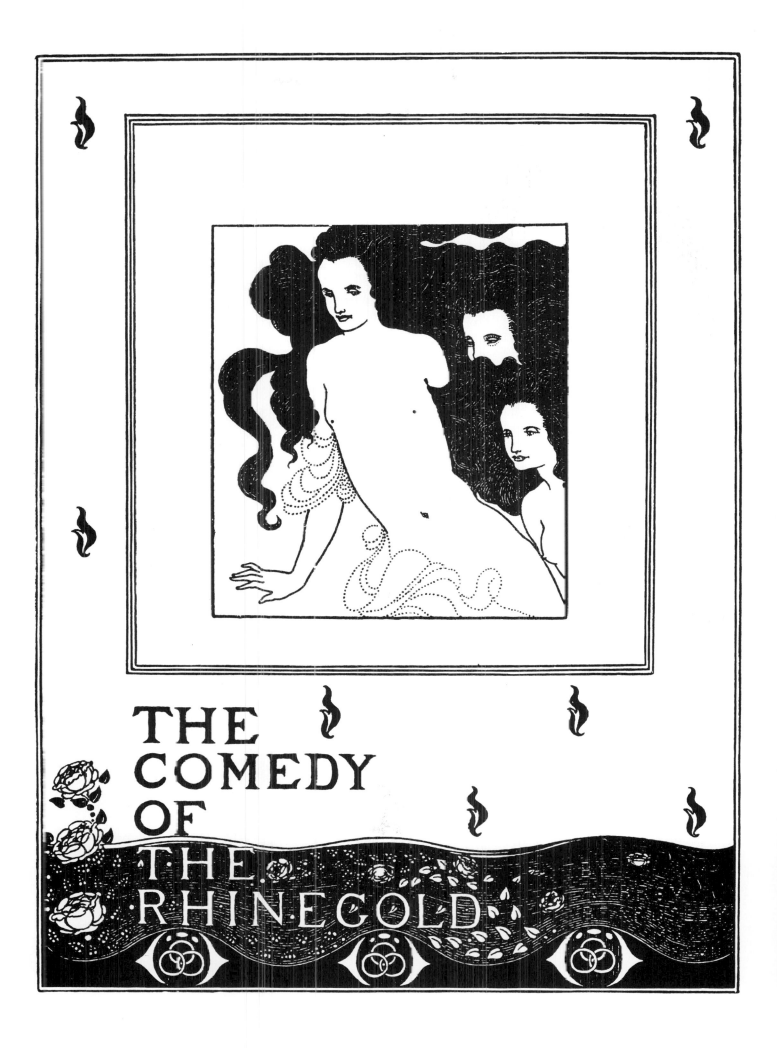

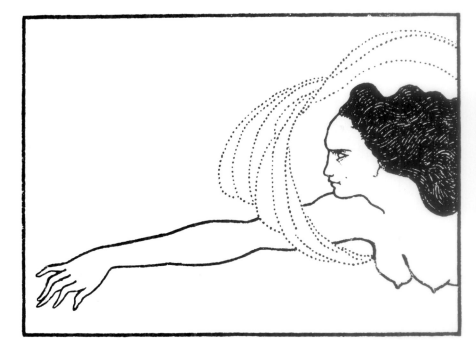

Right: FLOSSHILDE, 1896. This is the second of the four illustrations for *The Comedy of the Rhinegold* that were published in the eighth issue of *The Savoy*. Flosshilde is one of the Rhine maidens who guards the gold against such predators as the Nibelung dwarfs, and here she appears in arrested movement, as if she has just hurled an object at the enemy. This impression is enhanced by the swirl of drapery, for which Beardsley has used somewhat larger dots than usual.

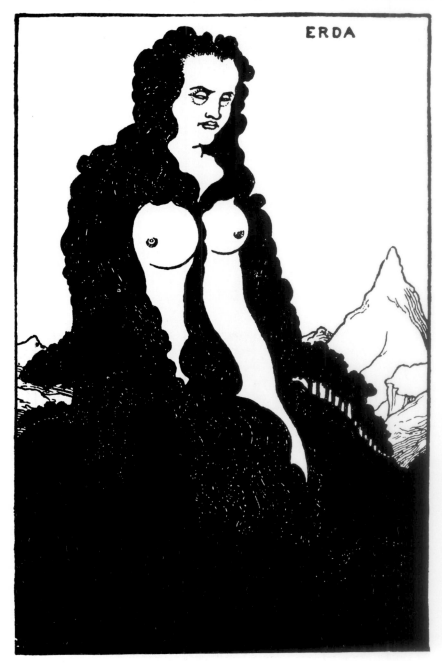

Right: ERDA, 1896. In this illustration for *Das Rheingold* Beardsley depicts Erda, the Earth Goddess, looming up like the mountains behind her, her hair defining her full breasts and becoming a river flowing down into the land. It was Erda who gave birth to nine warrior daughters, the Valkyries, to defend Valhalla. The expression of tired evil on Erda's face has been thought by some to signify the artist's lack of sympathy with the idea of the Earth Mother, and a tendency to confuse her with the *femme fatale*.

THE SPIRIT OF BEARDSLEY

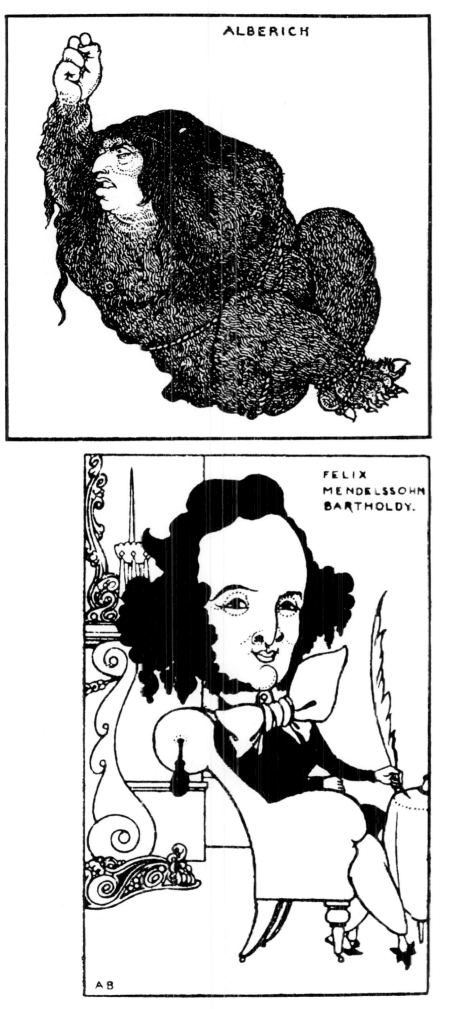

ALBERICH

FELIX
MENDELSSOHN
BARTHOLDY.

A B

Left: ALBERICH, 1896. A consummate grotesque, Alberich is the Nibelung dwarf in *Das Rheingold* who renounces love and forges a ring from the Rhinegold he has stolen, in order to become ruler of the world. This depiction appears to be the moment when he has been tricked by Wotan into parting with the ring and puts a curse on it. Beardsley's monster has been observed to have an affinity with Caliban (from Shakespeare's *The Tempest*), but it is also indebted to his own earlier *Bon-Mots* pieces. This is a creature of terrible deformity, with clawed feet and head set within his body — a veritable 'no-neck monster'.

Left: FELIX MENDELSSOHN-BARTHOLDY, 1896. The drawing was reproduced in *The Savoy*, No. 8, the same issue as the Wagner-inspired *Das Rheingold* drawings. The connection between the two composers in Beardsley's mind, apart from the fact that they both inspired him, may have arisen from an entry in Wagner's *Mein Leben*, in which he wrote that Mendelssohn confided to him that he considered himself a failed opera composer. In this portrait Beardsley has depicted Mendelssohn as being left-handed.

Right: CARL MARIA VON WEBER, 1896. Published in the eighth issue of *The Savoy*, this portrait of Weber was the second drawn by Beardsley. The composer would have attracted the young artist as a subject not only because of his music and his great influence on Richard Wagner, but also because Weber's death was hastened by tuberculosis, as Beardsley felt his own would be. To denote the composer's theatrical upbringing as the son of an actor-manager, Beardsley has placed him near a swagged curtain that suggests a stage, and presented him in dandified attire, as if taking a bow.

Far right: COUNT VALMONT, 1896. This drawing of the wicked Count Valmont, from *Les Liaisons Dangereuses* by Choderlos de Laclos, appeared in the eighth, last issue of *The Savoy*. In one of Beardsley's favourite novels, Laclos tells the story of a pair of aristocratic lovers who carry out a cynical plan to seduce a young and innocent girl for their mutual pleasure. Here the artist has chosen to present the villain as being naked beneath his cloak, and by the feminine fall of hair and décolleté neckline has managed to suggest an awful blending of the two decadent plotters.

Overpage: ET IN ARCADIA EGO, 1896. Printed in the last issue of *The Savoy*, this drawing is rich in allusion. It was produced by Beardsley during what he termed 'an agony of depression'. The theme, taken from Poussin's painting *Les Bergers d'Arcadie*, is that even in the happiest moment Death awaits. In this illustration the inscription, besides its two meanings of 'Even in Arcadia, there am I', or 'Alas, I too once lived in Arcadia', might also convey, 'Even in Arcadia one finds ego', in reference to the ageing dandy who picks his way over the grass like a dancer.

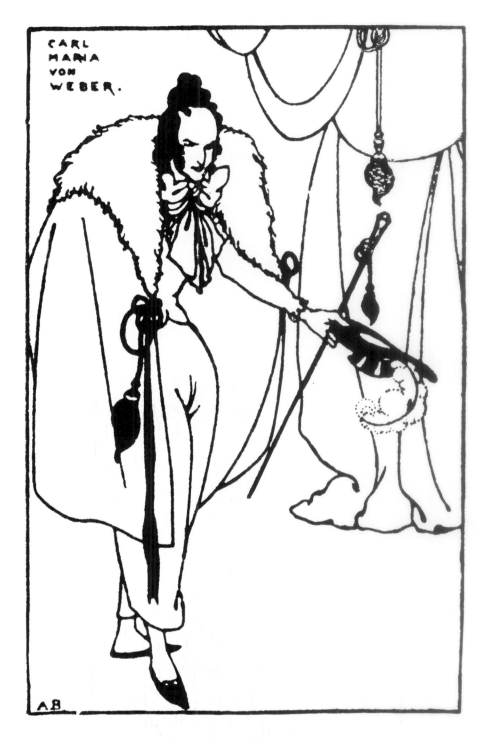

Les Liaisons dangereuses.

by Choderlos de Laclos

THE SPIRIT OF BEARDSLEY

PIERROT'S LIBRARY
AND OTHER
BOOK DESIGNS OF 1896

THE SPIRIT OF BEARDSLEY

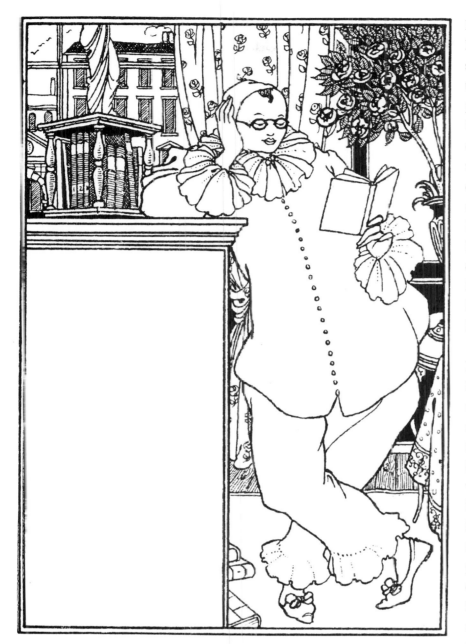

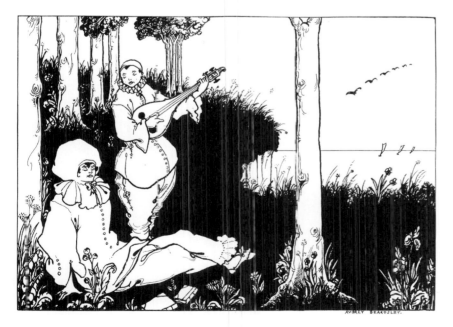

Far left: DESIGN FOR PIERROT'S LIBRARY, 1896. This design was stamped on the spines and front covers of this series of books, which were published by John Lane and illustrated by Beardsley. The artist identified obsessively with the character of Pierrot, to him an emblem of the death of the century, and of his own threatened demise. The Pierrot in this drawing is bookish and dreamy, his volume beneath his arm; but even in this peaceful composition there is a threat. In the lower left-hand corner are three strange holes, each viewed from a different angle, like moons in eclipse.

Left: TITLE-PAGE DESIGN FOR PIERROT'S LIBRARY, 1896. The scene outside Pierrot's window may be Beardsley's native Pimlico, and the sky features the frequently used motif of a column of birds in flight. This is a fairly innocuous design, with a relaxed, bespectacled figure reading his book in a comfortable, middle-class interior. If carefully scrutinized, however, small details betray Beardsley's preoccupations. The Pierrot's right-hand coat-folds are breast -shaped, the curtain-tie is a strange mask, and some of the flowers of the potted plant present malevolent little faces.

Left: FRONT ENDPAPER FOR PIERROT'S LIBRARY, 1896. Printed in olive green, this endpaper design depicts two Pierrot figures, one serenading the other, who looks fairly unimpressed by what he hears. The cliff-top scenery is reminiscent of the background of *Atalanta in Calydon* (p. 145), although the flowers and trees are more realistically drawn. In the sky a column of birds retreat or approach, a motif that must have had some particular significance for Beardsley as it appears in so many of his designs.

Below: BACK ENDPAPER FOR PIERROT'S LIBRARY, 1896. The two Pierrots of the front endpaper have taken to the road, donning clogs and shabby trousers. The Pierrot with stick and bundle looks towards a cryptic (and rather phallic) milestone and a pair of birds who fly apart from the others. It is not surprising that, with his love of line, Beardsley took pleasure in telegraph wires. Defending poster art, he once wrote in an article for the *New Review*, 'Beauty has laid siege to the city, and telegraph wires shall no longer be the sole joy of our aesthetic perceptions.'

Above right: DESIGN FOR THE BACK COVERS OF PIERROT'S LIBRARY, 1896. The motif of Pierrot as moon explains the strange holes or eclipses that appear in the illustration for the front cover of these volumes (p. 192), the connection between the sad clown with the moon having always been part of the Commedia dell'Arte tradition. Beardsley was not the first to use this conceit, an artist called Tom Meteyard having made a similar design (for a book published by John Lane in 1894) using three faces in the light section of the moon.

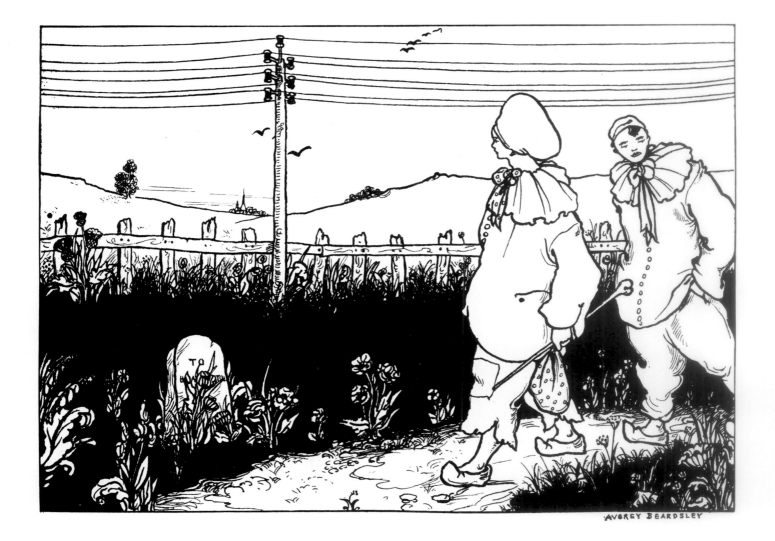

Below: FRONT COVER OF *VERSES* BY ERNEST DOWSON. 1896. Beardsley, the dandy, could not bear Ernest Dowson's sordid appearance and dissipated way of life, and undertook to illustrate his writing only upon the insistence of Leonard Smithers, who commissioned so much of Beardsley's work. When told that Dowson was 'a great poet', Beardsley replied, 'I don't care. No man is great enough to excuse behaviour like that.' He explained this cover design to a friend as representing the letter 'Y', standing for his own thought, '*Why* was this book ever written?'

THE SPIRIT OF BEARDSLEY

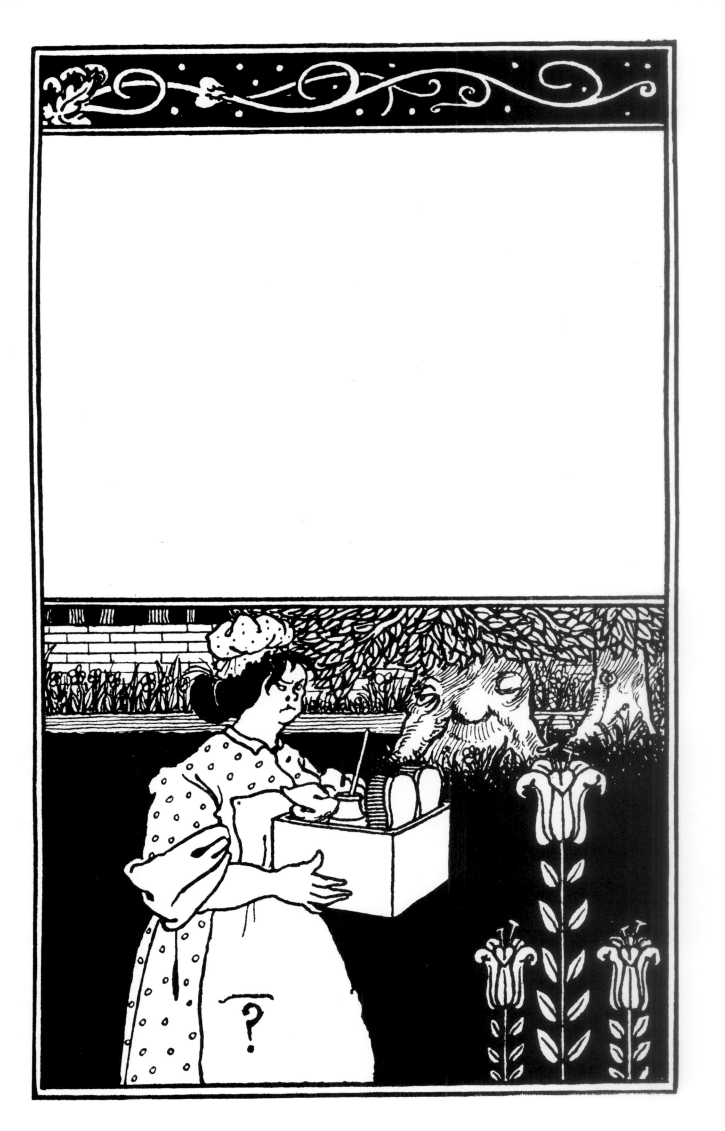

THE SPIRIT OF BEARDSLEY

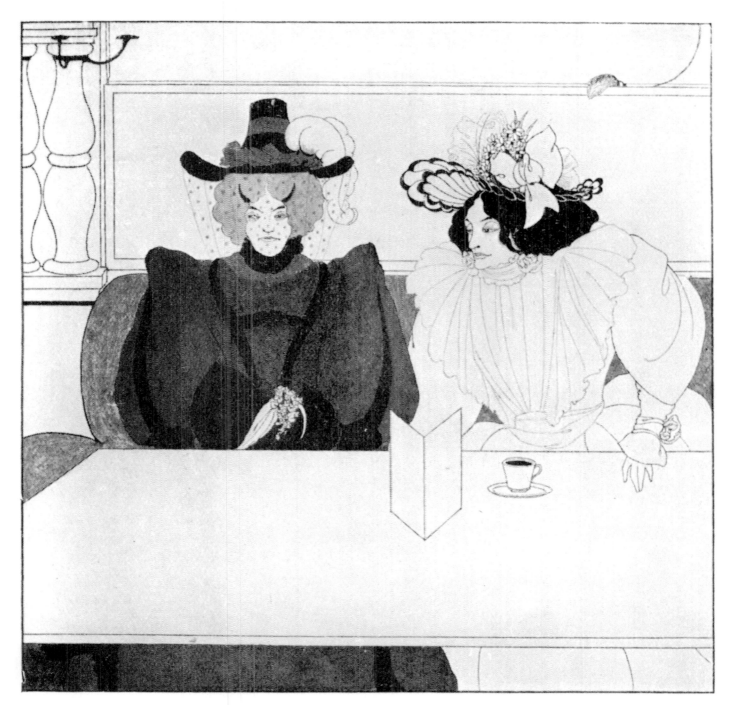

Left: COVER DESIGN OF *THE BARBAROUS BRITISHERS*, 1896. Here Beardsley parodies his cover for *The British Barbarians* (p. 72) published in 1895 in the Keynotes series of books. *The Barbarous Britishers* by Henry Duff Traill was subtitled 'a tip-top novel', and in this light-hearted work Beardsley has delighted in lampooning his personal quirks of design, like the stylized flowers and the excessively humanized tree trunks. The question mark on the maid's pocket may express her bewilderment about the nature of her slavery. Her battered face was a caricature of the actress Ada Lundberg.

Above: FIRST FRONTISPIECE TO *AN EVIL MOTHERHOOD*, 1895. Originally entitled 'Black Coffee', this work was drawn for the abandoned fifth volume of *The Yellow Book*. It was totally irrelevant to Walt Ruding's novel, the publishers of which were extremely annoyed to discover that this image of two prostitutes sitting in a café had already been printed and a few copies circulated. They withdrew the remaining copies, but not before people had been scandalized by the portrayal of degenerate 'devil' women, engaged, as some thought, in a lesbian relationship.

Overpage: SECOND FRONTISPIECE TO *AN EVIL MOTHERHOOD*, 1896. Beardsley only supplied this design when Elkin Mathews, the publisher of the book, arrived at his rooms and would not leave until the drawing was well under way, even arranging for Walter Ruding, the author of *An Evil Motherhood*, to sit two or three times for the figure in the chair. Many critics have read into this work an autobiographical comment on the dominance of Beardsley's mother, but it is more likely that the artist was, under duress, trying to be true to the author's text.

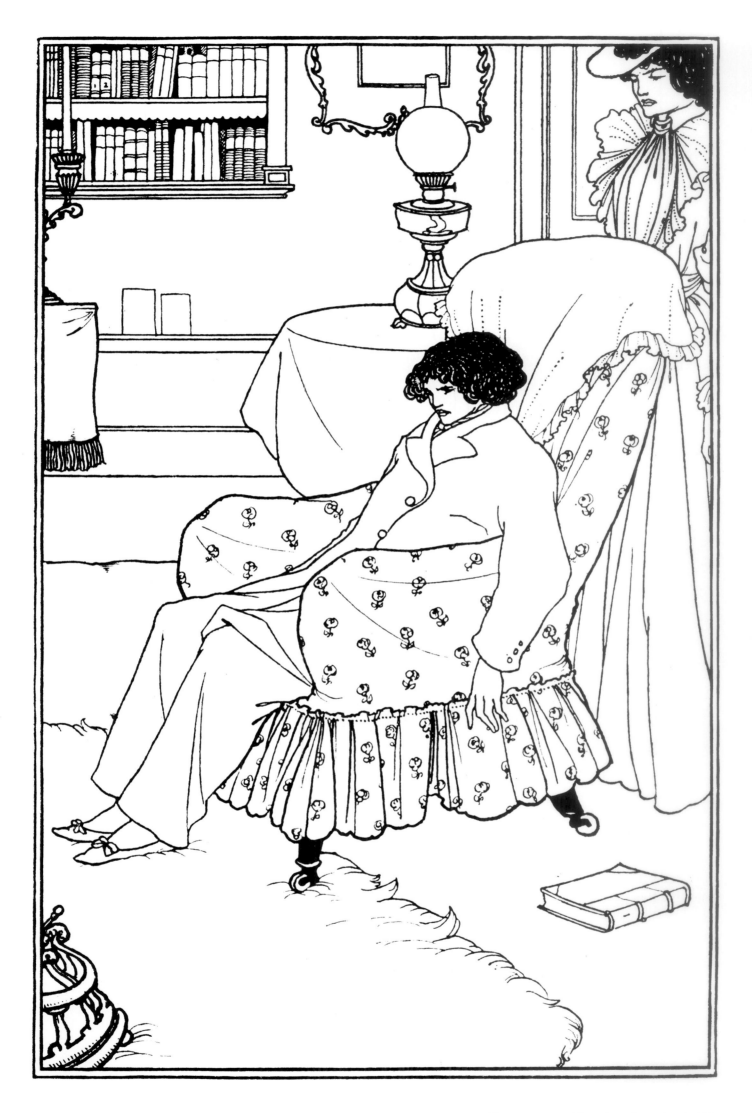

THE SPIRIT OF BEARDSLEY

Left: FRONT COVER OF *SAPPHO*, 1895. Elegant and minimal, this design, featuring a Greek lyre, was blocked in gold on the blue cloth binding of Henry Thornton Wharton's memoir and translation of the work of Sappho, the Greek lyric poetess. Only fragments of her verses survive, but those that do are expressed with a natural simplicity that Beardsley has tried to match in his design. The lyre was, of course, the stringed instrument with which the poets of the ancient world accompanied themselves, and during the Renaissance it became the symbol of lyric poetry.

Below: TITLE-PAGE OF *THE PARADE*, 1897. Beardsley drew this decoration for a book subtitled *An Illustrated Gift Book for Boys and Girls*, which was published by H. Henry and Co. Ltd. Perhaps the title of the book triggered memories of the Grand Parade in Brighton. The effect of Brighton architecture on the artist has often been acknowledged, and the ornate artifice of this design, and particularly the bizarre chandelier-lamp with its pineapple top, brings to mind the interior of the Prince Regent's wonderful folly, the Royal Pavilion, which, as a child, Beardsley had adored.

Overpage: COVER OF *CATALOGUE OF RARE BOOKS*, 1896. The term 'rare' books was a fairly loose one as far as Leonard Smithers was concerned in that it certainly included much erotic and pornographic literature. This makes it all the more ironic that Beardsley should choose to draw for Smithers's catalogue a demure woman reader, albeit rather pretty and with a revealing neckline. In this conventional composition, the eye is drawn to strongly graphic aspects of the design: the mass of hair; the black-and-white striped sofa; and the curve of the white skirt.

THE SPIRIT OF BEARDSLEY

THE SPIRIT OF BEARDSLEY

MADEMOISELLE DE MAUPIN

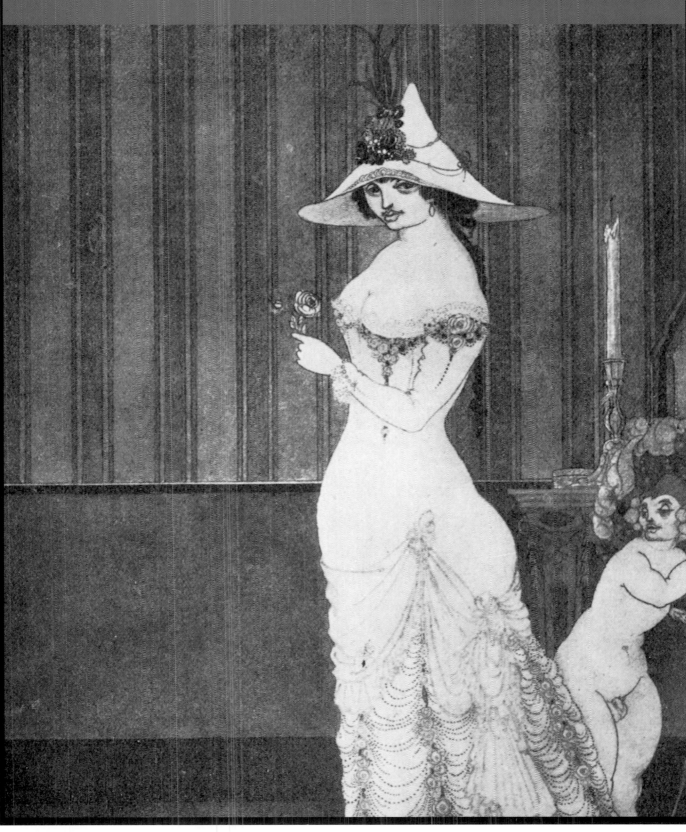

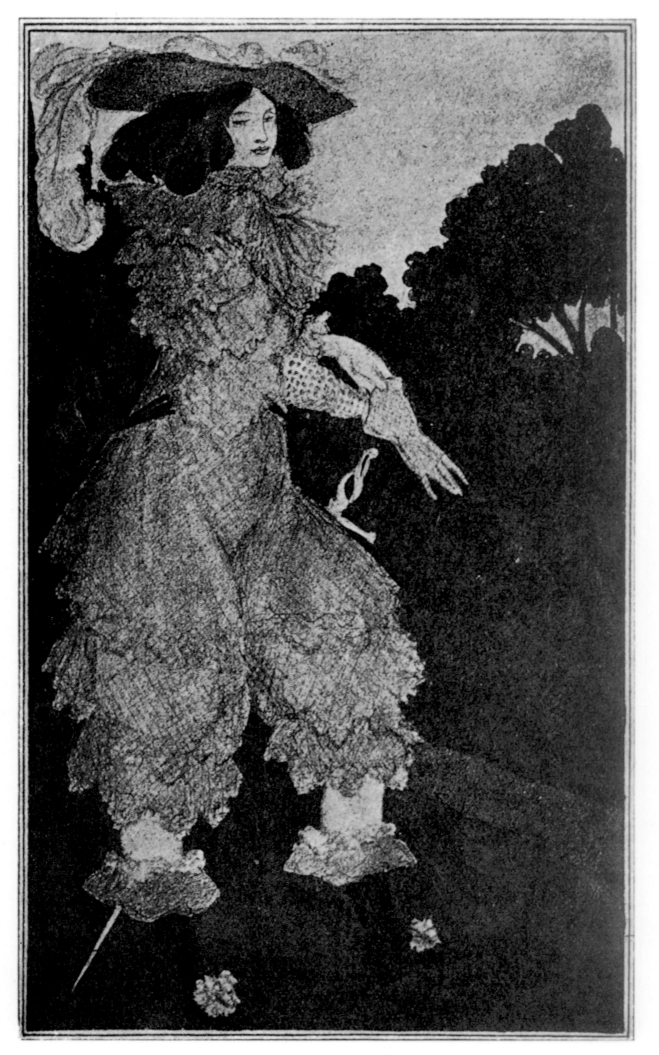

THE SPIRIT OF BEARDSLEY

Left: MADEMOISELLE DE MAUPIN, 1897. Theophile Gautier's novel, *Mademoiselle de Maupin*, written in 1835, fascinated Beardsley. He was especially interested in its eponymous heroine, a bisexual beauty who, before giving herself to the hero, D'Albert, enjoys his mistress first. Although desperately ill, Beardsley completed six illustrations in this series, of which this

work in pen, ink, and pink and green watercolour is the frontispiece. His sister Mabel, who had often dressed as a male for their early theatrical ventures, may have been in his mind for this portrait of Mademoiselle de Maupin, as the features rather resemble hers.

Above: D'ALBERT, 1897. The illustration is of D'Albert, hero of the

novel, a man obsessed with erotic experience to such a degree that he even desires to be a woman so as to taste further pleasures. Beardsley, in this extraordinary drawing, focuses on this aspiration, and the face under the strange hat is almost completely feminine, as are the hands, one of which toys with the head of the cane in an explicitly sexual manner.

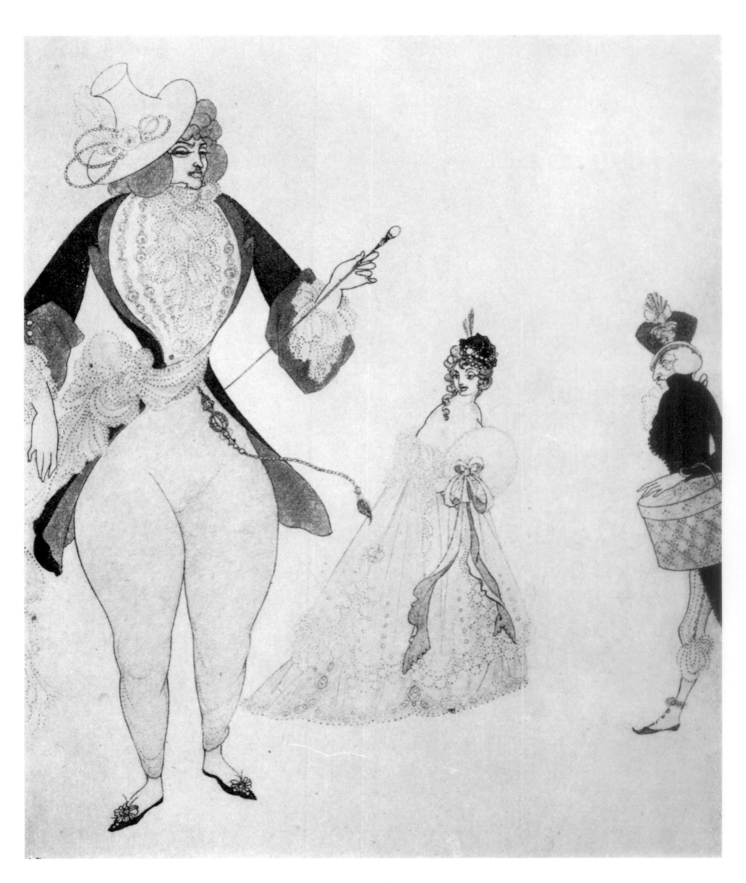

Above: D'ALBERT IN SEARCH OF IDEALS, 1897. In this pen-and-ink and watercolour wash drawing D'Albert's face looks slightly less feminine than in the drawing on the previous page, but now Beardsley has given him the hour-glass figure and massive thighs of a *fin-de-siècle* pantomime principal boy. He holds the delicate phallus-headed cane and stares ahead through heavy eyes, as if terminally bored, clearly rejecting the heterosexual female represented by the half-naked courtesan, and the type of homosexual male who struts in military gear and elegant spats.

THE SPIRIT OF BEARDSLEY

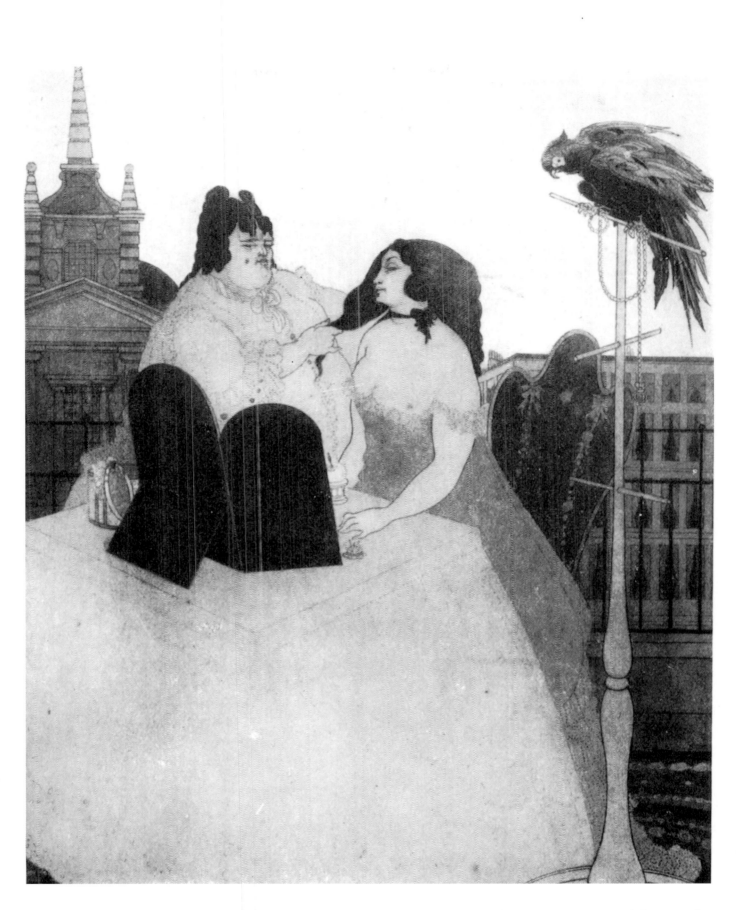

Above: THE LADY AT THE DRESSING-TABLE, 1897. Drawn in Indian ink and wash, this drawing is regarded as one of Beardsley's finest. Its composition creates an extraordinary impression of space and distance, which is party achieved through the slightly skewed perspective of the parrot perch and dressing-table, but also by the odd wall-less setting. as if on a roof or in a city square. The faces of these women are monumental, almost sculptural, set against the black of their hair and the white of the sky. Their solidity and passivity is contrasted by the feathered agitation of the chained bird.

Right: THE LADY WITH THE ROSE,
1897. The *Mademoiselle de Maupin* series
marks a change of style, with Beardsley
beginning to use large areas of wash and to
draw faces rather differently, with heavy-
lidded eyes and serenely sensual expressions.
The woman in this drawing wears a hat of
a shape unprecedented in Beardsley's work,
and stands against wallpaper very like that
of the artist's own rooms. The Pierrot type
as attendant figure is absent in this work,
the creature to the right, who gazes at the
woman's rump, being unique to this work.

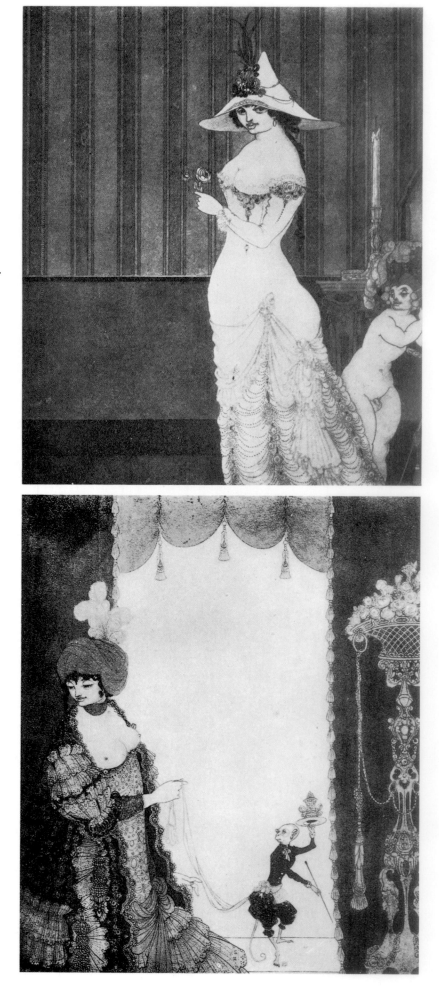

Right: THE LADY WITH THE MONKEY,
1897. Originally intended as an illustration
for *Volpone*, this drawing was added as the
last in the *Mademoiselle de Maupin* series.
The attendant figure has here been reduced
to a monkey, a creature Beardsley used to
convey either man as dominant and bestial,
as in *The Murders in the Rue Morgue*
(p. 137), or man as subservient to woman,
as seems to be the case here. The bare-
breasted mistress turns away, heedless of the
sycophantic courtier she holds with such a
loose rein.

THE SPIRIT OF BEARDSLEY

VOLPONE

Right: VOLPONE ADORING HIS
TREASURE, 1897-8. 'I can think of
nothing but "Volpone" and have set my
heart on doing it finely', Beardsley wrote
to his sister Mabel. This picture, intended
for the prospectus of the play, illustrates
Volpone's speech, 'Good morning to the
day: and next, my gold!/ Open the shrine
that I may see my saint.' Beardsley
considered it his finest work, an opinion
questioned by some critics but accorded
with by others, Brian Reade calling it
'one of the most exalted achievements of
penmanship in the history of art'.

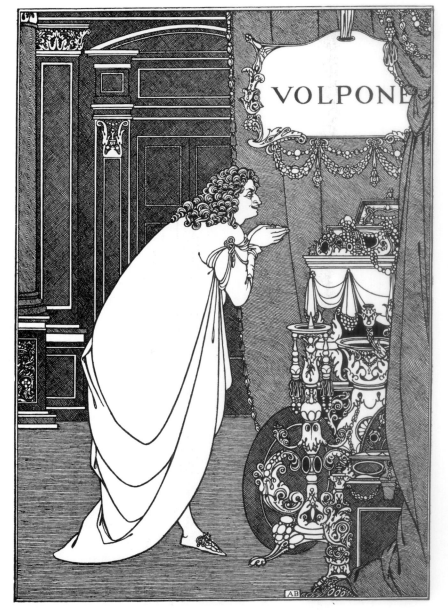

Below right: INITIAL V FOR *BEN
JONSON HIS VOLPONE*, 1897-8. This
is perhaps the least successful of the
decorated initials Beardsley designed for
Volpone. Flawed by a lack of balance,
this V seems insubstantial, its suspension
from the horizontal making sense on the
left but not on the right, where it
interrupts the classical column in an
ungainly way. The artist has shaded in
the sky with a soft pencil, a technique
also used for the other initials.

THE SPIRIT OF BEARDSLEY

INITIAL V FOR *BEN JONSON HIS VOLPONE*, 1897-8. For this, his last series of drawings, Beardsley returned to the design influence of his early youth — Brighton. Its architecture, and especially the interior design of the Royal Pavilion, furnished his imagination with the baroque imagery apparent in these 'embellishments', as he called them, and he wrote to Leonard Smithers, who commissioned the work, remarking that the *Volpone* drawings were 'a marked departure as illustrative and decorative work from any other arty book'. For this study of a bad-tempered, bejewelled elephant with fruit-bowl howdah, he used pen, ink and pencil.

INITIALS FOR *BEN JONSON AND HIS VOLPONE*, 1897-8. In this design the bird of prey swooping down through the letter S illustrates what Beardsley called the 'passionate virulence' of Ben Jonson's work. He wanted his drawings for the play to be equally 'full of force both in conception and treatment', and this evil predator, bejewelled harness flying, may be a symbol of the wild energy of the acquisitive Volpone. Like his literary idols, Pope and Jonson, Beardsley delighted in unmasking human hypocrisy.

INITIAL M FOR *BEN JONSON HIS VOLPONE*, 1897-8. Beardsley was always attracted by the fusion of pagan and Christian worlds, and this drawing shows a Venus and Cupid who could also be a Madonna and Child. It is possible, however, that this is the Roman goddess Diana, an interpretation reinforced by the many-breasted representations of Diana of Ephesus behind the mother and child. This divinity (whom Jonson called 'Goddess excellently bright') may have had a particular significance for Beardsley, as Diana brought death either gently or cruelly.

INITIAL V FOR *BEN JONSON HIS VOLPONE*, 1897-8. This illustration uses pagan imagery in the form of the herm of Pan, which is squat and brutish, not quite centred into the angle of the V and placed as if on a rooftop. In the background are Poussin-inspired trees, and in the lower right corner, if examined extremely carefully, there can be discerned a coliseum and mountains, one of which presents an anguished face. All the initial decorations Beardsley designed for *Volpone* include architectural details.

LATE WORKS

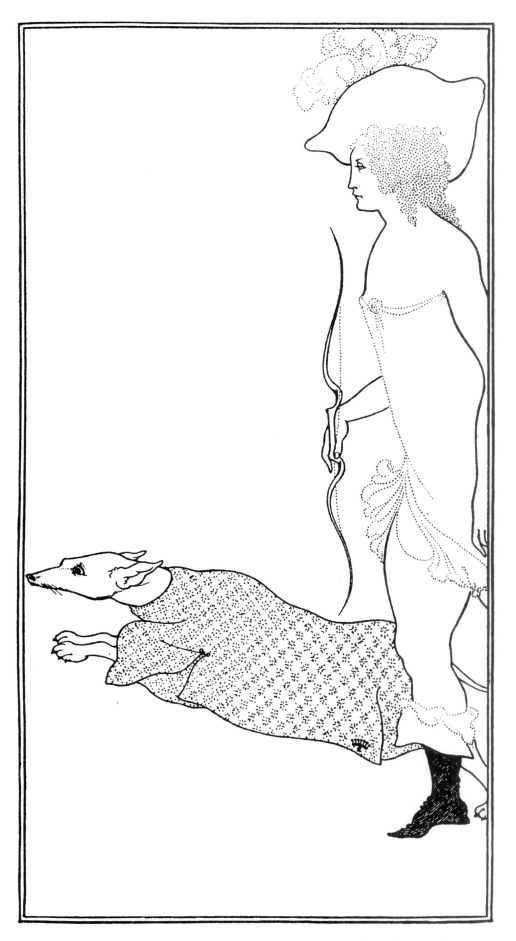

ATALANTA IN CALYDON, *c.* 1897. Also known as 'Diana', this is a reworking of an earlier composition (p. 145), but in a very different style. The technique in this design is more like that of the *Lysistrata* drawings (pp. 147-54), but, unusually, the hair is represented entirely by spirals of dots. In the earlier version Atalanta's bow is held out from her body at a phallic angle, while in this work the same angle is adopted by the leaping hound, which surges forward in a patterned coat with a coronet on its hem.

THE SPIRIT OF BEARDSLEY

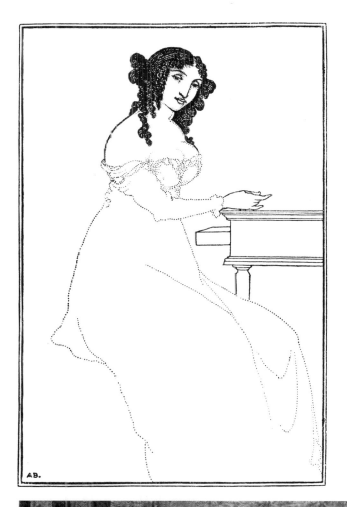

Above right: FRONTISPIECE TO *A BOOK OF BARGAINS*, *c.* 1896. This is an illustration for a collection of eerie short stories by Vincent O'Sullivan. The woman sitting at a desk represents a ghost, but Beardsley has made her physical parts extremely solid, only suggesting her otherworldliness by the faintness of her garment, her period hairstyle and the absence of a chair.

Below right: ARBUSCULA, 1897. The drawing represents a dancer from the early Roman Empire, but Beardsley's setting is distinctly eighteenth century. An illustration for *A History of Dancing from the Earliest Ages to our Own Times* by Gaston Vuillier, this is very much in the *Mademoiselle de Maupin* style, and like that series of drawings, executed in Indian ink, wash and pencil. The figure reclines in a posture reminiscent of François Boucher's *Madame de Pompadour*, holding a mask in which human eyes look sidelong at the viewer in an opposite direction from the dancer's own.

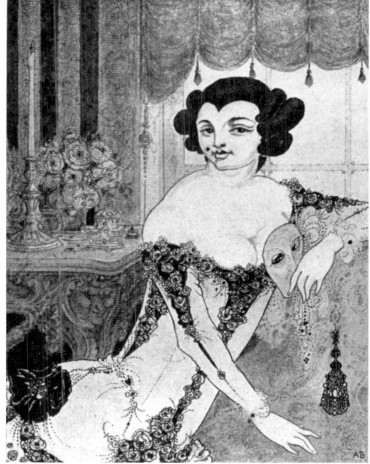

THE SPIRIT OF BEARDSLEY

THE PIERROT OF THE MINVTE.

Left: INITIAL P, 1897. While suffering from recurrent haemorrhages, Beardsley forced himself to work on what he referred to as 'a rather pretty set of drawings for a foolish playlet of Ernest Dowson's, *The Pierrot of the Minute*. Later he called it 'Dowson's filthy little play', a criticism of the quality of the writing rather than its content. A comparison between this decoration and those for the *Volpone* initials (pp. 209-10) gives some indication of the differing degrees of Beardsley's emotional involvement with the literature he was illustrating.

Below left: FRONT COVER OF THE *PIERROT OF THE MINUTE*, 1897. This little figure was blocked in gold on the cover of both the ordinary and *de luxe* editions of Ernest Dowson's dramatic fantasy, *The Pierrot of the Minute*. Although Beardsley disliked the play intensely, he was attracted to the subject, given his identification of himself with the character of Pierrot. In this design, both the flight of the figure and the hourglass he holds suggest the fleeting nature of the 'Minute'.

Below: CUL-DE-LAMPE FOR *THE PIERROT OF THE MINUTE*, 1897. This embellishment for the last page of Ernest Dowson's play features a Watteau-like Pierrot, who seems to be making a glum exit — perhaps another of Beardsley's wry allusions to his dislike of the work. In spite of this, it is a beautiful drawing, the impression of dappled sunlight in the garden simply achieved. The pin-prick-like patterned frame of roses, shells and ribbon, unique for its time, was to be a formative influence on later designers.

THE SPIRIT OF BEARDSLEY

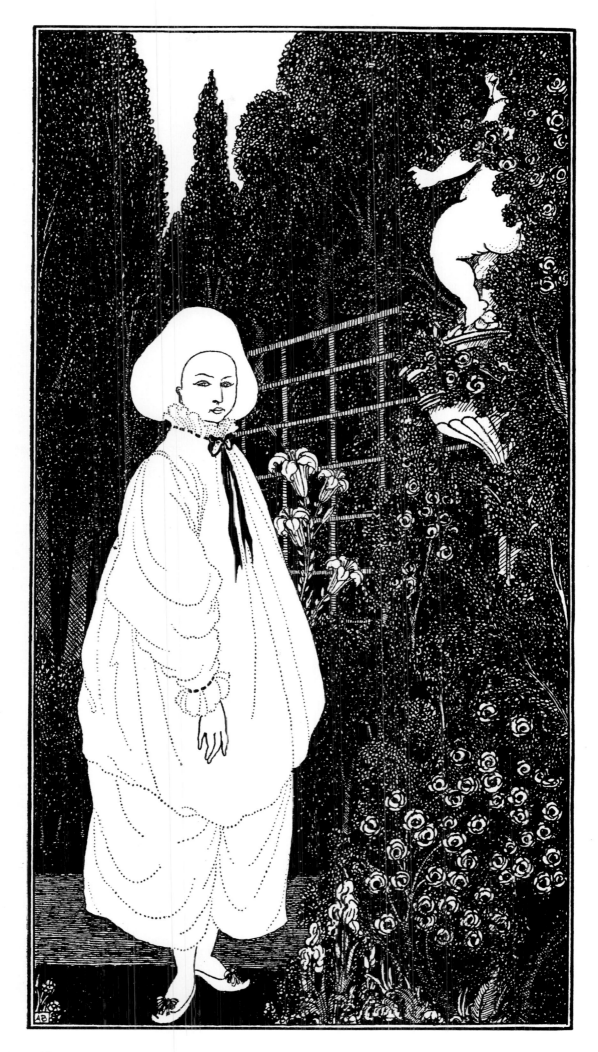

THE SPIRIT OF BEARDSLEY

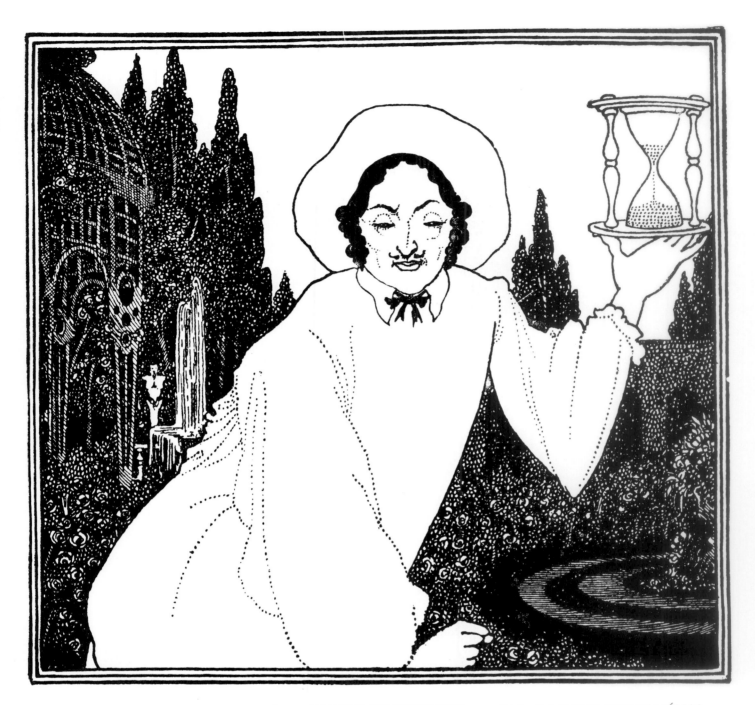

Previous page: FRONTISPIECE TO
THE PIERROT OF THE MINUTE,
1897. A comparison of this Pierrot
with the one in the painting '*Gilles*' by
Watteau reveals the strong influence
of eighteenth-century masters on
Beardsley's late work. It is likely that
the forced isolation of his illness made
Beardsley identify with Watteau's
depictions of loneliness. Both clowns
stand in their distinctive white
costume and hat, their posture is
similar, and each looks separated
from his surroundings. In Watteau's
garden the other actors ignore the
clown; in Beardsley's there is no
company except a stone cherub.

Above: CHAPTER HEADING FOR
THE PIERROT OF THE MINUTE,
1897. This illustration for Ernest
Dowson's play seems to reflect
Beardsley's reservations about its
literary quality. All the artist's
usual hallmarks are here —
the rose garden, fountain, herm,
cupola and stylized trees — but the
Pierrot fawns like a waiter,
presenting a plate of pasta rather
than the symbolic hour-glass
he holds. It was surely Beardsley's
intention to give this impression
by the exaggerated pose, curly
black hair and little gigolo moustache
of the clown.

Right: LA DAME AUX CAMÉLIAS,
c. 1897. In 1895, while in France
with Arthur Symons, Beardsley was
infinitely delighted to meet one
of his literary heroes, Alexandre
Dumas *fils*. At the end of a
successful visit, the author
presented the young artist with a
copy of *La Dame aux Camélias*,
which was obviously much
treasured as it was later to be buried
with Beardsley. This delicate
watercolour sketch was drawn on
the fly-leaf of the precious volume,
using a loose, light touch, said to be
somewhat in the style of the artist
Charles Condor.

216

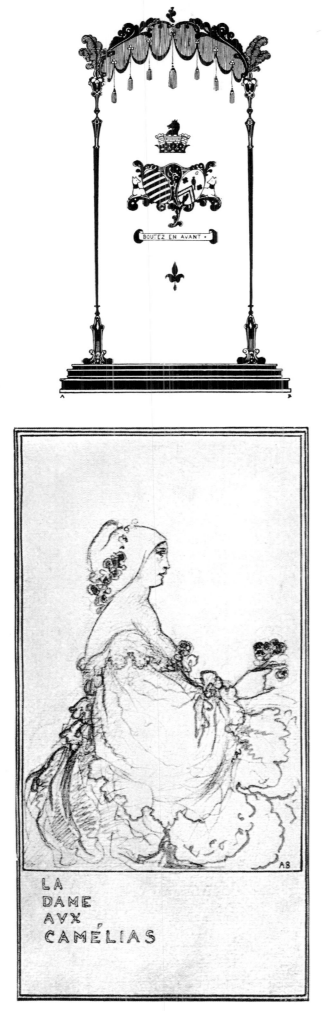

LA
DAME
AVX
CAMÉLIAS

Left: FRONT COVER OF *THE LIFE AND TIMES OF MADAME DU BARRY*, c. 1896. Highly influenced by eighteenth-century French stage décor, this design was blocked in gold on violet for the book of the above title, by R. B. Douglas. The equivocal motto '*Boutez en avant*' translates as 'push forward' or 'drive onward'. Above this command the coat of arms features two dogs couchant. Beardsley has signed his own initials on the left and right.

Below: FRONT COVER OF *THE HOUSES OF SIN*, c. 1897. Designed for another book by Vincent O'Sullivan, this work is considered one of Beardsley's masterpieces of suggestion. The pig face, flying on wings like a Victorian-scrap angel, seems to sniff, with sensuous snout, at a variety of nameless pleasures on offer. The image was thought to be influenced, albeit subliminally, by *Pornocrates* by Félicien Rops, in which a blindfolded woman, naked but for stockings, hat and gloves, is led by a pig while three putti fly before her.

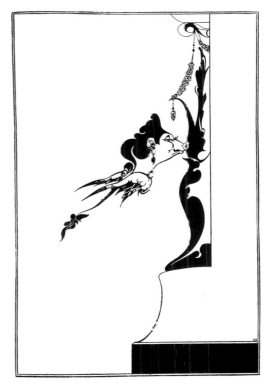

THE SPIRIT OF BEARDSLEY

Below right: DESIGN FOR AUBREY BEARDSLEY'S BOOK PLATE, *c.* 1896-7. Never actually used as the artist's book plate, this design ended up belonging to Herbert Charles Pollitt, a Beardsley collector. The disk supporting the heap of books is reminiscent of the unused cover design for *The Yellow Book* (p. 127), but here, in place of three little Pierrots, is a paunchy, bald grotesque who, confronted by a woman naked but for a hat, turns his eyes away in mute impotence.

Below: SILHOUETTE OF THE ARTIST, *c.* 1896-7. This self-portrait silhouette was used as the tail-piece to Beardsley's *A Book of Fifty Drawings*, which was published in 1897 by Leonard Smithers. Beardsley had used a silhouette at the end of a book once before: the little cupid for *The Ballad of a Barber* (p. 177), but it is not clear whether he knew the work of his maternal grandmother, an accomplished silhouettist. Despite being a caricature, it is a faithful representation of the profile known to so many from the photographs of Frederick H. Evans.

Right: FRONT COVER OF *A BOOK OF FIFTY DRAWINGS*, 1896. Forbidden by his doctor to do too much, but desperately in need of income, Beardsley made a selection of his past work for Leonard Smithers to publish. In this drawing Beardsley's hand seems unsure, probably due to his weak condition, but the overall design is well conceived.

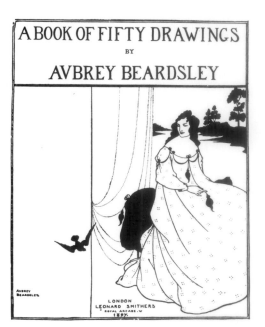

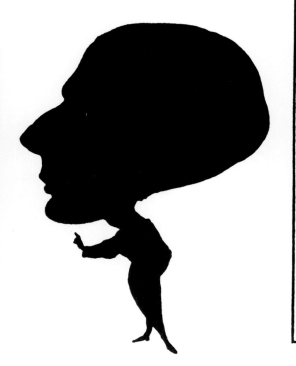

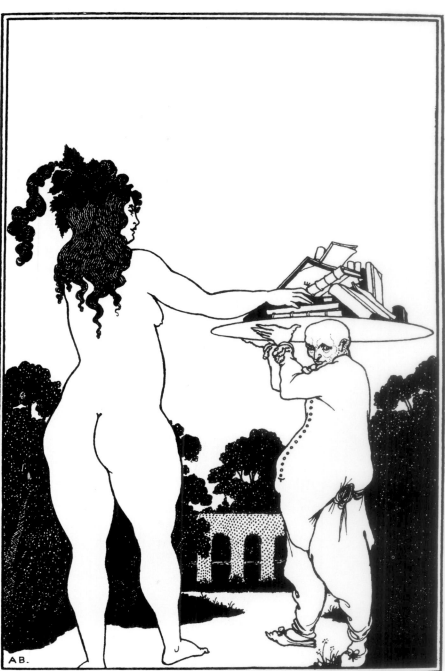

THE SPIRIT OF BEARDSLEY

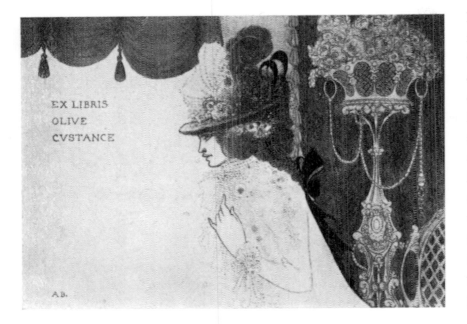

Left: BOOK PLATE, *c.* 1897. This plate is chiefly of interest because the poetess Olive Custance, for whom Beardsley designed it, afterwards became the wife of Lord Alfred Douglas, the homosexual lover of Oscar Wilde. Although it uses a similar technique and medium — pen and ink and wash — as the *Mademoiselle de Maupin* studies, the quality of this design is not comparable with them. The composition is unbalanced and clumsy, the hand and arm badly drawn, and the whole gives the impression of being rather hastily produced.

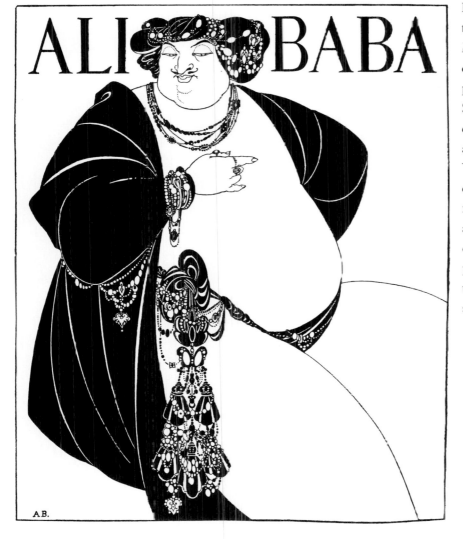

Left: ALI BABA, 1896. Beardsley drew this cover for a projected edition of *Ali Baba and the Forty Thieves*, never to be completed, while convalescing in 'two palatial rooms' (as he put it) in The Spread Eagle Inn at Epsom. The hugely corpulent rogue may have been yet another acrimonious caricature of Oscar Wilde, but whether or not that is the case, it is a masterly design, the bold flatness of the large black and white areas lending richness to the jewelled detail. Beardsley signed it with a prominent 'A.B.' to draw attention to the coincidence of the artist and subject sharing their initials.

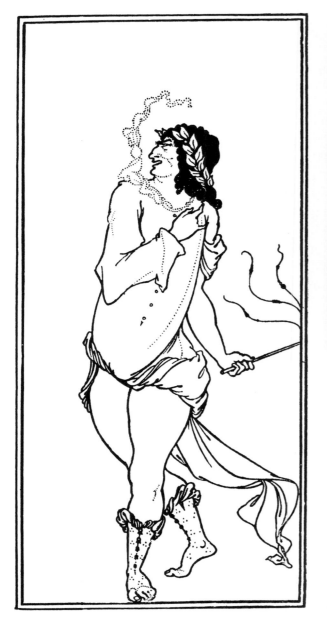

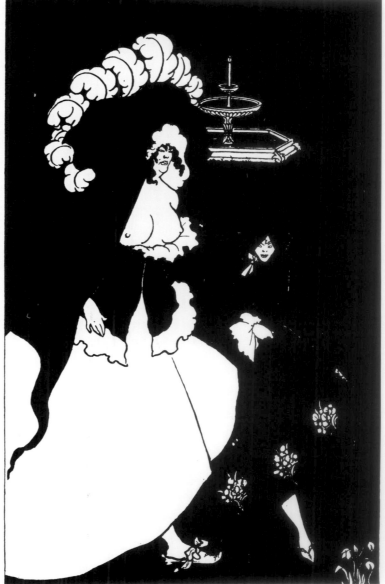

Above: JUVENAL SCOURGING
WOMAN, *c.* 1896. This is an
expurgated detail from a larger drawing
that shows Juvenal with bared genitals
scourging a woman curiously impaled
upon a column. An illustration to the
Sixth Satire of Juvenal, it was not
published until 1906 by Leonard
Smithers. Very definitely in the style of
the *Lysistrata* drawings, with its strong
outlines and contrasting dotted details, it
has been thought by some to show
Beardsley's slightly sadistic attitude
towards women, and by others to reveal
his empathy for them.

Above: MESSALINA RETURNING
HOME, *c.* 1896. Another illustration of
Juvenal, whose satires Beardsley
admired for their 'scorn and
indignation', this drawing shows the
wife of the Emperor Claudius of Rome,
renowned for her lasciviousness, coming
home after a debauch. No-one was
better than Beardsley at the depiction of
vice, made all the more arresting for
being slightly comic, as here in the bare
breasts, clumping step and exhausted
features of the decadent Messalina,
and the little degenerate face of her
tiptoeing companion.

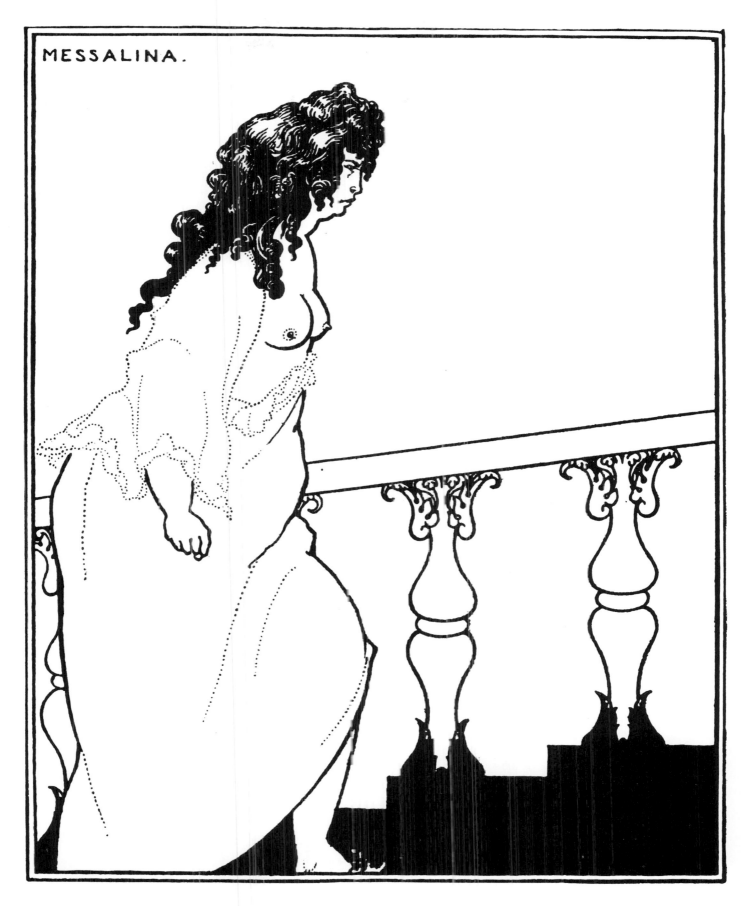

MESSALINA.

Above: MESSALINA RETURNING FROM THE BATH, c. 1896-7. Illustrating the *Sixth Satire of Juvenal*, the power of this formidable woman is conveyed by thicker outlines than usual, and the aggressive, thrusting angle of her stout body. Beardsley having been a frail, delicate boy led by an older sister and cosseted by a strong mother, had every reason for the obsessive recurrence throughout his work of large, domineering females and diminished, marginalized males. In these pictures of Messalina the dominated male has disappeared, as if, in anticipation of his own rapidly approaching death, Beardsley is leaving woman alone and triumphant.

THE SPIRIT OF BEARDSLEY

BIBLIOGRAPHY

Beardsley, A. *Under the Hill* (London, 1904)

Brophy, B. *Black and White* (London, 1968)

Brophy, B. *Beardsley and His World* (London, 1976)

Burkhauser, J. *Glasgow Girls: Women in Art and Design* (Edinburgh, 1990)

Gallatin, A. E. *Aubrey Beardsley's Drawings* (London, 1903)

Gray, J. *Last Letters of Aubrey Beardsley* (London, 1904)

Harris, B. C. (ed.) *The Collected Drawings of Aubrey Beardsley* (New York, 1967)

Harrison, M., and Waters, B. *Burne-Jones* (London, 1973)

Hind, C. L. *The Uncollected Works of Aubrey Beardsley* (London, 1925)

Jackson, H. *The Eighteen Nineties* (London, 1976)

Johnson, W. C. *Living in Sin: The Victorian Sexual Revolution* (Chicago, 1979)

MacFall, H. *Aubrey Beardsley: The Man and His Work* (London, 1928)

Madsen, S. T. *Sources of Art Nouveau* (New York, 1975)

Malory, T. *Le Morte Darthur*, ed. P. J. Field (Bangor, 1978)

Marillier, H. C. *The Early Work of Aubrey Beardsley* (London, 1899)

Marillier, H. C. *The Later Work of Aubrey Beardsley* (London, 1901)

Praz, M. *The Romantic Agony* (Oxford, 1970)

Reade, B. *Aubrey Beardsley* (London, 1967)

Reade, B., and Dickinson, F. *Aubrey Beardsley: Victoria and Albert Museum Exhibition Catalogue* (London, 1966)

Ross, R. *Aubrey Beardsley* (London, 1909)

Snodgrass, C. *Aubrey Beardsley: Dandy of the Grotesque* (Oxford, 1995)

Symons, A. *Aubrey Beardsley* (London, 1948)

Walker, R. A. *Aubrey Beardsley* (London, 1923)

Walker, R. A. *Some Unknown Drawings of Aubrey Beardsley* (London, 1923)

Walker, R. A. *The Best of Beardsley* (London, 1948)

Walker, R. A. *A Beardsley Miscellany* (London, 1949)

Weintraub, S. *Beardsley* (London, 1967)

Wilson, S. *Aubrey Beardsley* (London, 1976)

Zatlin, L. G. *Aubrey Beardsley and Victorian Sexual Politics* (London, 1990)

LIST OF ILLUSTRATIONS